PAINTERS OF THE ASHCAN SCHOOL

THE IMMORTAL EIGHT

BY BENNARD B. PERLMAN

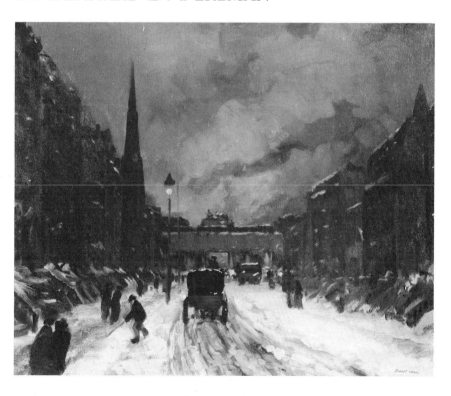

DOVER PUBLICATIONS, INC., *New York*

Published in Canada by General Publishing Company, Ltd., 30
Lesmill Road, Don Mills, Toronto, Ontario.
Published in the United Kingdom by Constable and Company,
Ltd.

This Dover edition, first published in 1988, is an unabridged,
slightly corrected republication of the second (1983) printing of the
work originally published by North Light Publishers, Cincinnati,
in 1979 under the title *The Immortal Eight: American Painting from Eakins
to the Armory Show, 1870–1913*. The illustrations on pages 129–144,
originally reproduced in color, are here reproduced in black and
white.

Manufactured in the United States of America
Dover Publications, Inc., 31 East 2nd Street, Mineola, N.Y. 11501

Library of Congress Cataloging-in-Publication Data

Perlman, Bennard B.
　　Painters of the Ashcan school : the immortal Eight / by
Bennard B. Perlman.
　　　　p.　　cm.
　　Reprint. Originally published: The immortal Eight. Westport,
Conn. : North Light Publishers, c1979.
　　Bibliography: p.
　　ISBN 0-486-25747-9 (pbk.)
　　1. Eight (Group).　2. Ashcan school of art.　3. Painting,
American.　4. Painting, Modern—19th century—United States.
5. Painting, Modern—20th century—United States.　I. Perlman,
Bennard B. Immortal eight.　II. Title.
ND210.P4　1988
759.13—dc19　　　　　　　　　　　　　　88-14989
　　　　　　　　　　　　　　　　　　　　　CIP

To
TWO MIRIAMS, DAVID, HELEN,
ROSANNE, JONATHAN, MARJORIE
and EILEEN
my eight
whose patient understanding and persistent encouragement
have made this volume of The Eight a reality.

LIST OF ILLUSTRATIONS

BELLOWS: *Stag at Sharkey's*, 1907

HOPPER: *Corner Saloon*, 1913

HENRI: *Young Woman in Black*, 1903

WHISTLER: *The White Girl*, 1861 - 62

MAURER: *Evening at the Club*, circa 1904

LUKS: *The Spielers*, 1905

LUKS: *Closing the Cafe*, 1904

SHINN: *Mouquin's*, 1904

LAWSON: *Winter on the River*, 1907

LAWSON: *Spring Night, Harlem River*, 1913

GLACKENS: *Chez Mouqin (At Mouquin's)*, 1905

DUVENECK: *Whistling Boy*, 1872

WHISTLER: *An Arrangement in Black and Grey*, 1872

CASSATT: *La Toilette (The Bath)*, 1891

HASSAM: *Mount Vesuvius*, 1867

WEIR: *Green Bodice*

TWACHTMAN: *Snowbound*, 1885

BENSON: *Portrait of Lady*, 1901

REID: *Fleur-de-lis*

TARBELL: *Josephine and Mercie*, 1908

DAVIES: *A Line of Mountains*

DAVIES: *Night's Overture - A Tempest*, 1907

DAVIES: *Dancing Children*, 1902

DAVIES: *Nudes in a Landscape*

SLOAN: *Memory*, 1906

SLOAN: *Fifth Avenue Critics*, 1905

MYERS: *The Tambourine*, 1905

GLACKENS: *The Boxing Match, July 4*, 1906

The Jury for the Annual Spring Exhibition at the National Academy of Design, 1907

DAVIES: *Canyon Undertones*, circa 1905

HENRI: *Jesseca Penn in Black*, 1908

HENRI: *Blue-Eyed Man*, 1910

SLOAN: *Boy with Piccolo*, 1904

SLOAN: *6th Avenue at 30th Street*, 1907

GLACKENS: *Roller Skating Rink*, 1906

GLACKENS: *29 Washington Square*, circa 1912

LUKS: *The Sand Artist*, 1905

LUKS: *Roundhouses at Highbridge*, 1909

SHINN: *Window Shopping*, 1903

SHINN: *The Orchestra Pit, Old Proctor's Fifth Avenue Theatre*, 1906 - 7

LAWSON: *Cathedral of St. John the Divine*, 1903 - 4

LAWSON: *The Pond in Winter*, circa 1909

PRENDERGAST: *Sailboat Pond, Central Park*, circa 1902

PRENDERGAST: *East Boston Ferry*, circa 1909

DAVIES: *Facades*, 1913

KENT: *North Atlantic Headlands*, circa 1909

SPRINCHORN: *A Winter Scene on the East Side, New York*, 1907

COX: *The Light of Learning*, 1910 - 13

HENRI: *The Art Jury*, circa 1907

HENRI: *On Being Interviewed on the Future of Art in America*, circa 1907

PRENDERGAST: *Revere Beach*, circa 1896

PRENDERGAST: *May Day, Central Park*, 1901

PRENDERGAST: *Central Park*, 1901

PRENDERGAST: *The East River*, 1901

GLACKENS: *Central Park - Winter*, 1905

Reproductions of *The Eight* show Catalogue, 1970

LUKS: *The Wrestlers*, 1905 - 7

Post card from Shinn to Sloan, 1908

SLOAN: *Haridresser's Window*, 1907

SLOAN: *The Cot*, 1907

BELLOWS: *Forty-two Kids*, 1907

DUBOIS: *Newsstand*, 1908

HENRI: *Eva Green*, 1907

SHINN: *Revue*, 1908

SLOAN: *Wake of the Ferry*, Number 2, 1907

J. Norman Lynd cartoon (*New York Herald*), 1908

RUSSELL: *Synchromy Number 3: Color Counterpoint*, 1913

DAVIES: *Negro Saloon*, 1912

COLEMAN: *By the Bridge*, circa 1909

GLACKENS: *A Football Game*, 1911

WEBER: *Nude Women Among Trees*, 1911

ACKNOWLEDGEMENTS

THE AUTHOR is forever indebted to the artists, their relatives, their students, and friends who were so generous in sharing diaries, correspondence, and memories which have contributed to the authentic background material for this book.

First, a special note of gratitude to those persons who have passed from the American scene since aiding in the research for this volume: Everett Shinn, Walter Pach, Guy Pène duBois, Will Luks, Violet Organ, F. R. Gruger, Mrs. George (Emma) Bellows, Robert G. McIntyre, Mrs. Jerome (Ethel) Myers, Mary Fanton Roberts, Harriet Sartain, and Eugene Speicher. Their words remain as their memorial.

To Mrs. John (Helen) Sloan, who has made a professional project of preserving the living history of the period, my special, heartfelt thanks. Her diverse interests and vast knowledge go far beyond the bounds of her immortal husband and teacher, and because of her youth, she, more than any other person, held the master key by which the doors of the period were thrown open. In addition, her vivacious nature and her desire for factual accuracy have made her an ideal research associate and an invaluable friend.

Now to those whose spirited responses echo the same vigor and emotion for the period that was inspired by the artists who lived it: Edward W. Redfield, Dorothy Grafly, Ira Glackens, Mrs. Will (Caroline) Luks, Mrs. George (Mercedes) Luks, David Shinn, Edward R. Anshutz, F. R. Gruger, Jr., Maxfield Parrish, Charles Rudy, Mrs. Jay (Mary) Hambidge, Mrs. Agnes Young Lay, Carl Sprinchorn, Stuart Davis, Richard Lahey, Carl Zigrosser, Rockwell Kent, Edward Hopper, Margery Ryerson, Helen Appleton Read, Manuel Komroff, Dimitri Romanovsky, Leon Kroll, Edward Steichen, Arthur G. Altschul, Charles T. Henry, H. B. Allen (Cozad, Neb.), Frances Hamerstrom, and R. Sturgis Ingersoll.

Also Rosalind Irvine, formerly of the Whitney Museum of American Art; Antoinette Kraushaar of the Kraushaar Galleries; Robert Graham of James Graham and Sons Gallery; Hazel J. Lewis of the former Macbeth Gallery; Norman Hirschl and A. M. Adler of the Hirschl and Adler Galleries; Bernhardt Crystal of the former Bernhardt Crystal Gallery; Edith Halpert of The Downtown Gallery; Adolf Karl, Florida State University; Hedley Rhys, Swarthmore College; Joseph J. Kwiat, University of Minnesota; Dudley Crafts Watson, The Art Institute of Chicago; Violette de Mazia, The Barnes Foundation; Christopher Gray, Johns Hopkins University; Sylvia Heyl, Moore Institute of Art; Martha K. Schick, formerly of the Pennsylvania Academy of the Fine Arts; Margaret A. Aber, Museum of New Mexico; Muriel Baldwin, formerly of the New York Public Library; and Nona Carlson, Plainfield, Wisconsin, Library.

In addition, to the staffs and research assistants of the following institutions: Metropolitan Museum of Art, Whitney Museum of Art, Museum of Modern Art, Frick Art Reference Library, New York Public Library, Library of Congress, Free Library of Philadelphia, Carnegie Library of Pittsburgh, Enoch Pratt Free Library of Baltimore, and the George Peabody Library, Baltimore.

And finally, thanks are extended to the countless individuals in museums and galleries, and to those private collectors, both here and abroad, who have aided in locating and who have so generously consented to the reproduction of the works of art contained in this volume.

B. B. P.

INTRODUCTION

I SHALL never forget the day I met Robert Henri. It was at the opening of a small gallery started by my cousin Leonora Morton, who had been one of his old students. She led me through the crowded room to a corner where a group of older people were seated. I was introduced as a pupil of his friend John Sloan. What Henri talked about in the next few minutes has always escaped my memory — I was so impressed by the graciousness of this great teacher who stood up to shake hands with a sixteen-year-old art student. A few months later I saw Henri for the second and last time, at the Art Students' League when Sloan was giving a lecture on composition. Henri saw me across the room and took the trouble to come over and say a few kind words. I noticed that he was limping, and a few minutes later Mrs. Henri came over to start him on the way home. He was suffering from rheumatism which was later diagnosed as bone cancer. It was characteristic of Robert Henri to be thoughtful of other people and their work.

He was tall and slender, moving with the natural elegance of a man who had been accustomed to horseback riding. In later years I might have compared his manner to that of Gary Cooper or Jimmy Stewart. There were romantic rumors floating around the art school that he had some family mystery, accounting for the French name. The truth of this story, about which he preserved a gentleman's reticence even on his deathbed, is a dignified chapter in American history which is now known and told in this book.

Henri and his friends grew up in the post-Civil-War period, steeped in the traditions of Christian humanism. They were interested in America; they had affection for this great new country and its people. In their desire to be artists, this interest in the wholesome life of their neighbors provided a subject matter of never-ending variety. As for the question of aesthetics, Henri's crowd made fun of the art-for-art's-sake theorists, while at the same time they were shocked by the often salacious effects in sentimental Victorian figure painting. Their rebellion against silly academic pictures and stupid politics in cultural institutions was a refreshing contribution to American art.

In the fifty years since the famous Armory Show of 1913, which Henri and his friends helped organize, modern art has meandered through every kind of subject matter and style. Now there is a return of interest in "the image of man," after a period of emphasis on the abstract factors in art. The new image of man, the popular image stressed by modern culture, appears no longer in the Victorian form of the last century but is now struggling with the Freudian costume. It is difficult for members of the generations that have grown up in the post-Freudian world to understand the minds of artists whose philosophy of art was formed by study of Shakespeare and the Bible, Dickens and Balzac, Emerson and Whitman.

Artists are not usually writers, or trained in philosophy. To grasp the tone of their ideas, we must hear them talking in diaries, letters, reports of conversations. This book is full of authentic anecdotes and conversations that bring to life the personalities of the artists who were leaders in the period from the time of Eakins up to the Armory Show. It is from this kind of document that interpreters of the American scene draw the illustrations which give a true and vivid picture of times that are in transition.

Biographical materials of use to writers are found in various incomplete forms. One incident may have

a lot of factual support, another may have existed without any contemporary documentation. In adding together all the source material that Bennard Perlman has traced down and evaluated, an honest judgment has been made. It pleases me very much that there is no padding or imagining in this book, such as one finds in the "biographical novels" written about artists of other times.

In the year 1908 eight artists held an exhibition at the Macbeth Gallery in New York City. These men, who were friends, were drawn together by a generous appreciation for one another's work, and by a profound concern for development of art in this country.

Preceding the now-famous showing of The Eight, there had been years of devoted effort on the part of this group to improve the quality of art education and to increase the opportunities for exhibiting all kinds of vital creative work. The culmination of their joint labors for more freedom of expression was the thought-provoking Armory Show, which brought ultra-modern art from Europe to the United States. From that time on, every student and professional artist has enjoyed the fruits planted by the men who were inspired by Robert Henri.

This book tells the story of these pioneers who gave their time to help later generations as well as their own friends and students. They were the rare kind of revolutionaries who have no desire for personal power. Here is the history of a remarkable rebellion *for* independence, one which succeeded in the field of culture because it was promoted by artists dedicated to the ideals and practices of the men who founded our nation.

It should be noted that the focus of the "revolution" occurred in Philadelphia, the community which was the apex of America in the nineteenth century. Many of these artists attended high school and art school in that city, where the traditions of liberty earned as the privilege of responsibility were a fundamental matter in education.

There is a serious habit of good citizenship and a courtesy of manner that mark these men. And while they were in earnest about their work, they had the greatness of heart to be full of good humor. Living in the *fin de siècle* of Whistler, Wilde, and du Maurier, they were the first to laugh at the *poseur* in those authentically big men.

Unlike the customary idea of the artist as a peculiar, tragic figure, these companions were full of fun and affection for their fellow men. They did not expect to make a living as "fine artists" in the changing period of industrialization—and so they did not carry a load of bitterness. They were indignant about injustice, without becoming morbid. They were sorry for other people; I never heard one of them complain about his own lot.

Henri taught his students and friends to be interested in the dignity of man and the wonder of life around them. This positive philosophy was a catalyst to many types of creative personalities, giving them a constructive plan of thinking. It put living a fine life *before* the making of art.

The author of this book has not delved into the personal tragedies which these men endured, having the graciousness to leave hidden what the men themselves rarely discussed. It is his purpose to demonstrate that the artist can select what he sees as noble in life when seen out of compassion—of praise for what is true and good, and sometimes beautiful. Yet he has not hesitated to show up the faults and eccentricities which the men speak of in their own words. I have worked with Bennard Perlman for the past ten years while he gathered the material for this history, and can assure the reader that the picture he has put together is both just and warm-hearted, like the subjects of which he is writing. In fact, from year to year, I watched him become a friend living through the period of the turn of the century—which I myself know only through the memories that John Sloan passed on to me many years later.

This is the great message which Henri taught: to see the nobility in man's spirit, and to record that kind of character in "pictures." What Henri called self-expression was not the self-interest or "recording of frustrations" so popular as a motive for creative work today. He encouraged his pupils to be interested in the world outside themselves, and to see beauty in what is familiar to others, often in what may seem drab or ugly to the callous mind.

There is a deep secret in this attitude, for it is hard to recognize the poetry of nature in the ordinary recurrent things of life. From time to time, the tradition of art has gone stale—when people and the artists who are responsive to community feeling stop seeing truth and beauty without the extraordinary

stimulus of strange experiences. Then it is that we are indebted to great-hearted thinkers who cut through cant and sophistication to rediscover what is strong and tender in reality.

Henri taught his generation to follow Whitman in "seeing America" as a place, and a country of personalities. He brought his students a plain sort of craftsmanship, based on his study of Manet, Hals, Goya, Velásquez, Daumier, and Rembrandt: the artists who were profound humanists. This technique was suitable for painting impressions, and served well at the time.

It is interesting that Henri had tried out the technique of the French Impressionists, and found it too complex for the work he knew Americans must do to become free of provincial and academic formulas. Fine pictures were painted by the poet-realists who were inspired by Henri's teaching. It is folly to regret that the man himself did not teach what was needed for another time, when what he gave had so much vitality and integrity. His teaching in *The Art Spirit* will be of value to students always, because he had the capacity to motivate the creative talent.

One of the mysteries of history, especially cultural history, is the birth of the right leaders. Henri was such an heroic figure, an emancipator. He had the gift of awakening confidence, and the honesty to attack corruption. He did two great things for American art. One was to provide the busy newspapermen-artists of the nineties with a technical procedure fitting for their painting of genre, portrait, and landscape. He got them *started* as artists, taught them how to keep the initiative of working. Many of them grew beyond their mentor as they matured, but they owed their original point of view to him.

Of more importance to American art as a whole, Henri had observed the faults of academic art in France at first hand. He came back to Philadelphia with practical wisdom about cultural institutions, and trained his friends to work for high standards of art and honest management of cultural organizations. In his day there were fewer art societies and greater unity among the progressive artists who wanted to improve matters. At the turn of the century, a few strong leaders could accomplish something. Today there are so many factions and the fashions change so quickly that the artists are often more interested in promoting themselves than in helping one another.

In the period which this book reports, groups worked together, dissolved and worked together in new combinations—without setting up rigid organizations or setting out to destroy institutions. We can learn how those men fought for good principles in those days, but the problems now are so different that we must look even more deeply to the questions of philosophy and education. Today, freedom of expression has become such an ideal that very few standards of judgment are left upon which there is agreement. Henri's rebellion was against the stiffness of the academic control; the contemporary problem is to find some kind of order in a field of confusion and ambiguous values.

It is good for us to look back into this recent history in which each one of us may find some nugget of hope and common sense. These are very difficult years for the artist who does not want to follow the crowd seeking success, the man who wants to do good work even if it is not recognized. Henri reminds us that a prophet is without honor in his own country, and that the genuine artists should not expect recognition. He proved again and again that the jury system in culture does not select the finest work, because it is subject to human stupidity and venal politics. Great democrat that he was, Henri never forgot that there is an aristocracy of talents which cannot be judged by popular vote.

This vital point—that there is no way of measuring values—is sometimes forgotten by those who would submit to the pragmatic theory that artists should respond to "the spirit of the age" or adjust to the standards of influential critics. The great artists of our time must be independent so that they can be free of shallow and materialistic philosophies.

When I look back over the years, it must be admitted that Henri was blind to many things—and because of this, he ceased to be an effective leader after the Armory Show in 1913. Perhaps he did not have the intellectual depth to study what the ultra-modern experimenters were searching for. The evil tragedy in totalitarian ideologies had not yet exposed itself and forced everyone to reconsider the goals and methods of our most sacred beliefs. He had too much faith in man's goodness and not quite enough perception of his capacity for evil.

After 1913, Henri withdrew more and more from artists' organizations. He kept his interest in stu-

dents, and traveled in search of interesting people to paint, perhaps in lonely isolation continuing to do portraits as a reminder for us that mankind is the great subject which the artist should never forget.

Henri's portraits are like his teaching, intensely warm, sensitive, and responsive to the other person. It may be that he was deeply shocked by the direction he saw coming in modern art—a direction which permits cruelty to take over when abstraction has dominated affection.

Thirty years after the Armory Show, John Sloan used to warn students against the tendencies in abstract symbolism, saying that things were moving "from the abstract to the abtruse to the absurd." He was grieved that most modern art is "heartless." No one had a greater hatred of sloppy sentimentality or morbidly false tragedy.

I am very happy that Bennard Perlman has written this book. It records faithfully the period and personalities of Henri and his friends . . . a time now passed into history, and yet alive for us who care about the pursuit of truth, goodness, and beauty. This story should be a tonic to many artists, and a very refreshing revelation about the artists' life for those who think it is necessary for artists to be irresponsible or queer.

The men are here in their own words, speaking from diaries and letters which the author has most diligently discovered and checked against other historical documents. I know of no other book which covers this period from 1870 to 1913 with so much scholarship and such delightful humor.

The story begins with Thomas Eakins. My husband said that Eakins was a very earnest man without much sense of humor. He and other students were happier in the Henri crowd. "We didn't think it was worth while or sensible to make such a fuss about posing nude models."

Today we are accustomed to the barely draped figure at every beach and in public advertisements— but art students no longer bother to distinguish between one kind of person and another. Art education has shifted from the guild system to the academy, and now to the correspondence course for amateurs.

This book tells the true and exciting history of a crucial period in art education—and the facts about a revolution that is almost buried under its own success.

HELEN FARR (MRS. JOHN) SLOAN

PRELUDE

Now Art should never try to be popular
The public should try to make itself artistic.

—OSCAR WILDE, 1895

AROUND the turn of the century, American art was at its lowest ebb. Sculpture had succumbed to the throes of commercialism when the demand for Spanish-American War monuments encouraged salesmen to go from town to town, offering the local city councils a selection of memorials from an illustrated catalogue. The small communities of America, too poor to commission a sculptor to do the job, thus became landmarked by duplicate statues, and it is not uncommon to see the identical soldier standing at parade rest in Connecticut, Illinois, and Kansas.

In architecture the innovator was dealt a temporary setback by the copyist. At the Chicago World's Fair of 1893 the question of whether a building's inner function should determine its outer form, or whether an ideal classical façade should disguise its interior, was settled for the generation to come. The Imperial Age had won out, and all roads led aesthetically back to Rome. In New York a railroad terminal was modeled after the Roman Baths of Caracalla and a library echoed the lines of the Pantheon.

Many years of progress were to be sacrificed during the decades when the ideal eclipsed the real. And the imposing classical structures were built to accommodate a servile proletariat who dwelt in crowded tenements devoid of any shiny stone veneer.

During this period, too, American painting found itself in a hopeless state of nothingness. Sentimental landscapes were being produced by the hundreds with little or no resemblance to the American scene. Figure painting had deteriorated to the point where academic nudes and storybook illustrations were the order of the day. Nearly all of the prize-winning artists who sold to the best-known collectors were to fall into complete obscurity half a century later. As a result of changing taste, their paintings

have long since been relegated to museum storerooms. Artists named Baudenhausen, Sichel, Begas, Wuerpel, Dessar, and Wiggins were among the popular painters in America at the turn of the century, yet not one of them has been remembered as a major contributor to the mainstream of progress.

As reflected in its art, the 1890's and 1900's were decades of pronounced contrasts. On the one hand the great cities of America were the scenes of sweat shops, murderous riots, and the growing unrest of their masses. On the other, gilt-edged society was building lavish mansions and amassing huge fortunes, and Diamond Jim Brady's enormous consumption of food epitomized the extravagance of the period.

This was the age of self-made men like Carnegie, Rockefeller, and Frick. Horatio Alger popularized the rags-to-riches theme, and Henry George's *Progress and Poverty* also became a best seller. A Labor Party arose to challenge political incumbents. The Homestead and Pullman strikes demonstrated that the Gay Nineties were anything but gay for the embattled workingman.

In response to the Statue of Liberty's fervent plea, Europe and Asia outpoured their tired, their poor, their huddled masses. During a peak year, one million persons from all lands were to swarm to this country of hope and apparent prosperity. But increasing hordes of immigrants caused an oversupply of labor. Unscrupulous employers were permitted to push down the rate of pay to a bare subsistence level. For two decades the country was in the throes of continual depression, and an anti-foreign panic demonstrated the people's anxiety over their jeopardized livelihood.

The sprawling hills and valleys of America had

always been sufficient to absorb the long line of waiting refugees. Since Thomas Jefferson's day, rural America had been the safety valve of the city, allowing the urban worker of today to become the farmer of tomorrow. The Homestead Act provided 160 acres of farmland to anyone who would settle and work the soil.

When Jefferson had predicted that the hinterlands beyond the American towns could consume the restless urban population for another thousand years, he had not foreseen the phenomenal growth of this country. By 1890 the frontier was closed, thus ending this unique opportunity for the common man. Terrible droughts in the late eighties had brought disaster to many midwest farmlands, and much of the populace that had heeded Horace Greeley's advice to go west was now beginning to return to the cities in droves as their lands became unprofitable. The sprawling, teeming metropolises experienced an incredible growth.

As the larger eastern cities continued to absorb the returning midwestern farmers, as well as immigrants from abroad, newspapers became powerful forces in molding public opinion. When journalistic competition increased, the papers searched for sensational news that would stimulate their circulations. The photograph had not yet been adapted to the rapid speed of daily publication, and artist-reporters were employed to draw on-the-spot sketches that furnished added appeal to news stories.

Such newspaper illustrators could not avoid the seamy side of life, as their fellow craftsmen, who painted polite pictures in oils, cared to do. The newspaper artist portrayed the weary and the downtrodden, and depicted the places where they lived, worked, and died.

Around these artist-reporters was born a Realist School of painting. It attacked the domineering attitudes of the art academies in a manner that paralleled the trust-busting of Theodore Roosevelt. The Realists were joined in their crusade by a vigorous coterie of art students, and by literary men who sought to expose political corruption and to spearhead general social and economic reforms.

Among the wealth of contributors to this movement, Lincoln Steffens and other muckrakers presented documentary articles in widely read literary magazines. O. Henry wrote a sociological study of New York in *The Voice of the City,* and Thorstein Veblen spoke of the workingman's claim to equality in his *Theory of the Leisure Class.*

The Realist artists were soon referred to with timidity as the first truly American tendency in art. They had appropriately begun their careers in Philadelphia, the seat of nationalism, but the group migrated to New York, where they began painting the varied subject matter provided by life in the slums.

Their art was considered unattractive and was rejected by the same patrons who despised the new American architectural form, the skyscraper, because it lacked the rococo decoration with which the elite had surrounded themselves. The realist painter's scrutiny of burlesque houses, Bowery bars, and bedrooms appeared out of place in an age of prudity which dictated that women's figures be padded beyond recognition. Their vigorously painted immortalizations of ragged street urchins was incongruous to a generation schooled in preserving on canvas only the most meticulously painted portraits of Little Lord Fauntleroys.

But the biting truths of the Realists' pictorial observations could not be denied. Their determination to freely exhibit their kind of art became a virtual battle for survival. Eventually the struggle led to the overthrow of dictatorial academic policies that had impeded the progress of an indigenous American art.

This, then, is their story, the story of America's artistic coming of age and of the men whose creativity and dedication made it possible.

CHAPTER ONE

IN LATE-NINETEENTH-CENTURY America, at a time when the sight of an ankle was shocking and even pianos were not spoken of as having legs, Realism in Art and Life was equally disturbing to the mid-Victorian sensibilities.

Painting was caught up in the waning throes of a neoclassic revival which had once prompted the naming of an Athens in Georgia and a Syracuse in New York State. Artists were no longer seized by the overtones of nationalism that had motivated the Hudson River School in the early decades of the new Republic. Now, instead, they produced nondescript landscapes in imitation of the Barbizon painters near Paris, or sentimental genre as practiced in Dusseldorf. The result, in either case, had little in common with the American scene.

Figure painting, once skillfully composed by America's "old masters," had deteriorated to Grecian-garbed models, obviously posed, or the insensibility of calendar-art nudes. A naked female dancing through a field of greenery might personify Spring, while the identical idealized figure atop a haystack represented Autumn.

An entire generation of artists who were capturing the prizes and selling to misdirected collectors were destined to fall into complete obscurity before their last canvases were dry. Paintings which flaunted such storytelling titles as *Nydia the Blind Girl of Pompeii, The Theatre of Nero,* and *Sheep Crossing the Dunes* would soon be lost among the shadows of museum storerooms.

Through this maze of academic sterility emerged a handful of artistic greats, but their voices were few and faint. Albert Pinkham Ryder remained aloof, living a life of seclusion. Winslow Homer withdrew to

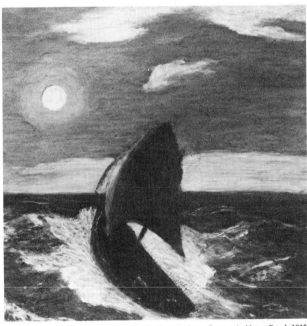

The Metropolitan Museum of Art, George A. Hearn Fund, 1915

RYDER: *Toilers of the Sea, circa* 1883.

an isolated rock-bound coast. Others, like Joseph Pennell, Mary Cassatt, and James McNeill Whistler, became expatriates, completely abandoning the New World for the Old.

Also numbered among this select group was the greatest Realist of them all, Thomas Eakins. Eakins would not flee his native land, nor seek the privacy of a recluse. He accepted hometown Philadelphia as his battleground and Realism as his battle.

As a painter of fact rather than fancy, Eakins was out of step with the times. His very first portrait commission of President Rutherford B. Hayes had upset his fellow Philadelphians, who expected an

HOMER: *Lost on the Grand Banks*, 1885-86.

idealized pillar of strength but gasped instead at a shirt-sleeved Chief Executive whose face was flushed by the summer heat. When Eakins, in 1875, painted a well-known surgeon performing an operation before a gallery of medical students, squeamish art critics condemned the picture for the prominent and offensive display of blood on the surgeon's hands.

Thomas Eakins had created this early masterpiece, *Gross Clinic,* with an eye toward having it included in the Philadelphia Centennial of 1876, the exposition which was to mark America's one hundredth year of independence. Thirty-four spacious galleries were designed within Memorial Hall to house the nation's first national art display; but when the applications for wall space began pouring in, a brick annex had to be hurriedly added, more than doubling the available galleries. Yet, although one thousand imposing canvases decked the grandiose art rooms, Thomas Eakins' *Gross Clinic* was not among them. It had been relegated instead to the medical section of the exposition!

The press was quick to divulge the reason. "It is

rumored that the blood on Dr. Gross' fingers made some of the members of the committee sick . . ." an art critic acknowledged. Another warned: "It is a picture that even strong men find it difficult to look at long, if they can look at it at all. . . ." One brave writer who sought to praise the likeness of Dr. Samuel Gross still found it necessary to qualify his statement: "If we could cut this figure out of the canvas and wipe the blood from the hand, what an admirable portrait it would be!"[1]

Despite the adverse publicity which *Gross Clinic* had received, Eakins was appointed Professor of Drawing and Painting at the Pennsylvania Academy, his alma mater, in the centennial year. For the next decade he focused his untiring effort and unceasing energy on his teaching. He brought new concepts concerning the study of art to the Academy's spanking-new brick and limestone edifice at Broad and Cherry streets. Regulations were eased regarding promotion to the life class. Sculpture was introduced into the painting curriculum in order that, through modeling, the students might better think in terms of

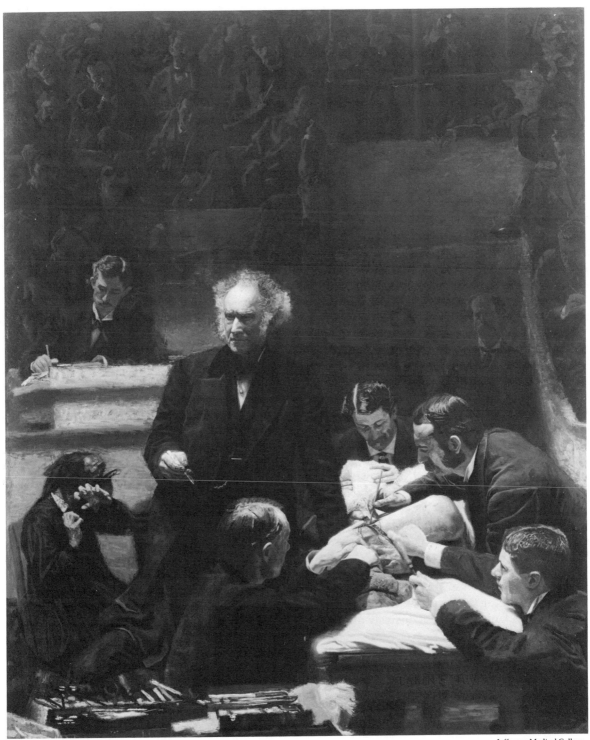

EAKINS: *Gross Clinic*, 1875.

form. And additional stress was placed upon the importance of dissecting as an analytical approach to anatomy. After six years of progress, Thomas Eakins' efforts were formally recognized when his title was changed to Director.

Though Eakins' dominant position at the Pennsylvania Academy appeared secure and unchallenged, opposition had been slowly growing beneath the surface. The bold realism of his own painting, for instance, had never really been accepted by the staid board of directors. In 1879 the Academy invited the Society of American Artists to display its annual exhibition in Philadelphia after the show closed in New York. But when the paintings were shipped to the Pennsylvania Academy, the already infamous *Gross Clinic* was found to be among them. Startled Academy directors refused to hang the canvas. They substituted instead an enormous painting by another artist, one which had, in fact, been previously rejected by the Society.

The artists' group protested. They threatened to withdraw the entire exhibition unless the Eakins canvas was displayed. Faced with a new kind of organization-backed artist, directors reluctantly agreed and *Gross Clinic* was finally hung—in the darkest corner of the gallery.[2]

Eakins' emphasis on dissection became another bone of contention. His own schooling, which included medical-school training, had involved such work. But dissection at best is an arduous task and many of the art students were repelled by the mere idea of cutting open an arm or a leg. Nevertheless, Eakins threw himself wholeheartedly into the grisly business, digging for knowledge through layers of muscle and tissue until he uncovered the underlying reason for each wrinkle and lump. Sometimes the reek of flesh escaped from freshly cut cadavers in his dissecting room, filling the Academy corridors with unpleasant odors which settled offensively under the noses of the directors.

By the 1880's nearly half the Academy's enrollment was composed of young ladies who simply sought an opportunity to engage in the respectable feminine pastime of china painting. But Eakins had them dissecting too. And of their desire to decorate pretty things, he chided: "Respectability in art is appalling."

Thomas Eakins' search for truth knew no bounds. His insatiable desire for accuracy paralleled the extremes of Theodore Gericault, who, in preparation for his monumental painting of *The Raft of the Medusa,* had commissioned a survivor of the tragic shipwreck to help reconstruct the life raft in his studio. Eakins, for his series of paintings of the Biglen brothers sculling on the Schuylkill River, had one of the full-length racing boats stretched out across his studio floor so that he might mark off the proper perspective grid and determine the exact position of reflections and cast shadows. For *The Swimming Hole,* Eakins modeled a precise plasticene representation of the diving figure, then drove a spindle through it so that the diver could be turned upside down and still hold the pose. And when the artist sought to paint a moving horse, he created a sculptural relief of the animal first, in order to study the arrangement of muscles.

Eakins' interest in anatomical movement led him to experiment with photography. In 1884 he was partly responsible for luring pioneer photographer Eadweard Muybridge from California to the University of Pennsylvania, where he was invited to continue his experiments. Whereas Muybridge had photographed a galloping horse with a battery of twenty-four cameras, Eakins designed one capable of recording successive phases of motion on a single film. While Thomas Eakins touched upon the basic theory of the motion picture, Muybridge made a monumental study of human locomotion, employing as subjects a host of Philadelphia men and women who willingly posed in the nude.

Eakins' students were encouraged to make similar records of the human figure, both draped and unclothed. Armed with a camera, his boys would cycle to the Philadelphia suburbs to stage striking group poses. In the classroom they would photograph themselves and their master with nude models of both sexes, standing or sitting in a variety of poses which would quench their thirst for anatomical knowledge.

It was Eakins' attitude toward the nude which caused the most friction. In teaching the life class he insisted that a study of the unclothed model was the only approach which ensured an understanding of the form and structure of the human body. To probe

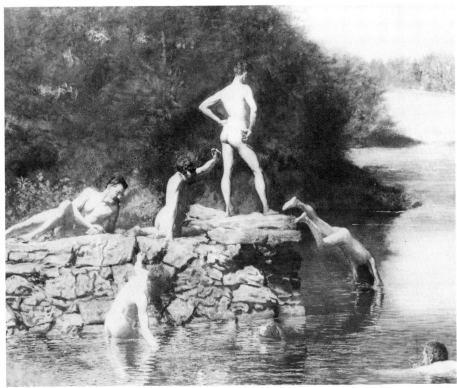

EAKINS: *The Swimming Hole,* 1883. Fort Worth Art Association

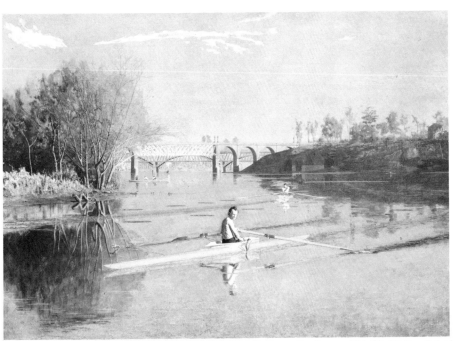

EAKINS: *Max Schmitt in a Single Scull,* 1871. The Metropolitan Museum of Art, Alfred N. Punnett Fund
 and gift of George D. Pratt, 1934

the muscles and bones in a cadaver was enlightening, but the lesson could not be complete without a comparative understanding of their relationship to the living, moving figure.

But like most pacesetters, Thomas Eakins was ahead of his time. The 1880's was the Age of Prudity, not nudity. Outside the Academy's walls the female body was protectively swathed in voluminous layers of wearing apparel, so complete in its coverage that more than a gentle spring breeze was needed before even an ankle would show. Yet with one fell swoop Eakins sought to strip the body bare.

The nude model in the Academy's life class was too recent an innovation to be altogether accepted. When Eakins had studied there two decades before, life classes were erratic, being held only when sufficiently interested students banded together and hired their own models. The Academy's part in the proceedings amounted to lending a room. But Eakins had changed all that, and established the life class on a regular basis. Now discarded plaster casts simply adorned the walls, with classical nudes pausing in their mythical battles to gaze down upon the unclothed human model below. Eakins' classroom rules and suggestions were both graphic and true to life; at times they seemed to be life itself: "Make the pelvis wide enough to fasten on two leg bones, one on each side," he would command; "and if it's a woman—well, give her a pelvis wide enough so that she won't die in childbirth."[3]

The Great Realist's sincere love of truth, coupled with a complete disregard for the then-prevalent hush-hush attitude toward sex, could not avoid running headlong into a number of unfortunate incidents. On one occasion, when the model failed to appear for the women's life class, Eakins turned to one of his students and requested that she substitute by removing her blouse. Instead, the young lady burst into tears and fled from the room. Another minor scandal resulted when Eakins indulged in the hitherto forbidden practice of laying his hands upon a nude model to demonstrate the manipulation of certain muscles. And again his teaching methods presented a problem when the more demure among the art students complained of his posing a nude male and a nude female model simultaneously.

With monotonous regularity Eakins was called upon to defend his uncompromising position before a challenging board of directors. The man was without doubt a leader in his field, but the Academy's reputation was at stake. Each time the successive incidents were smoothed over, but not entirely forgotten.

Then in the opening days of 1886, the dam of growing tension was abruptly broken by a wave of sensationalism which swept away all that stood before it. Spurred on by Eakins' continual emphasis on drawing from the nude, a dozen of his female students had decided to form a sketch class of their own. They had obtained permission to meet in one of the Academy's back rooms; but lacking funds with which to engage a model, they agreed to take turns, each posing unclothed before the rest of the group. The regular life models, as in Eakins' student days, were still required to wear masks to hide their identity and consequent shame from the members of the class. But here, in intimate confines and among themselves, the girls had no need to cover their faces.

It was from one of the members of this ambitious assemblage that Thomas Eakins received an invitation to come in and criticize their work. Unbeknown to him, the request had been made without the unanimous consent of the girls involved. One of the students was posing nude when Eakins entered the room. Unable to conceal her shame, she reported the incident to her fiancé, who in turn complained to the directors. The inevitable rumor spread like wildfire that Eakins "had been having the women students at the Academy pose for him in the nude."[4]

Before the art-school officialdom was able to map a course of action, an enraged Eakins had decided on his. Explaining the structure of the pelvis before the women's life class, Eakins turned to the male model and defiantly removed the loincloth. The deed had been done, and Eakins stood by as the hero of his own one-act production.

A special committee, hastily designated to pass upon the case, met in seclusion and security behind locked doors, where morals could be bashfully discussed. The directors had been tolerant long enough. Mr. Eakins would either exercise certain restrictions in the future or else resign. A lesser man might have succumbed to the demand, but Tom Eakins would not consider the compromise. His resignation was submitted and accepted on February 13, 1886.

The Academy directors were oblivious to the fact that a large segment of the student body sided with the ousted instructor. His struggle for artistic honesty was their battle too. The male students staged a protest meeting and drew up a petition requesting his reinstatement. Then the girls followed suit, with all but twelve aligning themselves with Eakins. In summing up the prevailing sentiment, one student stated: "The class as a whole is perfectly satisfied with Mr. Eakins. The disaffection is confined to a comparative few who have exhibited a prudery that is, to say the least, unbecoming among those who pretend to make a study of art."

Students boldly suggested secession if Eakins was not reinstated. They staged a rally and marched down Chestnut Street in their hero's studio. But demonstrations of loyalty were held in vain. With an air of finality the directors announced: "We will not ask Mr. Eakins to come back. The whole matter is settled, and that is all there is about it. The idea of allowing a lot of students to run the Academy is ridiculous. All this talk about a majority of them leaving the school amounts to nothing. Let them leave if they want to. If all left we could close the school and save money. . . . If any of them left it would be their loss, not ours."

During all of this caustic discussion, the ousted Eakins remained on the sidelines. The students had begun to talk of forming a new school, and Eakins stated his position quite clearly. "I could not give them the same advantages they have at the Academy," he admitted. "Of course, if a new school was organized, and I was requested to take charge, I would take a businesslike view of the matter and probably accept. But I would take no steps to organize such a school. That I can say positively, and I don't believe any will be organized."[5]

But Eakins was wrong. The Academy directors' dogmatic statement had served to call the students' bluff. When another student meeting was held thirty pupils stepped forward, ready to establish the new institution.

Even a name for the venture had already occurred to several of the group. Throughout the previous year, 1885, Eakins had been traveling to New York once a week to give anatomy demonstrations at the Art Students League. This school had been founded just a decade before by young upstarts who had objected to the National Academy's unalterable policy of requiring a year of drawing from plaster casts before admission into the life class. With an eye toward the kindred spirit which had brought the young New York institution into being, the monument to Eakins was labeled the Art Students League of Philadelphia.

The Philadelphia League had a struggle for survival during the few years of its existence. Its first class was held on Washington's Birthday, 1886, in poorly equipped quarters on Market Street, and in the months to follow the League came to know one temporary site after another. The tiny band of Eakins' faithfuls were often forced by a state of indigence to pose for one another, oblivious to the stories of immorality that were being circulated about them.

Meanwhile, the Pennsylvania Academy appeared unmindful of its loss, for neither Eakins nor his thirty student followers seemed to be missed. The classes the master had conducted were now divided among several of his former pupils. The directors resumed their covetous control over the school, and one by one the innovations which Eakins had instituted were dropped.

In a few short years the Pennsylvania Academy relinquished its new-found progressive position, and returned to unruffled academic slumber.

CHAPTER TWO

T HE STORM kicked up by Eakins' withdrawal from the Academy was still top gossip among the students when fall classes began. Upperclassmen pounced upon the incoming freshmen, eager to retell their enticing tales to such wide-eyed, impressionable youth. The Eakins story was served up piping hot, with a dash of spice added here and there to enliven the already well-seasoned dish.

"It was an excitement to hear his pupils tell of him," observed one of those entering freshmen named Robert Henri.[6] At twenty-one, Henri's knack for painting had lately been confined to decorating souvenir clam shells with intricate scenes near his home in Atlantic City. Now Henri, impressed by the Eakins commotion, realized that art could be inspiring and stimulating as well.

Any element of excitement in art held a natural appeal for the average thwarted art student of the 1880's. For Henri it served more as a necessary adjunct to living than as mere artistic adornment, for he had just closed the door on one chapter of his life which reads like a western thriller: a rough-riding life in the pioneer West of Buffalo Bill and the pony express, where cattlemen and ranchers fought over land and where gunplay was played for keeps — a life that had necessitated his adopting the assumed name of Robert Henri!

Robert Henri was born Robert Henry Cozad on June 24, 1865, in Cincinnati. He came into the world at the time of the great westward push, when the Homestead Act furnished the escape valve for the city, and thousands of families in search of adventure or a fresh start were making use of it. In rapid succession, sparsely settled territories were being admitted to statehood: Kansas in 1861, Nevada in 1864, and Nebraska in 1867.

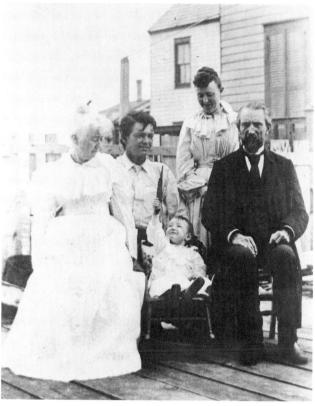

Collection of the Author

Robert Henri, age 2, with his grandmother, uncle, mother and grandfather, in Cincinnati, 1867.

Enterprising railroad companies were laying down miles of straight track through these underdeveloped regions, seeking to establish pioneer communities along their rights-of-way on land granted by the government. Sensing the opportunity, young Robert's father, John Jackson Cozad, made an exhausting trip by train from Cincinnati to Nebraska. There, in a no man's land of sage and sand, he gazed

upon a crude wooden marker proclaiming "100th Meridian," observed the plains adjacent to the old Oregon Trail, and returned to Ohio to buy a 40,000-acre tract from the railroad.

The settling of Cozad, Nebraska, in 1873 was undertaken with obvious peril. The proposed town-site was on exposed land, without benefit of natural protection in this hunting ground of the Pawnee and the Sioux. The first homesteaders were to settle in fear, well aware that a few years before, a westbound freight train had been wantonly looted and burned, its crew scalped alive, then killed. And the Indian danger was not a thing of the past, as Colonel George A. Custer and the 7th United States Cavalry were to discover at Little Bighorn four years later.

Unforeseen misfortunes harassed the Cozad pioneers too. Severe winters brought misery from lack of warmth and sustenance, and summer un-leashed an annual invasion of grasshoppers which played havoc with the settlers' crops.

When the search began for the county seat, a vehement sense of competition and hatred arose among neighboring communities. In near-by towns, John J. Cozad and his family were often sought out as the instigators of episodes calculated to frighten and intimidate the local citizenry. Once the hotel in neighboring Plum Creek caught fire while John A. Cozad, Robert's older brother, was registered there as a guest. Accused of arson, the bewildered boy was thrown into jail. His daring rescue was accomplished the following night by fellow townspeople, who se-cretly spirited him back to Cozad. On another occa-sion, Mr. Cozad's wooden house mysteriously burned to the ground. Doggedly he countered by building a more permanent one of brick.

Additional friction developed between the homesteaders and the cattle barons from Texas, who challenged anyone's right to settle on their limitless ranges. More than once Robert Henry Cozad, now in his teens, actively assisted his father in outmaneuver-ing the cattlemen. When large herds came bearing down on Mr. Cozad's hayfields, the well-dressed landowner would delegate Robert to approach the cowboys and request them to drive their cattle along the railroad right-of-way instead. At times when the cattlemen indicated a lack of compliance, Mr. Cozad and a drawn revolver were able to force the issue. "I

have been in Nebraska long enough," Robert once noted with adult comprehension, "to know that these cattlemen will promise to move off of premises immediately . . . and never make a move to do it."[7]

With the passing of each unpleasant incident, the safety of the Cozad family was more in jeopardy. Finally, one day in 1882, an inebriated cattleman staggered into the general store in search of John J. Cozad. There the drunkard found his man, bedecked in his customary high silk hat, Prince Albert coat, and kid gloves.

The first exchange was with words, then with fists. The violent intruder threw Mr. Cozad to the floor, then reached for a knife to finish him off. Struggling with his frock coat, Cozad finally man-aged to whip out his gun and shoot his assailant through the mouth. Two months later the attacker died from the wounds.

John J. Cozad quietly packed and departed. Though a warrant was issued for his arrest, he re-mained a fugitive from justice.

In secret communications with his family, Cozad arranged to have them join him in Denver. Before leaving, Mrs. Cozad disposed of all her husband's property, cautiously dealing in cash transactions to avoid the handling of checks. She concealed some of the money in her petticoats and sewed the rest into the linings of her sons' vests. Then, gathering a handful of personal belongings, the Cozads left Ne-braska forever.

Settling next in New York and later in Atlantic City, the family of John J. Cozad drew the curtain on their melodramatic past. The parents began life anew as Mr. and Mrs. Richard H. Lee. Their two sons, Robert and John, were to assume the guise of adopted children and foster brothers. Thus John A. Cozad was assigned the name Frank Southrn, while Robert Henry Cozad became Robert Henri. Mr. Cozad was of French Huguenot extraction, and undoubtedly preferred the French pronunciation of Robert Henri's newly acquired last name, but his son, unable to speak or understand the foreign tongue, uninten-tionally anglicized it.*

So it was that a pioneer youth, emerging from the wild West of Jesse James' day, signed his name

* Pronounced: Hen'rye.

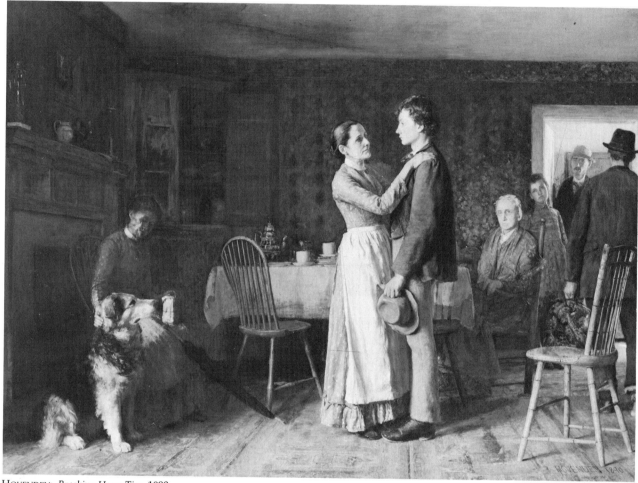

HOVENDEN: *Breaking Home Ties*, 1890.

Philadelphia Museum of Art

R. Earle Henri upon enrolling as an art student at the Pennsylvania Academy in the fall of 1886.

This newcomer to Philadelphia and to art school soon discovered that his impatience to learn was not always rewarded. In his eagerness, Henri sought to paint at night, but the then-unorthodox practice was soon discouraged. When instructor Thomas Hovenden viewed one such extracurricular effort, he demanded critically, "What's the matter with your color?" then answered in the same breath: "It's too hot!" The colors, of course, appeared much more intense in the daytime than they had to Henri under the inadequate illumination of gaslight.[8]

Actually, Hovenden subordinated the importance of color in favor of light-and-dark contrast, and to his students his name became synonymous with the oft-repeated suggestion, "Now don't forget the values." Henri pictured him as an almost comic figure who would, having once left the classroom, come running back, stick his perspiring head in the doorway, and gasp those five magic words.[9] At the outset neither student nor teacher impressed one another, but later they became quite friendly, and Hovenden is said to have used Henri as a model for a genre painting, his now-famous *Breaking Home Ties*. The subject of this canvas, by uncanny coincidence, was one for which Henri was well suited.

Thomas Anshutz and James B. Kelly, two of Eakins' pupils, had been chosen to instruct their former teacher's anatomy and life classes. It was

through the profound statements of Thomas Anshutz that Henri and the generation to follow heard much the same words that had previously come from the lips and heart of Thomas Eakins.

Anshutz stuck to the same classical system which Eakins had employed to analyze the figure. "The body," he would state, "is made up of three major solids: head, top of torso, and the pelvis, which are rigid masses attached to the spine. The action is directed by the spine to the arms and legs. The spine can twist and bend, but the three big forms attached to it are stable." Anshutz likewise performed the Eakins demonstration of building clay muscles upon the skeleton — shaping clay to the size and form of a muscle, then placing it properly along the bone.[10]

Robert Henri spent considerable time in the modeling class, where he soon learned to work and to loaf with equal adroitness. The cigar-puffing Academy students recognized no laws but their own in their artistic domain, where the practical joke was the order of the day. Although smoking, for instance, had always been forbidden in the life class, a sign proclaiming SMOKING PERMITTED mysteriously appeared on the bulletin board, and nude models soon found themselves comfortably veiled by the thickening atmosphere.

When a model occasionally failed to appear for the sculpture students, the boys would quickly select a rather chubby member of their class as a substitute. As soon as their vain Adonis emerged in majestic

ANSHUTZ: *Steelworkers–Noontime*, circa 1880–82.

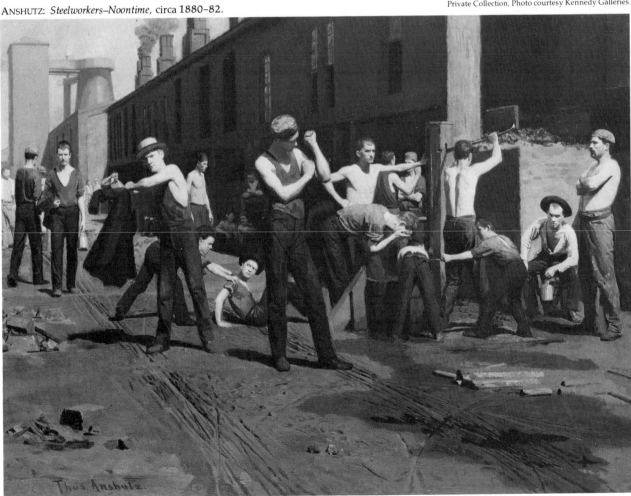

nudity from behind the model's curtain, wads of wet clay were hurled toward his tender skin. Hurriedly he would retreat to the safety of the model's compound, only to find his clothes gone, and faced with the prospect of spending the night alone and unclothed in the unheated building.

Between such schoolboy pranks, Henri worked diligently, but the rigid routine of drawing from the antique seemed tiresome and dull. Gripped by the wanderlust which was to plague him throughout his life, Henri restlessly gazed toward Paris, and dreamed the art student's dream of going there.

After two years of pranks, puffing, and painting at the Pennsylvania Academy, the vision of a Paris garret was on its way to becoming a reality. With four fellow students named Charles Grafly, Harry Finney, J. R. Fisher, and William Hefeker, Henri booked passage from New York, and on September 5, 1888, the five found themselves lining the rail, ocean-bound, taking their last strained glimpse of America.

This going to Paris was a bold decision. Their art studies would be quite serious business, when they reached their destination. But until then, they spent considerably less time sketching on shipboard than they did playing tug-o'-war and follow-the-leader around a mast or skylight. And when they did get down to drawing, it was in the form of a large charcoal head, sketched under cover of darkness on the wall of the dining salon. "Such boys!" Grafly noted quite frankly. "I guess they will think twice before shipping a cargo of art students again."[11]

Upon reaching the French capital, enthusiasm turned to gloom when they discovered that five Americans in Paris were unwanted by one concierge after another. But with typical Yankee ingenuity, Hefeker and Fisher, the two French-speaking members of the group, went apartment hunting on their own. They finally persuaded a jovial janitress at 12 avenue Richerand to rent them living space. Her merry Bon jour, messieurs, of the first day turned to utter dismay the next, when five luggage-toting young men, instead of the original two, trooped up her narrow spiral staircase to the rooms on the fifth floor.

The place was a romance. "It was a mansard room," Henri observed, "and it had a small square window that looked out over house-tops, and pink chimney pots. I could see l'Institut, the Pantheon and the Tour Saint-Jacques. The tiles of the floor were red and some of them were broken and out of place. There was a little stove, a wash basin, a pitcher . . . It was a wonderful place. . . ."[12]

One problem solved, another was born. When dining at cafés where English was not understood, Henri, Grafly, and Finney had little chance of satisfying their appetites unless linguistically rescued by the other two. Letting teamwork solve hunger pangs, they set up housekeeping for themselves; Hefeker and Finney were elected cooks, Fisher purchased the food, Henri washed, and Grafly dried.

With the problems of shelter and sustenance conquered, the boys proceeded to search out and enroll at their ultimate destination, their aesthetic goal, l'Académie Julian.

A typical workday at Julian's, they found, ran from eight in the morning until four or five in the afternoon. Two models were posed simultaneously for the hundred students in the drawing class, and all worked steadily, carefully, meticulously with sharpened charcoal, pencil, or pen. Erasers in the form of pieces of bread were provided by a janitor at one sou a slice.

It was customary, the boys learned, to spend a week on each figure drawing. Every new pose, therefore, brought a mad scramble for the choicest vantage points. The five Americans soon discovered the penalty for politeness and before long they, too, were elbowing their way along with the rest.

The French students seemed to be particularly uncouth hosts when it came to selecting models. On Monday morning several prospects would appear, anxious to gain class approval and thus be hired for the week's posing. Many times an inexperienced girl would be greeted by hoots and hisses as she disrobed, or the Frenchmen would hurl insults if her womanly proportions did not measure up to the classical ideal.

This classical ideal represented the ultimate of perfection in the academic circles of the day; fashions were keyed to it, models were measured by it, and paintings were imitations of it. The popular appeal of such sterile art made it highly remunerative, and financial success became the measuring stick for artistic greatness.

Of the masters of the sugar-sweet, idealized female, of goddesses who flaunted their transparent loveliness, William Adolphe Bouguereau represented the pinnacle of success. On New Year's Day, 1889, Bouguereau held his customary annual open house for the art students of Paris. The five Americans enthusiastically accepted the invitation, feeling privileged indeed to view the master's paintings within the confines of his studio.

Bouguereau's roomy workshop, the boys discovered, had been cleared to accommodate a steady stream of visitors. At the doorway stood the illustrious Bouguereau himself, all smiles, his plump figure resplendently bedecked in a black suit, with a Legion of Honor ribbon conspicuously placed on the lapel. As the room rapidly filled, Bouguereau began discussing his paintings, five of which, in various stages of completion, had been placed on easels before the massed assemblage. There was scarcely time to gaze about the walls at his earlier masterpieces, or to notice the plaster casts of heads, hands, and feet which lay cluttered at one side of the room. His verbal comments completed, Bouguereau shook hands with the departing students, who were immediately replaced by the next surging throng.

The boys were overwhelmed by the master's mammoth reception and sumptuous studio. Back in their garret quarters they raised their rose-colored, wine-filled glasses and offered a toast: ''For the success of Americans in Paris, may they all become Bouguereaus, starve until they are thirty-five, then become immensely rich!''[13]

Soon the boys were informed of their satisfactory grades at the end of their first term at Julian's. Jubilantly they trooped to l'Ecole des Beaux Arts, the very school that their hero Bouguereau had attended for seven years, to register for the coming entrance examination. Although an art student's road to fame invariably passed through the hallowed portals of this august institution, the entrance requirement made admission an achievement in itself. The Beaux Arts' exam required a virtual knowledge of world history, the ability to produce a drawing of an antique figure in twelve hours, a figure drawing from the posed model in the same amount of time, a two-hour memory sketch of some bone in the human body showing the attachments of muscles, and an ele-

mentary architectural drawing to be completed in six hours.

The boys lost no time. Their tiny garret became the scene of a battle against clock and calendar for the acquisition of knowledge. Mornings were consumed studying architecture, afternoons spent at Julian's, and evenings memorizing history and anatomy. The cramming was interrupted only for meals, with an occasional bit of horseplay when they tossed sous for a last slice of meat.

Then, all too suddenly, the dread day was upon them. The first torturous hours of the art examination found four hundred nervous candidates competing for admission in hushed, dignified silence. The stillness of the walnut-paneled rooms was marred only by the scratching of charcoal and the smack, smack, smacking of wet clay. Splendidly uniformed guards, brass buttons and all, sat statuesquely at strategic points, determined to prevent copying. Occasionally a grunt or a groan revealed a candidate compelled to make a fresh start after belatedly measuring his half-finished drawing or sculpture with a meter stick, only to discover it was not the required size.

''The last hour was notable,'' Grafly observed. ''You could then see mistakes you never dreamed of. But no use, time is up; mistakes or no mistakes, we are summarily ordered to carry our work into the cellar and place it beside the studies of previous sections, there to remain until Wednesday or Thursday when all will be judged. Then the ones chosen can take the rest of the examination, and the others must wait until the next *concours* in July or August.''[14]

For a week after the examination the boys, in uninspired, routine fashion, continued their studies at Julian's. It became increasingly difficult, however, to concentrate on anything but the outcome of the Beaux Arts competition. When the time finally arrived for the results to be announced, the dismal day seemed to predict defeat. Through mingled rain and snow Henri, Grafly, and Hefeker trudged to the Beaux Arts, there to join others who watched and waited for the posting of the successful candidates' names. The tenseness was now and then broken by the singing, shouting, and shushing which greeted each new arrival. Then the official . . . the list . . . A pushing, howling mob converged. Then silence. As the names were read aloud in singsong French, there

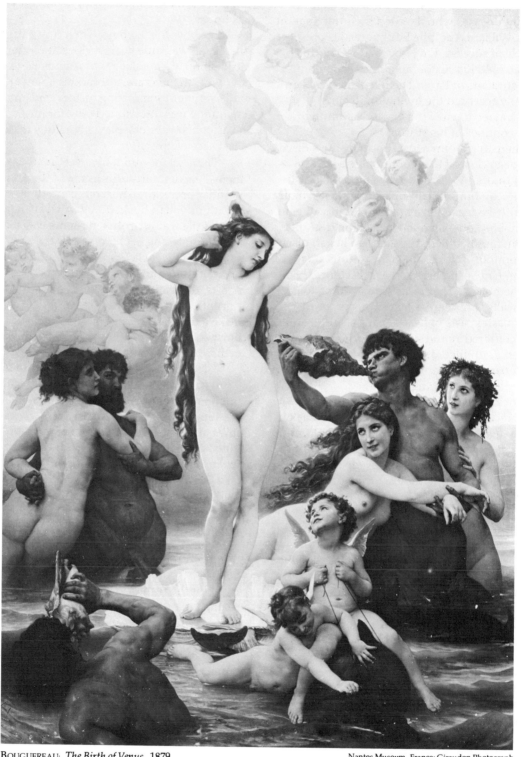

BOUGUEREAU: *The Birth of Venus*, 1879.

Nantes Museum, France; Giraudon Photograph

came an occasional sigh of relief, a grin from ear to ear . . . but despair for the five Americans, who learned that they were not among the chosen few.

Dejected, they sought solace in their classes at l'Académie Julian, but the strict regimentation there now made them impatient. The industrious Grafly tired of his classical composition *Ceres Showing Triptolemus the Art of Plowing,* and consoled himself by modeling in bas-relief a sculptural portrait of Henri.

The boys tried to keep their lagging spirits up by spending evenings at the Moulin Rouge and the Folies Bergère, and mornings exploring the city. The chief attraction in Paris at this time was the expanding framework of Gustave Eiffel's tower, which was slowly stretching skyward, to become the crowning feature of the soon-to-open Paris Exposition. Yet even the excitement encountered on the exposition grounds did not seem to overcome the gloomy air of disappointment that hovered over their garret. Tempers grew short; arguments flared. The monotonous diet of rice and horse meat became unbearable, and the initially quaint, cluttered quarters no longer cast their magic spell.

As the summer months approached, the five Americans decided temporarily to abandon their cooperative housekeeping. To dispose of numerous jointly owned possessions, a private auction was ceremoniously held among themselves in their fifth-floor apartment at 12 avenue Richerand. Robert Henri assumed the role of auctioneer; Grafly was the caller. Each and every article which had bedecked the crowded garret went under the auctioneer's hammer, from a broken stewpan to a French family Bible.

Then, arms loaded with their newly acquired personal belongings, the five American art students parted company.

CHAPTER THREE

WHEN THE garret combine dissolved, Charles Grafly and William Hefeker established themselves in new quarters on the rue Bonaparte. But Henri, looking elsewhere for the much-sought-after yet elusive inspiration, set out on the search alone.

With the restless determination of an avowed nomad, Henri abandoned the French capital for the summer, choosing instead the quaint fishing village of Concarneau on the French west coast. Immediately the distraught art student was captivated by the picturesqueness of the seaside resort, the romance of the ancient fortified town, and the pattern and color of massive sails silhouetted against the sky. The change in scenery was indeed conducive to artistic creativity, yet Robert Henri painted little. Instead, in quiet meditation, he contemplated the course of his future in art.

The answer appeared fortuitously one bright and sunny afternoon. At Concarneau, Henri had encountered Philadelphia-born Alexander Harrison, one of the first American artists to follow the Impressionists' lead of *plein air* painting. Forsaking the darkened studio for the brilliant sunlight of the out-of-doors, Harrison had brought models from Paris and was painting their shimmering nude bodies against the glistening, plunging surf.

As Henri passed Harrison's single-storied, steep-roofed studio one day, he gazed into a faintly lit room formerly utilized for the storage of grain. There a thin, dazzling shaft of light from a highly placed dormer window streamed down upon the painted representation of a crouching nude bather. The sunlight injected vibrant warmth into the brightened flesh tones and emphasized the broad brush strokes which seemed to suggest form without

slavish detail. As the beam of the sun's rays began to fade, the illuminated canvas gradually disappeared into the shadows.

When Henri returned the next day to gaze upon his exciting find, he was cordially invited in. Once inside Harrison's studio, a new world of art was spread before his eager eyes.

Henri had found the answer. Returning to Paris that fall, he resumed his art studies in earnest. He enrolled once more at l'Academie Julian, joined by Grafly and Hefeker, together with Edward W. Redfield, another former classmate at the Pennsylvania Academy newly arrived on the European scene.

Henri's technique quickly reverted to the style of his Philadelphia days. In the life class at Julian's he tried sketching the figure the way Thomas Anshutz had suggested, building the muscles properly and letting the outline take care of itself. But this approach was in direct opposition to the accepted French method of drawing as taught at Julian's. There they dictated that the outline be drawn first, then the areas of solidity stuffed in.

Week after week the struggling art student received repeatedly unfavorable criticisms from his teacher, William Adolphe Bouguereau, who evidently expected the same degree of polished perfection in his students' work as he exhibited in his own. The master saw and recorded the curvacious human form with an insatiable lust for detail, observing through a pair of lens-like eyes with the precision of a camera. But Bouguereau's art was too good to be true. And his teaching verified this same kind of repression of the bold and the real. With shoulder shrugging and a shake of the head, he would say with marked disapproval: ''The model looks brutal

enough without making him more so."[15]

For Robert Henri the pipe dream of becoming a prosperous Bouguereau at the age of thirty-five was beginning to fade. He became increasingly dissatisfied with the demands of the master over his work. He was beginning to tire of the veil of dreamy sentimentality which the art dictator wove over his disciples. With his eyes now wide open, Robert Henri concluded: "The perfection of finish in a Bouguereau is tame and unlifelike."[16]

In vain the impressionable youth had sought the dynamic method of painting which he had witnessed that summer at Concarneau. But at Julian's, Henri and the others were continually cautioned against the detrimental influence of the Impressionists, those contemporary painters who preferred the optical blending of color to the conventional mixing of pigments on the palette, who discarded their tubes of black and proceeded to enliven murky shadows with tints of blue and purple.

The Impressionists Claude Monet, Camille Pissarro, Edgar Degas, and Pierre Auguste Renoir depicted dazzling sunlight as it danced across a surface of rock and sea or upon the pristine whiteness of

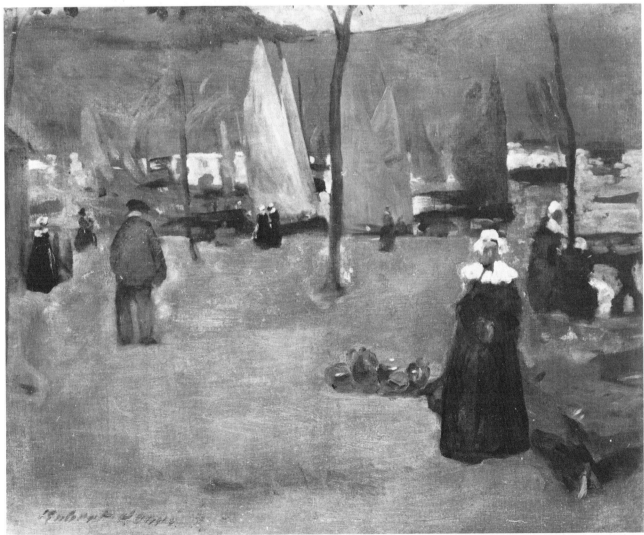

HENRI: *Quay at Concarneau*, 1899.

new-fallen snow, the brightness of sunlight on the gleaming bodies of bathers or the radiance of bright lights playing across the graceful forms of ballet dancers. By thus painting people and landscapes as they appeared at any given moment, instead of as they actually were according to their permanent form and color, the Impressionists became artistic outcasts in the eyes of the academicians.

Students at l'Académie Julian were similarly sheltered from the presumably harmful effects of Georges Seurat, the pointillist painter who had recently placed the last dots of pure color upon his mural-size masterpiece, *Sunday Afternoon on the Grande-Jatte.* Vincent Van Gogh, painting his final frantic canvases in Saint-Rémy less than a year before his tragic death, was to be neither spoken of nor imitated. And fifty-year-old Paul Cézanne, the father of modern art, who was then creating pyramidal masses of Mont-Sainte-Victoire, was the subject of hushed conversations outside l'Académie. For Robert Henri, as for his duped confreres, the excitement of Paris stopped at the Académie door.

In desperation, the disillusioned American did what generations of art students had done before him. Shedding his academic blinders, he sought refuge in the picture collections of the Louvre and Luxembourg museums. Sometimes accompanied but often alone, Henri would stroll aimlessly through the Louvre, roaming from gallery to gallery to discover for himself the works of the old masters. Yet by comparison, it was the Luxembourg that held a much greater fascination for him because its collection included the canvases of contemporary artists.

At this time custom dictated that paintings acquired by the state remain in the Luxembourg for ten years after an artist's death; then the finest examples would be culled and transferred to the Louvre. The Luxembourg, therefore, still housed the enticing creations of the much-abused Impressionists, including the scandalous canvases of Édouard Manet, who had passed from the scene a scant seven years before.

Henri quickly developed a taste for such forbidden fruit. He gazed without ill effect at Manet's unblushing *Olympia* and at the urbane elegance of *The Balcony.* He observed Manet's skillful use of flat tones of color, as opposed to the carefully graded and shaded method he had been taught at l'Académie.

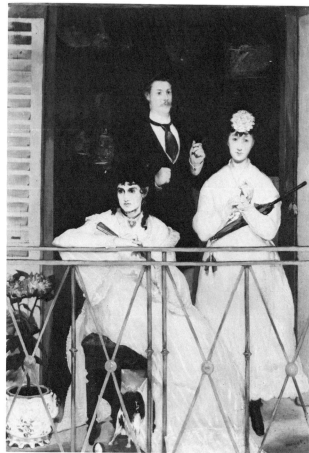

MANET: *The Balcony,* 1869. The Louvre, Paris; Giraudon Photograph

For Robert Henri, this illicit viewing became the origin of a life-long admiration for the work of Édouard Manet.

Henri's disinterest in the Julian classes was far from unique. Of the other Americans, Harry Finney, for example, had already forsaken the insipid instruction of Bouguereau, preferring instead to try his hand at portrait painting on the fashionable Right Bank. And by the summer of 1890, Grafly, Hefeker, and Redfield joined with Henri in an escape from the stifling atmosphere of their Julian-dominated Paris.

Traveling to the south of France, the four established headquarters at the Hôtel Saint-Nazaire, in the town for which it was named. Seeing nature for the first time under the vivid Mediterranean sun, the art students sought to capture the dazzling effect of

light. Although Monet was the rage among *plein air* painters, Henri and Redfield showed greater interest in another Impressionist, Frédéric Montenard, whose work they had seen in near-by Marseilles and Toulon. Montenard allowed a greater amount of subject matter to come through his daubs of color, so that, as Redfield observed of his mural in Marseilles' Hôtel de Ville, "You could tell the grapes from the vines."[17]

Henri and Redfield, sharing the same room at the hotel, tried to outdo each other in their use of startling reds, blues, and yellows. They criticized one another's work and painted long and hard. But the hours they kept nearly cost them their friendship. Redfield was usually off to paint at 4 A.M., hoping to capture the early morning sunrise in true Impressionist fashion. He would often bring back two oil sketches before breakfast, only to find Henri, having

just arisen, wasting the precious morning hours washing and doctoring his acne-covered, pock-marked face. On one such occasion, Henri frowned critically upon Redfield's glistening paintings, and suggested that the shadows were too long. "If *you* got up earlier you would find them long," was Reddy's curt defense, and for the next two weeks, though they ate and slept within the same four walls, hardly a word passed between them.[18]

Everyone seemed on edge, and sometimes depleted finances created friction among the group. Henri was living on fifty dollars a month, sent him by his father, Mr. Lee. If anyone ran short of funds, Henri would usually "grubstake" them until their monthly allowance arrived. Once Henri made such a loan to Hefeker, then promptly criticized him for the purchase of pastry, which Henri considered an un-

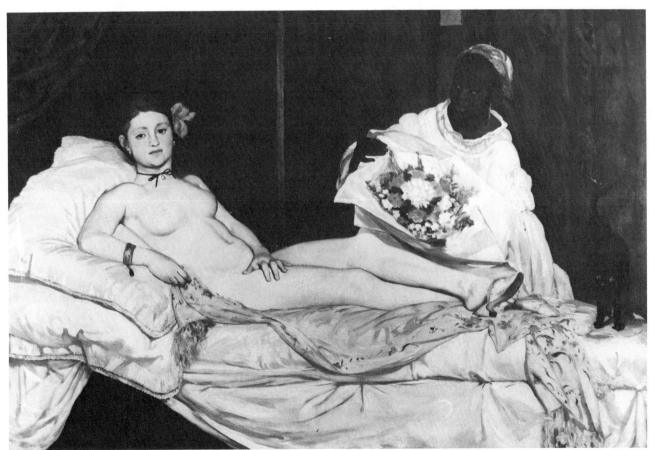

MANET: *Olympia*, 1863.

The Louvre, Paris; Giraudon Photograph

necessary luxury. Heated words were exchanged, and some weeks passed before the incident was altogether forgotten.

As a much-needed diversion, the boys engaged almost nightly in a game of poker. Wagers were held to a two-penny limit, but when anyone's luck resulted in a gain of twenty-eight cents, the winner, by table rule, had to purchase drinks for the entire gang. The lure of neighboring Monte Carlo and professional gambling never occurred to the crowd; never, that is, until Edward Redfield, inebriated one morning from too much wine, unintentionally entrained for the casino. There he discovered the roulette wheel and disaster. That night a sober Redfield returned to Saint-Nazaire, clear-headed and virtually penniless.

The unhappy experience aroused Robert Henri's curiosity. Before long, he too headed for the gaming tables to try his luck, which turned out to be much better than his roommate's. It was a happy Henri

GRAFLY: *Hugh H. Breckenridge,* circa 1899.

who came back victorious from his initial encounter, richer by one hundred dollars.

With autumn approaching, the adventuresome lot returned once more to the French capital. There the boys' enthusiasm for painting sometimes waned, but never their taste for poker. Now they were joined in their game by another Pennsylvania Academy alumnus, A. Stirling Calder, a sculptor whose father was designing the figure of William Penn to be placed atop Philadelphia's City Hall and whose son, Alexander Calder, would one day create the mobile.

The nightly shuffle of cards was usually accompanied by the rhythmic strumming of a congo harp and the chanted limericks of English-born Ernest Thompson Seton, also a newcomer to the carefree crowd. Seton had already written and illustrated his first of a long series of nature books; two decades hence he was to be instrumental in founding the Boy Scouts of America.

Thompson's current interest in formal art training was quickly squelched by his poker partners. To-

CALDER: *Man Cub,* circa 1903.

Courtesy of The Pennsylvania Academy of The Fine Arts

SCHOFIELD: *Winter*, circa 1899.

BUNCE: *Early Morning, Venice.*

The Metropolitan Museum of Ar
Gift of George A. Hearn, 1909.

gether, Henri, Grafly, Redfield, Calder, and Thompson abandoned Paris, this time establishing themselves at Brolles, some twenty-five miles to the south. There for a few months the five played the part of artistic rebels. They pretended to have forsaken the Paris atelier for the open air of the Forest of Fontainebleau, just as Claude Monet and the Impressionists had done a quarter of a century before, when they established themselves within a few miles of the same town.

Unlike their predecessors, however, the young painters and sculptors found artistic suffering difficult and unhappiness hard to come by, in the light of their pleasant accommodations at the Hôtel d'Élégant. They even encountered two more Pennsylvania Academy graduates there — Elmer Schofield and Hugh Breckenridge — who happily joined the enlarging clan. Like polished and pretentious artists, the seven boys boldly submitted their work to the Paris Salon. Five of the seven felt the anticipated sting of disappointment. Although a full-length portrait by Henri was considered by some of the gang to be the best of their entries, only Redfield's first snow scene and a work by Thompson Seton were accepted.

Once more the group split and changed. Grafly and Hefeker acquired bicycles and pedaled through Holland, Belgium, and Germany. Henri and Redfield traveled south by train, seeking the solitude of luminous Venice. They found the Italian city a lazy sort of place, full of wonderful hues which neither of them seemed capable of capturing on canvas.

Still painting in a high and colorful key, they caught the inspiration of Gedney Bunce, a middle-aged American expatriate who now called Venice his home. Like Manet, Monet, and Montenard, Bunce was an Impressionist. In fatherly fashion, he showed his water colors and oils to Henri and Redfield, and demonstrated his method of painting with palette knife and fingers, as well as with the brush. He spoke of Titian as his master, and aroused in Henri an interest for the sixteenth-century Venetian painter. And, above all, Bunce revealed the Impressionist philosophy as a desire to produce effects with a total disregard for minute detail.

The few paintings which Henri and Redfield completed that summer of 1891 were on the same

REDFIELD: *Overlooking the Valley*.

order as those created the year before in the south of France. But for the most part the boys just loafed. They were rendered inactive by the southern sun, spending most of their time in idleness, riding barges and gondolas, and listening to music. "It was a dreamy experience with nothing accomplished," admitted Redfield, "unless killing bedbugs and catching lizards off the walls with a fishhook count."[19]

The roommates were becoming accustomed to their lazy routine and companionship. Then one morning Redfield awoke with a start, bothered by a bad dream. In it he pictured Henri floating in the ocean off Atlantic City with his pants pockets turned inside out. Before the two puzzled long over the dream, Henri received a letter from his father in At-

lantic City, requesting that he return home at once. Mr. Lee described the difficulty he had had with police as a result of his resisting the efforts of the city to route a boardwalk through his pavilion and pier. In the midst of the struggle over the property, Mr. Lee's Cincinnati House hotel burned to the ground.

Suddenly silent and somber, twenty-six-year-old Robert Henri must have seen similar events in his youth flash before his eyes — a home burned to the ground in long-forgotten Cozad, Nebraska, and a previous occasion when his father had brandished a gun.

Leaving Venice and Art far behind him, Henri returned quickly to his native land, to stand by the side of his beleaguered father.

CHAPTER FOUR

ROBERT HENRI arrived in the United States seasick from his ocean voyage and fearful of his family's future. But by the time he reached Atlantic City apprehension vanished when he was informed of his father's plan to recoup the family fortune.

Mr. Lee had already defended his riparian rights with shotgun in hand, threatening to shoot the first man who tried to break through. He had stymied the building progress of the Atlantic City boardwalk at Texas Avenue. Now this skillful real estate developer was negotiating the purchase of a large tract of ocean-front land just beyond his initial investment; when the second property was properly deeded, he would willingly sell his rights to the first.

Robert Henri soon realized that his presence was not required in Atlantic City, for his father had the situation once more well in hand. Henri therefore determined to continue the pursuit of his abruptly interrupted art career.

Through a continuing correspondence with his fellow art students abroad, Henri learned that Charles Grafly was already meeting with some measure of success. Two of his entries had been exhibited at the Paris Salon of 1890, and one of these, a sculptured head entitled *Daedalus,* had just been purchased by the Pennsylvania Academy, where Grafly was now teaching.

Henri journeyed to Philadelphia to visit his former classmate turned instructor. It was a happy reunion. Grafly paraded Henri around like the conquering hero returned home. He escorted him into the Academy's evening life class, where Henri spoke of the paintings he had seen in Europe, then proceeded to make a charcoal drawing of the model before the assembled group. Later Grafly held an in-

formal studio party, to which he invited a number of the more serious and energetic Academy students, along with those of his European traveling companions who had also returned from abroad.

GRAFLY: *Daedalus,* 1889.

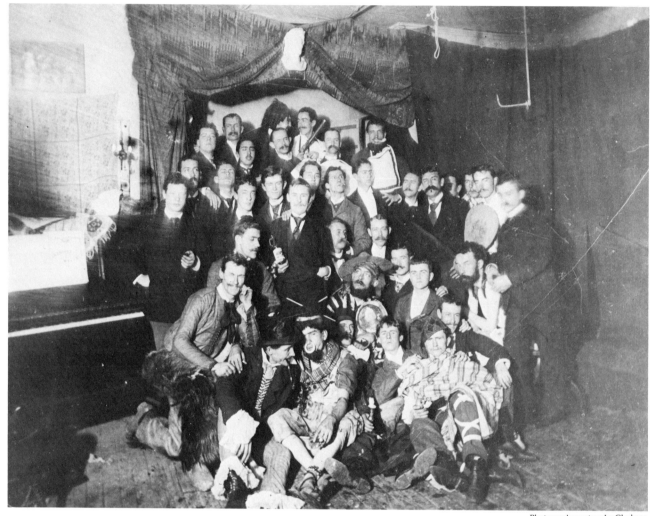

The Grafly affair was strictly stag, with nearly forty Pennsylvania Academy alumni and students attending. Many of the artists appeared in costume, a custom commonplace in those days when young men gathered to entertain themselves. Robert Henri arrived wearing a top hat and the ruffled cuffs of a French gentleman, while Edward Redfield came dressed as a bearded sheik with a ring through his nose. Breckenridge was there too, enveloped in a turkish towel, and Schofield arrived bedecked in a sporty scarf and bib set. Host Grafly's clothes were purposely incongruous, combining a flowing black artist's cravat with fur-covered cowboy chaps.

The contingent of invited Academy students was more sedate in manner and dress, wearing only an occasional false mustache in the hope of adding years and distinction to some youthful countenance. Among those present at the Grafly gathering were James Preston, Edward Davis, William Glackens, and John Sloan, all destined to gain fame through their art careers in the years to come. It was as a result of the chance meeting of these younger men that Robert Henri began to muster about him a number of lifelong associates.

Of the group, Sloan and Henri were to become the most intimate. Clean-cut, talented, Pennsylvania-born John Sloan had been exposed to art during most of his twenty-one years, but especially since

The Grafly Studio Party, Fall, 1892.

1. Robert Henri
2. Edward W. Redfield
3. James M. Preston
4. Hugh Breckenridge
5. Charles Grafly
6. Charles S. Williamson
7. William J. Glackens
8. John Sloan
9. Elmer Schofield
10. Edward W. Davis

John Sloan in his studio at 705 Walnut Street, Philadelphia, 1893.

Sloan Collection, Delaware Art Museum

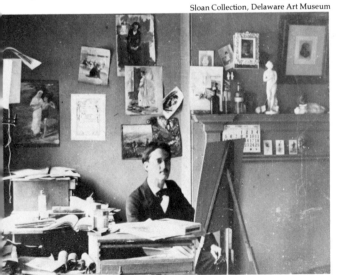

his sixteenth birthday, when he became assistant cashier at Porter and Coates, Philadelphia's leading dealer in books and prints. An art education in disguise, there passed through his youthful hands the original etchings and engravings of Albrecht Dürer, Rembrandt, and Hogarth — a continuing parade of the world's masterpieces of graphic art.

Sloan's first employment with paint and brush was at the fancy-goods establishment of A. Edward Newton, the future bibliophile, where he designed Christmas cards, matchboxes, and bookmarks, alongside sixty giggling girls. Sloan's innocent countenance was the focus of continued female flirtations, and this shy Sloan repulsed many a visual advance in the workroom where hand-painted candy boxes were decorated with French lovers philandering over the lids.

During Sloan's first meeting with Robert Henri at the Grafly party, the subject of their conversation gravitated toward a mutual interest in books. When Sloan had been employed at Porter and Coates, he had read through complete sets of the French realists — Balzac, Zola, Victor Hugo, and de Maupassant — while Henri was currently absorbed in Thomas Paine and Emerson. There was one writer, however, who received their unqualified mutual admiration. That was Walt Whitman, the great poet who had just recently passed from the American scene in March, 1892. Henri already possessed an 1884 edition of Whitman's *Leaves of Grass*, but Sloan, eager to win the older man's friendship, subsequently presented him with a later and finer edition.[20]

For Robert Henri, the Grafly gathering must have seemed like old home week, a most stimulating evening in which he recalled with his classmates the excitement of three years in Europe, and chatted briefly with some of the younger men about what the future held in store.

Having made the decision to remain in Philadelphia, Henri rented lodging and studio space at 806 Walnut Street, locating himself by chance just a block away from John Sloan's studio at 705. Sloan was eager for the association of this older and more mature artist, for although Henri, at twenty-seven, was six years his senior, the two appeared to have much in common.

Since February, 1892, Sloan had been working

on the art staff of the *Philadelphia Inquirer,* and now, in the fall of that year, he was supplementing his daytime career with an evening class at the Pennsylvania Academy. Studying drawing with Thomas Anshutz, Henri's former teacher, Sloan found himself in the company of F. R. Gruger, Joe Laub, J. J. Gould, Guernsey Moore, Maxfield Parrish, William Glackens, and almost two dozen other students. Many of them, like himself, were newspaper artists. For these talented young men, who labored by day amid the noise and turmoil of competing metropolitan newspapers, the boring routine of the Pennsylvania Academy night class must have seemed dreadfully dull indeed. For a few hours, once a week, they would assemble in the classroom to sketch the outline of plaster casts in charcoal, then polish up the details. There was never a live model and no instruction in painting — just the monotonous repetition of drawing from casts.

How different the teaching methods of Thomas Anshutz appeared to these evening students, in contrast to their inspirational effect upon Robert Henri in the day school just a few years earlier. Naturally, there were some evening-school students who were satisfied with the classroom routine. Others voiced disapproval yet unhappily accepted their fate. But for John Sloan, the situation was intolerable.

Prior to his enrolling at the Pennsylvania Academy, Sloan had attended the evening school of the Spring Garden Institute, a Philadelphia trade school founded by the Baldwin Locomotive Works in order to train draftsmen. For two years Sloan had drawn with painful accuracy from plaster casts, then spent an additional term working from the clothed, costumed model. Having won two second prizes and an honorable mention for his antique and figure drawing, he had hoped to be admitted directly into the life class upon enrollment at the Pennsylvania Academy.

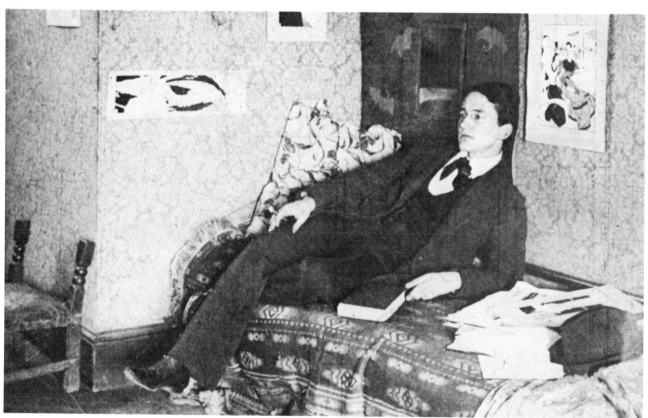

Sloan Reclining on Henri's "Rag Bag" at 806 Walnut Street.

Sloan Collection, Delaware Art Museum

But previous training, prizes, or capability be damned — Sloan had to spend another year drawing from the antique, just like any other entering student.

The dreariness of the Academy building only made matters worse. It was not at all conducive to productivity — dark and dingy, with walls resembling those of a historical society proudly lined with the dusty paintings of America's old masters. For a time a group of newspaper artists let idleness and horseplay substitute for learning. They lolled around the classroom and occasionally congregated in one of the large empty rooms to sketch by themselves. But for the most part they simply fooled around, taking pride in such nonartistic achievements as coming down the grand stairway on a drawing board for which event F. R. Gruger was crowned speed champion.[21]

By the end of his first term in February, 1893, John Sloan could tolerate the Academy no longer. Turning to Joe Laub, a fellow artist on the *Philadelphia Inquirer* who shared the studio with him, Sloan discussed the hopelessness of the situation. Then he approached Robert Henri, who listened sympathetically.

As an outcome, John Sloan called into existence an organization which was dubbed the Charcoal Club. There was no protest meeting or ultimatum this time, as in the case of Thomas Eakins' forced withdrawal from the Academy six years earlier. A large segment of partisan students simply failed to register for the Academy's second term.

Renting a photographer's studio on Ninth Street and buying half a dozen easels and chairs and a posing stand, the Charcoal Club offered a model and a place to work at half the fee charged by the Academy. Admittedly the revolt was partly economic, for the Academy's evening school tuition was four dollars a month, an excessive amount in the eyes of the struggling newspaper artists.

When the Charcoal Club held its first semiweekly meeting on the fifteenth of March, treasurer John Sloan collected dues of two dollars a person for the first month. There had been an attempt on the part of some Academy students to discourage the plan, contending that the newly formed club would hurt the parent institution. Their prediction was indeed accurate. Enrollment soon soared to three dozen members, almost twice the number attending

F. R. GRUGER: Figure Study from the Charcoal Club, 1893.

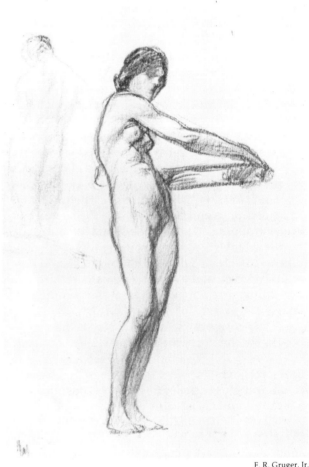

F. R. Gruger, Jr.

the competing Academy class from which they had just fled.

Additional income soon enabled the Charcoal Club to purchase Welsbach lights, a real advance over the dimly-lit Academy classrooms. Robert Henri, at twenty-seven the oldest one present, was chosen to speak informally on the compositions. John Sloan was asked to give criticisms of homework. For many of the group, including Laub, Gruger, Glackens, and Davis, as well as for Sloan, these twice-a-week sessions offered the first studies and drawings from the nude model.[22]

Revolt at this time was not limited to the art world, for there were many aspects of American life that needed revision. By 1890 the western frontier had closed, bringing to an end the urban escape valve

of unlimited homesteads. Emphasis upon rural life in America had done an about-face, and with an agricultural depression in the making there evolved a movement back to the teeming, thriving, industrial areas. In such urban concentrations the growing labor class began to revolt against its unfavorable working conditions, and this social and economic unrest contributed to the Panic of 1893.

By the summer of that year the country was in the grip of a depression. As numerous business failures were experienced throughout the nation, so Art in Philadelphia suffered a serious setback. The Charcoal Club, after only six months of existence, came to an inauspicious end. As one by one the membership began dropping off during the summer months, disheartened John Sloan philosophized: "Co-operative schemes at two dollars per month won't stand hot weather."[23] By mid-September the Charcoal Club was dead, and even the cooling autumn breezes were unable to revive it.

The Pennsylvania Academy played the eager host in welcoming back its former students. Worried Harrison Morris, the school's director, was so relieved at the club's failure that he even purchased its chairs and Welsbach fixtures. But this hospitable overture could not alter the conditions which had caused the Charcoal Club to be called into existence. In fact, the situation had grown worse. Thomas Anshutz was just back from a six months' stay in Paris, where he had worked under the detrimental influence of William Adolphe Bouguereau. The Frenchman's domination of Anschutz momentarily overshadowed any progressivism or open-mindedness which he might have retained from his former teacher, Thomas Eakins.

Grudgingly Sloan returned with the rest to Thomas Anshutz's evening class in the fall, hoping to find a more liberal attitude in the instructor's teaching. But it was not there. Finally bored one evening with the prospect of continuing to draw an antique cast, Sloan casually pulled his chair off to the side of the room and began filling the margins of his paper with sketches of some of his industrious classmates. Anshutz spied the nonconformist. "You have no business drawing anything but this project from the antique," he admonished angrily. "You shouldn't be wasting your time doing illustrations and cartoons."[24]

Infuriated by this unwarranted attack, Sloan gathered up his supplies and stalked out of the classroom, never to return.

Meanwhile during the summer, along with other members of the ill-fated Charcoal Club, Sloan had helped to transform the dying weekly life class into a lively discussion group which met each Tuesday evening at Henri's studio. An air of kindred companionship permeated these weekly gatherings, and 806 Walnut Street soon became a veritable haven for painters and art students alike.

The number of those in attendance at Henri's weekly open house varied from time to time, but among the regulars were John Sloan, William Glackens, James Preston, Edward Davis, and Frederic Rodrigo Gruger, all newspaper artists; Charles Grafly, A. Stirling Calder, Edward Redfield, Elmer Schofield, and Hugh Breckenridge, former traveling companions in Europe.

At the outset the meetings were general gabfests, with a number of the older men expressing varied opinions on existing conditions or problems of a local nature. But almost immediately it was host Robert Henri who assumed the role of moderator, and before long it was the eloquent and dynamic Henri who captivated his hushed and attentive audience. There was never any announced topic to be discussed; thoughts simply came to him as a kind of improvisation. Yet in giving them form, Henri, like fabled Aesop, would weave a magic spell, becoming at once witty, trenchant, unhesitating, decisive.

Henri was a natural-born speaker, forceful and fluent, and the massed assemblage would visually follow his lean six-foot frame as he paced about the room. He would seldom begin without lighting a cigar, the smoke from which seemed to lend appropriate atmosphere to his curious Eurasian features which combined strangely with a slight southern accent.

Although a few of those present were themselves art instructors, hardly a word was spoken, lest the spell be broken. Only occasionally were questions directed to the speaker. Not that Henri demanded silence or felt he deserved the reverential quiet of a gifted orator, but rather that he had, perhaps unconsciously, ignited a spark which would burn until, of its own accord, it went out.[25]

Robert Henri was perhaps cognizant of poet

Stéphane Mallarmé's Tuesday-evening gatherings when he chose that same night for his weekly talks on art. Mallarmé's Paris get-togethers, which were conducted in the same manner, had been frequented by Claude Monet and other Impressionists, whose light and bright palettes of jewels still dazzled the impressionable Henri. Yet in America, the Tuesday evenings at 806 were unique. Other gatherings, like those of the Tile Club or the Art Club in New York City, were either strictly formal, with elected officers, or purely social in nature.

An obvious point of departure at the Henri gatherings was the general lack of enthusiasm for the Pennsylvania Academy. Virtually every man present had at one time or another tasted the flavor of instruction at that art school. Henri, who once praised his alma mater, now voiced opposition to its exhibition policy, which seemed determined to overlook the work of the newspaper artists who were studying there. To him the Academy exhibits did not contain "vital art" of the type that would eventually contribute to the art history of America. Henri also bemoaned the general lack of interest in the Academy classes, pointing to this indifferent attitude as indicative of the contradictory art worlds which consumed the student in Philadelphia and Paris. Such statements were certain to bring a vigorous round of applause from the younger element present, which abruptly but only momentarily interrupted the unbroken silence of the listeners.

Much of Henri's dynamism and biting wit had its origin in William Morris Hunt's *Talks on Art,* both volumes of which Henri possessed and virtually memorized as the basis for his own philosophy and teaching. Any art student who had been subjected to a dry-as-dust instructor could not help but appreciate Henri's lively delivery of Hunt's message:

> The highest light on the face is usually on the spot which would get wet first if you were out in the rain. . .

> You think it an insult to put a shadow upon a face! The Lord doesn't think so!

Other portions of Hunt's discourses offered Henri more serious food for thought:

> Some people have expressed themselves as discouraged in their expectation of finding any art in America,

and have "long since ceased to hope!" Let us remember that art . . . has always existed, in all nations, and the tradition will probably not die here.

Henri employed other stimuli. George Moore's *Confessions of a Young Man* was openly critical of the popular taste of foreign art students in France. "The Americans come over here, and what do they admire?" Moore queried. "Is it Degas or Manet? No, Bouguereau and Lefebvre." The Moore volume, published in 1888, had been perfectly timed to substantiate Henri's own choice of teachers. "Judging a Manet from the point of view of Bouguereau," he readily acknowledged, "the Manet has not been finished. Judging Bouguereau from the viewpoint of Manet, the Bouguereau has not been begun."[26]

Yet, the opinions of George Moore and Robert Henri to the contrary, popular taste was not yet willing to topple Bouguereau from his spurious throne. At the very moment the walls of 806 were resounding with dramatic tremors denouncing this sylvan god, the official French art exhibit at Chicago's Columbian Exposition boasted three pretentious Bouguereaus, while Manet was not even represented.

The critics and public alike were as yet unprepared to accept Manet's subjects, one of which a Rutgers professor had described as a "scrawny old maid and . . . disreputable dirty-looking boy."[27] But Henri moved to Manet's defense. "He followed his individual whim," Henri asserted. "He told the public what he wanted it to know, not the time-worn things the public already knew. . . ."[28]

Henri readily acknowledged that his taste for European painters was identical with those whom Manet had respected. When the Frenchman portrayed his starkly-naked *Olympia,* he was conceding his fondness for Titian's sensuous *Urbino Venus.* Manet's mortally wounded toreador confesses the painter's debt to Velásquez. His plump carouser in *The Bon Bock* drinks the beer of Frans Hals' Haarlem. And *The Balcony,* which Henri had viewed in the Luxembourg, was Goya-inspired and composed.

Yet for Robert Henri the effective stimulation of these masters lay in that segment of their work which displays a rare approach to portraying a dignified humanity. Henri would say:

> Every bit of Frans Hals' painting is sheer invention. . . He saw life and people in his own peculiar way

and he was a supreme master of the tools in his hands. . . .

It was the attitude of Velásquez toward his model that got for him the look which so distinguishes his portraits. . . . His King becomes a man for whom you have sympathy, pity and respect. . . . When the dwarfs posed for Velásquez they were no longer laughing stock for the court, and we have seen in their portraits a look of wisdom, human pathos and a balancing courage. . . . Everybody he painted had dignity, from a clown to a king. . . . He was a man in love with humanity.[29]

But European artists notwithstanding, Henri reserved his highest praise for Thomas Eakins, "a deep student of life" who was unafraid of what this study would reveal to him. Eakins had pleaded with students of art "to peer deeper into the heart of American life . . . to portray its life and types . . . to strike out for themselves, and only by doing this will we create a great and distinctly American art."[30]

Henri clearly substantiated this plea when he concluded: "To have art in America will not be to sit like a packrat on a pile of collected art of the past. It will be rather to build our own projection on the art of the past, wherever it may be. . . ."[31]

Robert Henri's personal magnetism and passion for verbal communication made his Tuesday evenings a thrill to behold. To some extent the uniqueness of the weekly gatherings stemmed from his enthusiasm for the prevailing unity of all the arts. Drama, music, and literature were allotted as much consideration as painting. Discussions of Ibsen's plays and Wagner's compositions were interspersed with Whitman, Emerson, Tolstoi, and Dostoievski to provide the equivalent of a liberal arts education for those in attendance.

Henri's keen awareness and understanding of literature reflected the days of his youth in Cozad, Nebraska, when reading provided a welcome daily diversion. After a few hours of supervising the construction of his father's bridge across the Platte River, or baling hay to be sent off to Denver, Robert would read anything he could lay his hands on: McElroy's *History of Andersonville Prison, Nicholas Nickleby* by Dickens, or a whole host of short stories and serials featured in the *New York Ledger*. Having kept a detailed diary from the time he was fourteen, Henri very nearly succumbed to his youthful ambition to become a writer. But having once penned an original composition, which he labeled his *Runty Papers*, he derived a greater satisfaction from illustrating the work with decorative letters and ambitious drawings of a minstrel troupe.

As was the case with the painters he revered, Henri was motivated by literary men who cherished the importance of individual expression. Leo Tolstoi revealed it in *What is Art?* when he contended "that a work of art was not the record of beauty already existent elsewhere, but the expression of an emotion felt by the artist and conveyed to the spectator." As Emerson phrased it in "The American Scholar," "Man thinking must not be subdued by his instruments. . . . When he can read God directly, the hour is too precious to be wasted in other men's transcripts of their readings."

And as set forth in the writings of Walt Whitman: "Leaves of Grass, indeed (I cannot too often reiterate), has mainly been the outcropping of my own emotional and other personal nature — an attempt from first to last, to put a person, a human being (myself, in the latter half of the nineteenth century, in America) freely, fully and truly on record. I could not find any similar personal record in current literature that satisfied me. . . ."

These, then, were the art and literary figures whose vital messages acquired new meaning for the spellbound assemblage at Henri's Tuesday evenings. To hear him was to believe in what he said, to realize that the forerunner in every form of art had to struggle against the opposition of critics and public alike before recognition was forthcoming. Henri took a commanding view of the contemporary situation and defied popular taste, seeking the energetic and disregarding the fearful and the dainty. At a time when Whitman, Eakins, and Wagner were being ridiculed, ignored, or misunderstood, Henri was proclaiming their greatness.

And perhaps most significant of all, Henri implanted in his associates his fundamental belief, the idea of "the importance of *life* as the primary motive of art." Through Henri's singular effort, the popular belief in "Art for Art's sake" could now be corrected to read "Art for Life's sake."

CHAPTER FIVE

ROBERT HENRI'S Tuesday evenings had a positive effect upon most of the newspaper artists and Academy students in attendance. The younger men provided a receptive audience, ripe for Henri's impelling philosophy. Some, like John Sloan, would readily admit the influence, he having once observed that "Henri could make anyone want to be an artist . . ." then adding: "I don't think I would have been a painter if I had not come under his direction."[32]

Others acknowledged his contribution in silence. Frederic Gruger would walk home from the weekly talks on art with William Glackens, and noted that on more than one occasion not a word passed between them for nearly a mile. Soft-spoken "Butts" Glackens was perhaps the most reserved among the group, for words did not flow freely from his lips. Sometimes his mouth would move slightly, engaged in inaudible conversation; at other times, sentences would come sputtering out. Yet his shortcomings as an extrovert and conversationalist and his lack of verve and dash were more than compensated for by his art ability and good looks. Square-jawed, with dark wavy hair and a perpetual smile, Glackens was the pride of the newspapermen, who pronounced him the most talented among them.

A native Philadelphian, William James Glackens had earned an early reputation as a draftsman in high school, where he was always much in demand to make blackboard drawings before the school assemblies. He and John Sloan became acquaintances at Central High, both boys having entered the school in September, 1884. But at that point in their lives age acted as a barrier and Glackens, then fourteen and a half, seldom associated with Sloan, who was not quite thirteen.

With the exception of their art studies, neither boy received a formal education past the high school level. Thus the weekly discussions at Robert Henri's studio helped fill a gap which could not have been satisfied by mere book reading.

Henri's Tuesday evenings continued for a number of years, but before long the nature of the gatherings was somewhat altered by the introduction of beer parties and amateur theatrical productions which were intermingled with the more serious sessions. Make no mistake, the two types of open house were not to be confused. On those evenings when Henri held forth in his usual, captivating manner, nothing was served which might dull the power of comprehension. But at the 806 parties, the general conduct that was encouraged was quite different.

On those evenings the gang would troop up the narrow stairway to Henri's fourth-floor domain like cattle being driven to slaughter. Sloan, an innocent at poker, would be drawn into a card game while Glackens, posing as captain and center of a football team, assembled a hungry horde along an imaginary thirty-five yard line. With empty plates in hand, signals were called and the ravenous teammates descended upon their gastronomic goal.

At one such memorable party, a neighborhood restaurateur supplied a boiler full of spaghetti to the happy throng. By mistake it was well seasoned with Roman cheese instead of Parmesan, which resulted in more than the usual imbibing of beer. Before long the light-hearted crowd became light-headed as well. Some happy fellow scattered a fistful of spaghetti about the room, touching off a pitched battle with the left-over food as the sole ammunition. Visual evidence of the spaghetti party remained on the walls for years after.

The amateur theatricals at 806 were altogether

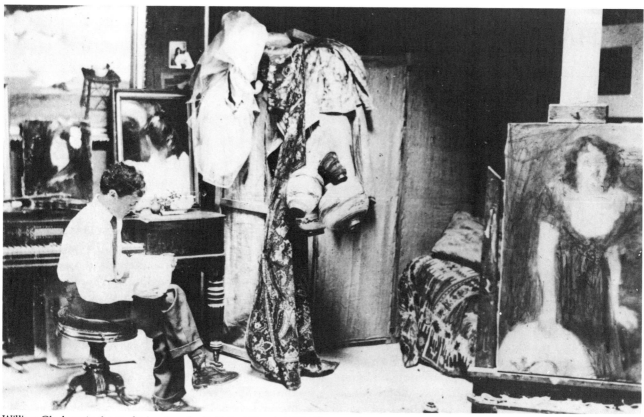

William Glackens in the studio he shared with Robert Henri at 1717 Chestnut Street, Philadelphia, 1894.

Courtesy Ira Glackens

different. They were the product of a group who loved to entertain themselves, a clean and wholesome bunch of artists and students seeking enjoyment at their own expense. Half a dozen burlesques were presented by and for the group, with elaborate costumes, elegant scenery, and printed playbills. The programs listed each production as the penned brainchild of Charles S. Williamson, a Pennsylvania Academy graduate turned math instructor at near-by Girard College. With the playbills proclaiming "Costumes from everywhere" and "Performance begins at our earliest convenience," there is suggested the Olsen and Johnson variety of slapstick comedy which could evoke a continuous round of hearty laughter from a conditioned crowd. As John Sloan once reminisced:

> It is hard to convey in words why these productions were so much fun for both actors and audience. I used to spend weeks in advance working on the sets and

costumes. Ed Davis always directed the choreography, which spoiled my taste for the Rockettes. Henri and Glackens helped with costumes and makeup. On the big day, we turned the studio into a little theatre. The first row sat on newspapers, the next on chairs and benches, and the back seats consisted of window-shutters laid on carpenter's horses. The audience was provided with beer and crackers, and there was more time devoted to intermissions than the play itself, which was part of the party. The actors never had any refreshments, however, until the show was over.

> After one performance I had had nothing to eat all day, and someone handed me a whole mug of sherry which I drank at one gulp. A moment later I was laid out half paralyzed but conscious, on one of the shutters — and suffered the indignity of having Ed Davis walk up my prostrate body. I think I never forgave him. [33]

Productions entitled *The Poison Gum-Drop; or, The Apple-Woman's Revenge, The Widow Cloonan's Curse, 2 Pound 4 and 6,* and *Annie Rooneyo* afforded the

talented troupe with an opportunity to display its versatility. Henri, Sloan, Glackens, Grafly, Calder, Davis, and Laub were among the regulars who doubled in both masculine and feminine roles. Others, spurning the actors' spotlight, became stagehands, as in the case of Edward Redfield, whose key tasks included pulling the strings which parted the curtain and operating the spigot on the keg of beer.

All these amateur burlesques proved to be merely a prelude to one magnificent effort billed as the "Third Grand Christmas Effusion" of the Pennsylvania Academy students, and presented on December 29, 1894. By now, recognition of the 806 Players had spread beyond the bounds of Henri's studio, and as a result, the dramatists were invited to stage their production in the Pennsylvania Academy's assembly room.

The year 1894 found the art world abuzz with talk of George du Maurier, the veteran English artist who had become a popular novelist overnight with his suddenly successful *Trilby*. The 806 playwright, Charles Williamson, adapted du Maurier's best seller

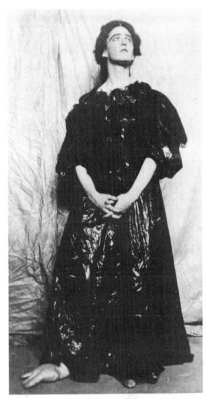

Sloan Collection, Delaware Art Museum

John Sloan as Twillbe, 1894.

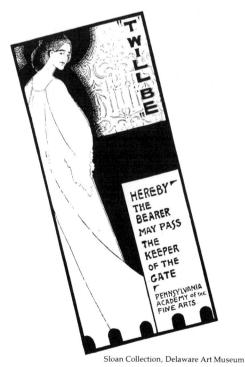

Sloan Collection, Delaware Art Museum

SLOAN: Ticket for *Twillbe*, 1894.

while it was still red-hot and, in fact, still under moral attack by Anthony Comstock. Williamson's Gilbert-and-Sullivan type of farce was renamed *Twillbe*, with Sloan playing the part of the heroine, Henri cast as Svengali, and Glackens as Gecko, "a fiddling genius."

Sloan was outfitted with enormous false feet, in obvious contrast to the delicate ones for which Trilby was already famous, and donning a comical wig, he sang "Sweet Alice Ben Bolt" in his very best falsetto. Sloan's sister, Marianna, had fashioned him a dress employing a Watteau pleat to mark the front. In all the excitement, Sloan slipped it on backwards, causing him continually to trip over the hem and evoking unexpected audience approval.

The mistake in dressing brought about another difficulty. At one point in the play Twillbe was slated to jump onto a table at the sight of a mouse. "This violent action caused my busts to fall out," Sloan blushingly reported. "Henri, who played Svengali, kicked them into the wings with a serene and magni-

SLOAN: *Night on the Boardwalk,* 1894.

ficent gesture I shall never forget.'' In the grand finale, Henri met a fate befitting the villain when he was bitten to death by New Jersey mosquitoes which swarmed upon him in the form of red balloons manipulated by wires offstage.[34]

The play was a smashing success. In it a newspaper artist named Everett Shinn made his acting debut with the troupe, being cast as the expatriate painter James McNails Whiskers. Small for his age

and young in years, Shinn, at eighteen, was the baby of the group, nicknamed ''the Kid'' because of the five- or six-year age spread which separated him from most of the other newspapermen. Having just begun a hitch in the art department of the *Philadelphia Inquirer,* Shinn found himself befriended by fellow *Inquirer* artist John Sloan, who invited him to the Tuesday evenings. Too preoccupied with dating girls and being a dapper dresser to take much interest in Henri's serious talks on art, Shinn was persuaded to join the occasional parties and theatricals held at the Walnut Street ''hangout.''

The paths of Shinn and Sloan had nearly crossed several years earlier, but neither had been aware of the other. While Sloan was enrolled in the Spring Garden Institute's evening drawing class, versatile Everett Shinn was studying there fulltime, his mornings devoted to mechanical drawing and his afternoons spent in the machine shop.

Shinn had come from Woodstown, New Jersey, to Philadelphia for the sole purpose of following his scientific inclination. He had never intended to be an artist. His adolescent aptitude for mechanics had been awakened by an article in *The Scientific American* describing the invention of the submarine. Inspired by what he had read, the boy had spent a whole summer at home making a tiny model of his own. The miniature ship was built of scraps of metal from the waste heap of a near-by tin shop, and was authentic in every detail. When the minute-sized submarine was launched without fanfare in the kitchen sink of the Shinn home, it came to rest on the bottom of a shallow ocean. But that performance merely demonstrated its power of descent. ''Its rise to the surface was a secret device,'' Shinn confided. ''Four steel drums were released from the body of the ship that would rise to the surface on chains, where four sailors, inside the drums, would wind the submarine to the surface. Then again the four drums would fit neatly into the body of the ship. A hatch would close above the drums, and the sailors emerge from the bowels of the undersea craft, breathless, but having done their duty.''[35]

Everett Shinn's imagination and inventiveness did not stop there. Construction was begun on a larger model built to hold two boys, but this ship never reached water; it was wider than the barn door opening through which it had to pass.

Shinn possessed a mechanical mind, and at the Spring Garden Institute his hand was trained to transfer detailed material with painful accuracy. A typical class problem involved the drawing in three colors of a Maltese cross set back at an angle of sixty-two degrees with the sun throwing a cast shadow on it at ninety degrees. Afternoons in the machine shop provided an outlet for young Shinn's creative genius and, left to his own devices, he evolved a rotary engine containing but seven parts. "It wasted too much steam to be efficient," Shinn admitted, "but it worked."[36]

Shinn sought to follow his mechanical inclination by accepting employment in the drafting room of Thackeray's Gas Fixtures Works, but he was unable to force his creative bent into such a rigid mold. Soon bored with the inflexibility of a chandelier drawing, he turned to the virginal margins of his paper and sketched the two-block expanse of Broad Street, from Market to Arch, complete with hansom cabs, drays, and scurrying pedestrians. Then the inevitable . . .

the foreman's shocked discovery, the initial indignation, and the eventual dismissal. But Shinn's understanding overseer parted company with these words of advice: "You're getting seven dollars a week at this job," he said. "The most you can get here is thirty dollars a week. Go to art school, young man, and after a year report to me how you get along. You have the gift to draw — do it because you can and I can't."[37]

Shinn sought to follow this advice by enrolling at the South Broad Street School of Design, but he soon found himself becoming mechanical again when confronted with the task of designing wallpaper. Unhappily he left Philadelphia for home.

The following fall, in 1893, Everett Shinn returned to the city with the announced purpose of entraining for Swarthmore, Pennsylvania, to enroll at the college there. But one glance up Broad Street toward the Pennsylvania Academy and he changed his mind. Walking the two short blocks from the station to the art school, he registered as a full-time student; then, for fear his father might sever his allowance, he

Art staff of the *Philadelphia Inquirer*, 1894.

landed a job with the *Philadelphia Press*. "I sat up all night waiting for the paper to come out," Shinn confessed, "to see if my drawing was in all the editions. There it was, on page eight of every one. Not in all my life have I had such a thrill from anything I have ever done."[38]

In those days when Everett Shinn, John Sloan, and William Glackens, together with Gruger, Preston, Davis, and Laub, were employed by various Philadelphia papers, there were neither wirephotos nor photographic supplements. The artist, in essence, was a reporter, following the tradition established by Winslow Homer some three decades before when his sketches of Civil War campaigns had decked the pages of *Harper's Weekly*.

The artist-reporter was assigned to translate into drawings what the news reporter put into words. He was called upon to sketch every type of event that made news, from a coal-mine disaster to a holiday parade. His work had to be factually accurate, yet executed with the speed demanded by newspaper work.

Sketches were made hurriedly on the scene, and the newspaper artists carried envelopes, menu cards, and laundry checks for just such a purpose. Any scrap of paper which might contain even a small working surface was suitable. Such on-the-spot sketches usually consisted of a myriad of markings with numerals shot off at tangents, a sort of artistic shorthand developed through trial and error. "If a fire was to be covered," Shinn related, "then a marginal notation . . . 'eight stories and seven across,' representing windows. A quick note of some detail of a cornice or architectural peculiarity was drawn in more carefully. More crosses where fire blazed in windows. Marks indicated fire engines, scaling ladders, hydrants, hose and other apparatus. . . ."[39]

Then the mad rush back to the newspaper office, with attempts to elaborate on the drawings while being joggled and jolted in a bouncing hansom cab. A dash to the drawing desk, the scribbled notations rapidly assembled, and the quick-sketch artist began a hasty scratching with pen and ink on a large segment of illustration board. Here the penciled hieroglyphics were swiftly transformed into a finished drawing. Soon the chemically stained hands of the photo-engraver gripped the margin of the emerging artwork, and a seemingly unsympathetic voice

warned: "Two minutes to the deadline." Then the still-wet sketch was whisked off, to be propped in front of the newspaper's only camera, a big, bellows-type affair that would photograph the artist's line drawing as the first step in the reproduction process.[40]

The artist-reporter is obsolete to the newspaper staff of today, but in the early 1890's the photograph, and the halftone process used to reproduce it, had not yet made its entry into newspaper production. Although the first photographs appearing in an American magazine graced the pages of *Harper's* in November, 1889, it was to take nearly a decade to adapt the camera and the reproduction process to the rapidity of a daily publication, and still longer for general acceptance of the innovation.

In the meantime, quick-sketch artists were in great demand. Following the lead of the *New York World*, which had blossomed forth as a picture paper in 1884, nearly every daily newspaper in New York City was illustrated by drawings within six years, and by 1892 all Philadelphia papers had followed suit. Competition grew keen, and when it was observed that sensational news stories readily resulted in a sudden surge of circulation, the octopus-like shadow of "yellow journalism" spread its greedy tentacles across the land, with the artist-reporter caught in a whirlpool of competing presses.

Each news editor became obsessed with one primary concern: How to scoop the others? The headlines tell the story: JAPANESE SPY CAUGHT IN LEAGUE ISLAND NAVY YARD, BANK OFFICIAL ADMITS EMBEZZLEMENT, ATLANTIC CITY PIER BURNS, EIGHTEEN MEN INJURED IN TROLLEY STRIKE.

No expense was too great for an editor's O.K. if the story had page one potential. Word raced through the *Press* building one afternoon of a tragic rail disaster in which two excursion trains had collided at right angles on the Jersey flats near Atlantic City. A hurried call to the railroad yards to charter a locomotive and baggage car, and Everett Shinn and a reporter were on their way. No one thought of taking aid for the dying; there was no time to round up doctors and nurses. The train sped along miles of straight track, arriving on the scene in time for Shinn to observe the still-smoldering passenger cars and to hear the shrieks and groans of the injured.

Before the newspaper artist had time to complete his quick sketches, the locomotive began its jolting

journey back to Philadelphia. Finished drawings had to be ready upon his return if the artwork was to appear in the evening edition. "I was lying on my stomach on the baggage car floor," Shinn recalls, "but when the train started I couldn't even hold the pen. The reporter sat down across my back to hold me steady, and he would hold my hand whenever I dipped into the bottle. The drawings weren't very good but no other paper had any."[41]

Often ingenious methods were tried to aid in the race against time. Once the *Ledger* decided to send Frederic Gruger to New York to cover an international yacht race. Unable to return by train and still meet the required deadline, a resourceful editor determined that the completed material might be slipped into a capsule and flown by carrier pigeon back to the *Ledger*.

And Sloan was assigned to an abandoned Coast Guard station, in order to cover a rescue along the Jersey coast. After dozing off during what was to have been an all-night vigil, he and a fellow reporter awoke the next morning to find themselves half buried by a snowdrift which filled the room. By the time they dug themselves out, the rescue had been accomplished.

No Philadelphia paper included a news photographer on its staff in the early 1890's; photographs were merely submitted by free-lance agents. But within a decade the papers began sporting regular staff cameramen, even though for some years artists were still assigned to important events in case the photographer drew a blank. On one such occasion, Sloan had to cover a football game in New York City. Having virtually no understanding of the contest, he let the staff photographer do his bit and trusted to luck that the negatives would come out. Fortunately, they did.

Sometimes the scene of action was too far removed, and the drawings were based upon photographs or the imagination. The great land grab at the opening of the Cherokee Strip and the Klondike gold rush are typical of the exciting stories depicted by these young artists who had never ventured west of the Ohio River. Similarly, during the Spanish-American War, composite pictures of Manila Bay and other important locations were fabricated, and the newspaper artists often made drawings in advance that could not be used because a particular battle did not materialize.

For a decade — the decade from 1890 to 1900 — the artist-reporter was in vogue. Ten short years saw the rise and fall of a profession, one which necessity brought into being and invention erased from the American scene.

CHAPTER SIX

WHEN Everett Shinn joined the *Philadelphia Press* in the fall of 1893, he was not yet acquainted with the newspaper artists with whom he would be associated in the production of *Twillbe* the following year. Attending the Academy by day meant being assigned, except for Saturdays, to the newspaper's graveyard shift. This virtual isolation left little opportunity for fraternization with artists on competing papers, little chance to discover Glackens or Gruger working full-time on the *Ledger* or Sloan laboring by day on the *Inquirer*.

Having found commuting between Woodstown and Philadelphia impractical, Shinn had rented a one-room flat at Eighth and Chestnut, where he lived in seclusion, unaware of the companionship available at Robert Henri's studio just two blocks away. At seventeen, Everett Shinn's life was a lonely one.

Then one day a high-spirited, felicitous fellow joined the staff of the *Press* just after the first of the year and approached young Everett with an offer of sharing living quarters. Shinn eagerly accepted. Never again was he to know solitude, for his new roommate was a crowd of fun, rolled into one. His name: George Benjamin Luks.

When Shinn moved to the new living quarters on Girard Avenue, he could not possibly have anticipated the hours of side-splitting laughter which Luks would provide. Life, to Luks, was a game, a play, a bluff. It was merely a medium for disguise. Luks tried to avoid coming face to face with its realities; instead, he skirted them or ignored them completely.

Everett Shinn was no match for Luks except in size, for at five feet, five and one half inches, Luks' height was unpretentious. But his antics and mode of dress more than compensated for the lack of stature.

LUKS: Self Portrait, 1893. Hirshhorn Museum and Sculpture Garden, Smithsonian Institution

Even Everett's loud silk shirts were no challenge for George Luks' fantastic getup, which included trousers sheared away just below the knees in conformity with the "peg tops" of the Parisian Latin Quarter.

"In those days at the Philadelphia Press Art Department," Shinn explained, "Luks' clothes were shadow plaids of huge dimensions, the latest word in

suburban realty maps. Little alteration was attempted on his coats. Vests, however, were featured, cream-colored corduroy, like doormats laid out in strips of a hawser's thickness, or bark-stripped logs on a frontier fort stockade. A flowing black tie like a soot-dyed palm tree splayed out under his high and immaculately clean minstrel collar. A bowler, usually black, tilted in a cockey slant over his blond hair. Once he wore a white one with a black band; this one he might have found at a race track."[42]

Luks was a great actor, and his interminable entertainment did not depend upon flashy wearing apparel. He would rouse Shinn out of a sound sleep in order to provide an audience for his early-morning performance of soaping the bathroom mirror with his shaving brush, then carefully scraping the lather from his reflection, revealing stroke by stroke his un-shaved face.

One morning Shinn was awakened with a start by a bellowing voice. "Heavy-eyed, I staggered to the bathroom door," Shinn recalled. "Luks' silky blond head was slowly emerging from the depths of the tub. Gripping the bathtub rim, Luks yelled, 'Captain Rufus Mizzen, you mistook your man this time. Little did you know when you read the burial service over me that I was alive. Ha ha, alive! Ha ha, for the past month I have lived on the barnacles on the hull of this slave ship. I have come up to tell you that I have fastened the rudder so that you will sail in a circle to the end of your days. Ha Ha!' And he went under again."[43]

On the *Press* there was no cessation to George Luks' jocular activities. Once art editor Frank Crane came storming up to Luks' drawing table waving a still-wet piece of his artwork.

"See here, Luks, what ya' mean, done?" Crane questioned, pointing a quivering finger toward the middle of his drawing of a crowded courtroom. "That's the judge, his eyes are closed. He hasn't any eyes."

"His eyes were closed during the trial," George responded.

"Won't do, Luks; won't do."

"Sorry, Crane; that's justice."

"But this is not a cartoon."

"It's me," snapped Luks, "and I'm literal."[44]

Grabbing hold of a pen, Crane dotted the eyes

himself and rushed to the photo-engraving room with the artwork. Luks leaned back and laughed; then turning to the disbelieving Shinn, he surmised: "I don't think the judge was in the court room anyway. I'll lay ten dollars that it was a dummy of the judge on the bench. Sure, he was off playing golf. Sure, his eyes were closed. Wax eyelids melted in the lawyer's hot arguments. His Honor's face is in the cuspidor by now."[45]

George Benjamin Luks had already become a legend at the age of twenty-six. Born, as only he could so colorfully relate, "just about the time our god-damn Congress was trying to bash Andy Johnson out of office,"[46] Luks spent his childhood among the coal miners in the east-central Pennsylvania town of Shenandoah. Despite this uncultured environment, young George was reared amid a family of individualists who showed remarkable talent in the arts: Anna, the eldest child, became a singer in Lillian Russell's company; brother Leo's career was that of an orchestra violinist; and brother Will wrote sonnets and songs and sang, before becoming superintendent of a New York out-patient clinic.

George himself had an adolescent fling at the stage. Teaming up with Will as a vaudeville act billed as "Buzzy and Anstock," George developed his witty gift-for-gab while Will accompanied him with song and guitar. Willowy Will Luks, quite tall and thin, contrasted comically with his short and stocky brother George to form the forerunner of the Mutt and Jeff or Laurel and Hardy teams.

The Luks boys had just launched their budding stage career in Philadelphia when in November, 1883, fire swept Shenandoah, Pennsylvania, and the would-be actors returned home to assist in rebuilding the family fortune. Their short-lived vaudeville careers squelched, Will succumbed to his father's professional predilection and went off to medical school, while George, being encouraged by a maternal inclination for art (his cultured mother dabbled in paint, and boasted of her descendency from Peter Geroux, the copperplate artist), decided upon painting as a career.

So off to Philadelphia, then Europe for ten mysterious years in which George Luks lived the life of leisure, often forsaking the study of art for the art of

drinking. The decade of supposed art schooling, like much of his life, is steeped in invention and falsehood. In 1884 he is said to have enrolled at the Pennsylvania Academy, yet his entrance and exit are a mystery. Then to Düsseldorf, where he roomed with a distant relative, a retired lion tamer, and put in an occasional appearance at the academy there. Next, Munich, where he was welcomed into the home of his mother's half sister. Then, moving on to Paris, he resided at the American Art Association. Finally, in London, he stayed with his father's family.

Ten years as if but a day, shrouded in secrecy and obscured for all time. Back to Philadelphia and the sudden emergence of a mellowed Falstaff upon the art staff of the local press. Ten years had vanished and were neatly summed up in typical Luksian fashion: he simply stated that he had studied under "Lowenstein, Jensen, Gambrinus, and some Frenchmen, from whom I never learned anything, always excepting Renoir, who is great any way you look at him."[47]

By the fall of 1894, George Luks and Everett Shinn had learned of Robert Henri's Tuesday evenings, and were attending an occasional serious session. But they never missed the parties, and once there, Luks was an immediate success. Soon no evening was complete without a performance by George Luks, who would stand on a box and mimic each man in the room.

George became a sort of mascot, to be paraded about by his friends or to perform at the drop of a hat, a kind of Peck's bad boy whose audience would wait with eager anticipation to observe the kind of mischief he would come up with this time. One evening he would carry on a continuous line of jibberish while preparing Welsh rarebit, waving a frying pan over a gas jet and splashing the cheesy, greasy mess over everything. Another night he was adept at imitations, pretending to be a sly villain or Virtue triumphant, a berry picker or a person in flight across the frozen surface of a pond. "His escape on the treacherous ice," observed an admiring Shinn, "was achieved by buckling his knees and fanning the air for tree branches that were not there. So great was his pantomimic power that he actually seemed to be breaking through into frigid water. There was a marked difference between a precarious balance and this scene of a precipitous ducking. Luks was subtle in a loud way."[48]

The favorite role of all his performances involved a fictional fracas in the boxing ring. It began as a mock battle, staged during one of the 806 parties for the benefit of an amateur photographer. Luks, stripped to the waist and crouching low like a sparring pugilist, had donned boxing gloves for the first and only time. Yet the buffoonery in George enjoyed the role. A good Irish jigger and light on his feet, he was soon bobbing and weaving on the streets and in bars.

In his various pugilistic impersonations, he assumed the guise of a number of euphonious phonies: Lusty Luks, Socko Sam, Curtain Conway, and Monk-the-Morgue; all were harmless George, whose dancing blue eyes betrayed his clenched fists and scowling brow each time he expanded his ring career.

George Luks' imaginative boxing successes did not stop at the amateur level. Once he tapped a light jab to Sloan's shoulder and queried, "John, did I ever tell you about the time I licked Fitzsimmons?"

Sloan smiled, then sought the twinkle in Luks' eyes. "Since when have they put Fitzsimmons on a postage stamp?" Sloan quipped.[49] An unmistakable sign of disappointment enveloped the would-be fighter's face, for George was all prepared to vividly describe his crushing defeat of the then-world's heavyweight champion.

Though Luks was stymied in his efforts to convince his associates that he was the bruising boxer he claimed to be, his straight-faced presentation of his ring exploits was taken at face value by many. When his name began to appear periodically in print, it was not unusual to read of "Chicago Whitey," under which nom de guerre Luks fought some 150 battles in the prize ring during his student days,"[50] or that Lusty Luks was the former holder of the light-heavyweight crown. His embarrassed friends hesitated to set the record straight at the time, fearful of hurting poor George's tender feelings.

The acting was virtually flawless, but John Sloan eventually revealed the truth, bursting the bubble which boasting had built. "Luks wasn't really anything of a fighter. He would often pick a fight in a saloon, say something nasty and get things going and then leave the place, with people who had nothing to do with the argument left to finish the fracas."[51]

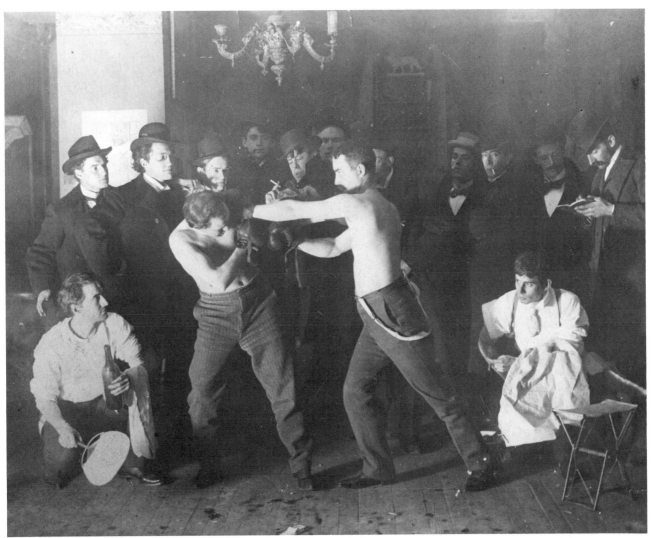

A mock boxing match photographed in 1895 at 806 Walnut Street. Standing, from left: James Preston, John Sloan, Everett Shinn and F. R. Gruger (holding cigarette). ''Boxer'' on the left is George Luks.

If fabrication and bombastic bragging were Luks' most sinful traits, then excessive drinking certainly ran a close second. By the time he had acquired an art position on the *Philadelphia Press*, continual imbibing of beer and liquor was an integral part of his baccha- nalian nature. Luks had an early start in this direction in Shenandoah, where, at the tender age of sixteen, he had lost a drugstore job twenty-four hours after his initial employment because he was found drunk behind the counter. ''George spotted a barrel of cider and got pie-eyed,'' brother Will revealed. ''It cost Dad five dollars for the cider.'' It cost George his job.[52]

The carousing Luks was intolerant toward teeto- talers. ''Shinn,'' he would say to his non-drinking roommate, ''you've got a hell of a lot of promise, but you'll never make the grade. And why won't you? You don't drink. That's sad. Licker does it, licker and nothing else . . .''[53]

Conveniently for Lusty Luks, O'Malley's Bar was suitably situated just across the street from the *Press*

building. With almost daily regularity, a reluctant Shinn would enter its distasteful confines and seek out his inebriated friend. One drink, and George Luks was ripe to cross the line into a world of complete fantasy. With vivid authenticity, Shinn noted how "his rumbling advance along a bar rail was like a tank rolling on with a child at the wheel and all guns popping cork."[54] For George Luks, existence was painless and wonderful.

For nearly two years now Everett Shinn and William Glackens had been shuttling back and forth between the *Press,* the *Ledger,* and the *Inquirer,* often, as Shinn proudly observed, at hikes in pay. "Glackens and I drew very quickly and they kept us busy no matter how much we turned out," Shinn revealed. "By being fired back and forth between two papers, I got a dollar raise each time until I was up to eighteen dollars a week."[55]

John Sloan, on the other hand, had not budged from the staff of the *Inquirer,* although having forsaken the excitement of the artist-reporter. "The art editor soon discovered I didn't have the speed necessary to cover spot news like fires and accidents," Sloan confessed, "so most of my work was done for the Sunday Supplement. This consisted of illustrating stories and making decorative tail-pieces and spots."[56]

By mid-1895, the *Philadelphia Press* art staff could boast of the talents of Glackens, Shinn, and Luks. However, by the time the trio convinced John Sloan to leave his perch on the *Inquirer* in favor of the *Press,* Shinn had once more moved back to the *Inquirer,* while Luks cast his lot with the *Evening Bulletin.* Although the four were never employed by the *Press* simultaneously, its fifth floor domain became their rendezvous.

"It is not hard to recall the *Press* 'art department,' " Sloan once reminisced, "a dusty room with windows on Chestnut and Seventh streets — walls plastered with caricatures of our friends and ourselves, a worn board floor, old chairs and tables close together, 'No Smoking' signs and a heavy odor of tobacco, and Democrats (as the roaches were called in this Republican stronghold) crawling everywhere."[57]

No matter what paper the artist-reporters served, spare time between assignments found them emerging from their various roosts and converging

upon the *Press's* twelve-man art department. A usually sizable crowd would loll around, conversing or reading books, which they would circulate among themselves. The newspapermen were easy prey for a host of volume-a-month book salesmen, whose fast-talking sales pitches would keep the artists paying on several sets at a time.

"We felt a natural kinship with Poe," Shinn recalled, "because he also observed what people did around him."[58] Yet while the bulk of the newspapermen read the realist writers, contrary George Luks would center his attention on volumes of the *Ingoldsby Legends* and *Tristram Shandy.*

The very presence of the entertaining Luks assured a daily diversion in the art department of the *Press.* Invariably loud in speech and dress, he would herald his own approach and proceed to produce the unexpected. One day upon entering, Luks impersonated the deafening staccato blast of a trumpet, then softly repeated the musical run in faraway, muted sounds. George gazed at the row of puzzled faces. "The band at the end of the pier in Atlantic City," he explained. "Get it? It's a hell of a way out on the pier . . . it's the wind . . . get it? Distance. Damned real, hey?"[59]

On another occasion an apparently serious Luks ushered a companion into the crowded art room and proceeded to introduce him as "My old friend, Charles Dana Gibson." The laboring artists, bowed low over their drawing boards, looked up in unison to gaze upon this fashionable artist whose stylish, wasp-waisted American women had already assumed their place of honor on the center spreads of *Harper's Weekly.* Halfway through the performance, Luks' accomplice revealed his identity as a hoax when he turned to his friend and asked, "What did I do, George, that wasn't right?" Ignoring the inappropriateness of the question, Luks turned to the aroused group and confided: "Tomorrow, Rembrandt."[60]

The newspapermen were always full of mischief, eagerly welcoming the arrival of each newcomer to the staff as an opportunity to reveal their collection of tricks. Any neophyte, for instance, who made the mistake of leaving his pen-and-ink drawings unguarded would return to find an empty, overturned bottle of ink and a ruinous ink blot covering his art-

work. The distraught beginner experienced a few uncomfortable moments before careful scrutiny revealed the blot of ink as only a harmless piece of irregularly cut black paper.

As an added pastime to pranks and masquerades, the artist-reporters played games aimed at training their memories. Constantly confronted with the task of sharpening their sponge-like minds in order to absorb and store details of every possible variety, the artists repeatedly tested one another, using the routines they had discovered in Lecoq de Boisbaudran's book, *Training of the Memory in Art.*

"Glack, I'll give you five minutes to go into that room and tell us what's on the west wall," Shinn would challenge. When time was up Glackens emerged, ready to astound his colleagues by systematically rattling off even the most minutely detailed objects. "Guess how many steps there are from here to there?" one of the group demanded. "How many tables are in the next room?" Again and again an observant Glackens quietly uttered the answers with consistent accuracy, a feat which gained him the title "the photographic mind most likely to succeed."[61]

Often the artist-reporters would congregate outside of the *Press* to engage in another favorite pastime, that of walking behind a stranger in an effort to observe the characteristics of his movement. Camera-like eyes would register the shuffle of trousers, the swing of an arm, or the twist and turn of a body — a memory test which served as a practical study of anatomy.

For the newspaper artists, these spare-time diversions were great sport, like "college days, all the fun and no examinations," as John Sloan once put it.[62] But they also represented a remarkable schooling for men who would spend the rest of their lives recording, first on paper, then on canvas, the realities of the everyday American scene.

CHAPTER SEVEN

UNLIKE THE newspaper artists who learned anatomy through daily observation, Robert Henri was engaged in the study of the human form in a somewhat less-creative manner.

In the fall of 1892, Henri had been offered a teaching position at Philadelphia's School of Design for Women, where he was to instruct classes in anatomy, portraiture, and drawing from the antique. In order to strengthen his own schooling in these areas, Henri enrolled at the Pennsylvania Academy with Robert Vonnoh, a newly appointed instructor in portrait and figure drawing.

Responding in earnest to Vonnoh's demand for quick and unlabored artwork, Henri found himself overcoming the apparent weakness for meticulous drawing which had plagued him since his undergraduate days at the Academy. During his two-year association with Vonnoh, he proceeded to draw and paint the figure with a certain sureness and dash that recalled the inspiring Montenards viewed in Marseilles, and Alexander Harrison's shimmering nudes seen at Concarneau.

But Henri's newly-acquired technical facility in his own art found little chance for application in his teaching at the Women's School of Design. A glance at the school catalogue convinced him that progress played no part in the courses offered. First-year students were encouraged to travel the road of dilettantism, being exposed to drawing fruit and flowers from plaster casts and evolving tight, geometric designs. "The admirable and extensive collection of statues and busts, cast from the best specimens of Greek, Roman, and Renaissance Sculpture, offers great advantages for the study of the antique," the girls were properly informed.[63] And even the realities of the life

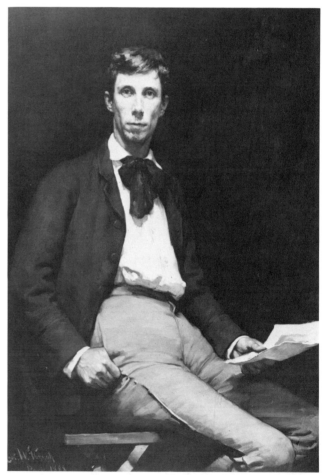

VONNOH: *Companion of the Studio* The Pennsylvania Academy of the Fine Arts

class were refused to the two hundred sheltered females who were given no opportunity to gaze upon an unclothed model.

But all this was soon to change. Besides Henri,

60

VONNOH: *November*, 1890.

Courtesy of The Pennsylvania Academy of The Fine Arts

the teaching staff now included three former Eakins students who had begun transmitting their master's inspirational methods. An outdoor sketch class was a recent addition to the curriculum, and under Henri's direction the girls discovered light, color, and sunshine. "I remember going on an excursion with a group of girls with Henri as our instructor," remarked Harriet Sartain, whose aunt was then principal of the school. "There was a real estate development in Avalon and the promotion of this resort as a fine spot for sketching was extolled. We went down for the day and sketched on the beach with all looking on."[64]

Henri became a sort of public relations man for the school, bringing the outside world into its protected life. In the fall of 1893 he arranged to have Beisen Kubota, the Japanese art commissioner to the

Chicago World's Fair, visit the school. Kubota made large, free-hand brush-and-ink drawings from memory before the assembled student body, impressing the girls with "the power an artist gains through training his memory so that the artistic thought can be expressed freely."[65] The stimulating effect of his demonstration was felt for many semesters to come.

Before Kubota's departure from the city, Henri introduced him to John Sloan, whose first newspaper drawings the year before had already shown signs of a developing two-dimensional oriental style. Sloan was immediately moved by Kubota's sketchbook of brush-and-ink drawings, and soon the newspaper artist was carrying a bottle of ink in his pocket, making heavy-lined sketches in the oriental manner. Sloan had already decked his studio walls with Japanese prints, and had saved a copy of the *Press* which con-

tained a full page of them. By mid-1894 his flat-pattern, black-and-white-style newspaper illustrations were being well received.

Henri, too, found oriental art to his liking; in fact, so had Édouard Manet and the Impressionists when Japanese art had first come to their attention in the 1860's. Although it was the dynamic balance and flat patterns of Japanese prints which appealed to the Impressionists and influenced Sloan's newspaper illustrations, the attraction to Robert Henri was primarily one of decoration, prompting him to adorn his studio with several Japanese lanterns and similar trappings.

In the summer of 1894, Henri subleased the studio at 806 Walnut Street to Sloan and Joe Laub while he made another trip to France. When Henri returned in the fall the trio shared living quarters and studio space. Then, when the cramped accommodations proved unsatisfactory, Henri moved in with Glackens.

This arrangement appeared to be perfect. With Henri teaching mornings at the Women's School of Design and Glackens occupied on the *Press* in the afternoons, the availability of working space was ideal. Yet Henri was unable to make use of it. With an exhausting routine of teaching and studying, he had little time left to paint. Henri discontinued his classes with Robert Vonnoh at the Academy in an effort to lighten his work load. Still, by the spring of 1895, he was spending five mornings a week at the School of Design teaching anatomy, composition, drawing from the antique, and portrait painting from life.

Robert Henri was tired. In May, he taught his last classes at the Women's School, declined to instruct summer courses there, and decided to head for Paris. His decision was made to coincide with the plans of Charles Grafly, who was also resigning his teaching position at the Pennsylvania Academy in anticipation of a June wedding and setting up housekeeping in the French capital.

Henri left for Paris with Glackens in tow, and once there, the two continued to share studio and living space for nearly a year. Within the first few days they visited the Passage des Panoramas, l'Académie Julian. Glackens had acquired from Henri a profound disdain for the school, so neither registered. Following the pattern set by Henri in his stu-

dent days, the two roamed the museums in preference to formal art training. Henri gazed longingly at his favorites, the *Olympia* and *The Balcony*, and Glackens seemed in complete agreement that Manet was the greatest French artist of the nineteenth century.

A nightly rendezvous took place in the Graflys' quaint little home, which had once served as part of the servants' quarters for the Luxembourg Palace. There the artists would argue art and religion, sometimes pitting the Bible against Thomas Paine's *Age of Reason,* or discuss volumes of Tolstoi, Hamlin Garland, and Emerson, books which Henri's mother had sent him from Wanamaker's.

During the day Glackens and Henri walked aimlessly through the streets and parks of Paris in search of subject matter. Often they were joined by James Wilson Morrice, a Canadian who had recently abandoned his studies at l'Académie Julian, and together the three went sketching about Paris and the neighboring countryside.

In August, Henri and Glackens cycled through Holland and Belgium, drawing as they went. In Amsterdam they viewed the work of Rembrandt and Hals, then dispatched a set of reproductions of Rembrandt prints to their stay-at-home confrere, John Sloan. Sloan was quick to acknowledge the gift, and equally quick to report his solitude: "There is a dullness in the Artistic Atmosphere which, while making me feel damned lonely, is to yourself and Glack flattering to an immense degree. . . . If I don't have some companionships damned if I don't think I'll be driven to marriage."[66]

Three months later, and still single, Sloan wrote: "I wish it were possible for me to follow your footsteps to Paris and accept the 'shakedown' you so kindly offer."[67] Although Sloan sorely missed the association of Henri and Glackens, his existence in Philadelphia was anything but lonely now. Still residing at 806, Sloan had continued the Tuesday evenings inaugurated by Henri. Gone, however, was the intellectual tone and peaceful contemplation, and in its place was one rowdy, boisterous party after another.

In a letter to Henri just before Christmas, 1895, Sloan described the regular weekly "orchestra" tuning up, picturing himself scraping an umbrella across an easel in imitation of a bass viol, Jimmy Preston

strumming a broken guitar, Shinn using two tin plates for cymbals, Davis playing the ocarina, and George Luks bellowing into a conch shell.

Luks was his usual, uproarious self, imitating every living man, bird, and beast, and winding up with a side-splitting discourse on gambling. As a grand finale, Luks dramatically announced his almost immediate departure from this haven of hilarity for the island of Cuba. And his paper, the *Evening Bulletin*, was to foot the bill.

For once Luks spoke the truth. Cuba's long-smoldering internal strife had flared into open revolt, and the *Evening Bulletin* was dispatching him with its correspondent, Maurice O'Leary, whose stories Luks was to illustrate. By Christmas the two were on their way, and by mid-January Luks' first sketches were reproduced. Soon war drawings by George Luks appeared at regular intervals, occasionally occupying a double column on the front page of the *Evening Bulletin*. Twenty-nine such sketches were reproduced in all, some hasty pen-and-ink drawings, some incorporating soft, shaded tones of wash.

George's war coverage was termed "Sensational!" by the newspaper artists back home, who daily scanned the pages of the *Evening Bulletin* in hopes of perceiving another Luks scoop. But the crafty Luks was up to his old tricks. While his drawings looked convincing enough, in reality he was seeing the Cuban uprising through the haze of smoke-filled barrooms. From the relative safety of Havana, Luks would listen to dramatic descriptions of the fighting, then create the episodes in visual terms.

The results were astounding. One reproduced drawing carried this caption: "An insurgent scout has been overtaken by Spanish troops in a rocky defile near Guara. They fire upon him, and *The Bulletin* artist in Cuba sketches him as he falls from the saddle." But Luks had been nowhere near the scene of the shooting.

The artist's courageous coverage was a bluff. His timidity had already been displayed in the company of war correspondents Stephen Crane and Richard Harding Davis, who were also in Cuba to cover the uprising. Along with other newspapermen, they had been rolling along in a rickety train when an abrupt volley of gunfire burst out far in the distance. Luks reacted automatically by diving under his seat, then

LUKS: Drawing in the *Philadelphia Evening Bulletin*, February, 1896. Caption: *In Hot Pursuit of a Scout—An insurgent scout has been overtaken by Spanish troops in a rocky defile near Guara. They fire upon him, and* The Bulletin *artist in Cuba sketches him as he falls from the saddle.*

looked up to see the others unmoved. "You fellows sit up there," he challenged. "I have a future."[68]

By the end of March, the steady flow of Luks' drawings ceased to appear in the *Evening Bulletin*. Word began to filter back to his friends in Philadelphia that he had been fired for drunkenness and failure to forward his work regularly. Luks naturally made no mention of this in his elaborately-illustrated letters to former roommate Everett Shinn. He did,

however, shed some light on the whereabouts of an expensive pipe which Shinn had been missing ever since war artist Luks had left for Cuba.

"In one letter," Shinn recalled, "Luks had depicted himself in a tent with General Garcia. My pipe is in the General's mouth. In a balloon of smoke over the rebel leader's head, there is a caption reading, 'Pass George Luks anywhere he wants to go and give him the key to Cuba.' "[69]

In April the *Evening Bulletin* reported the capture of correspondent O'Leary, together with an artist named Dawley of *Harper's Weekly.* There was no reference to George Luks, who had already been dropped from the employ of the *Evening Bulletin.* A week later O'Leary was reported released.

When Luks heard the news of his former companion's fate, he seized upon the idea for his own graceful exit from Cuba. He circulated the fable of his supposed imprisonment and brush with death. "The Spiggoties slammed me in the cooler," Luks vividly revealed, "put me away with the rats and the Cubans and deliberated whether to shoot me at dawn or sundown."[70]

With the story of his escape properly planned, Luks accepted his impending deportation from Cuba. Perhaps during his routine voyage back to New York he recalled the oft-forgotten advice of his father, who had said, "Be honest with yourself," for on the back cover of one of his numerous sketchbooks Luks knowingly scrawled:

> And he that doth one fault at first,
> And lies to hide it, Makes it two.[71]

Luks landed in New York one evening in April, cold, hungry, and broke. Wearing a linen suit and a battered straw hat, he spent the chilly night sleeping on a park bench, then embarked on a new career in the morning when he sought employment with the *New York World.*

It was a confident though unpresentable Luks who gained audience with Arthur Brisbane, the paper's managing editor. Brisbane and Luks were not total strangers. They had met briefly on board a ship two years before, when Luks was returning from his decade of lavish living on the Continent. With the casualness of a passer-by, Brisbane had suggested to the art student that he turn to illustration as a means of livelihood, in preference to the painter's plight of

starving in an ivory tower. Now the brazen Luks reminded Brisbane of his advice. He got a job.

Luks was added to the art staff of the *New York World* at a time when William Randolph Hearst and Joseph Pulitzer were firing the initial volleys of what was soon to become a full-scale journalistic war. Hearst had invaded the New York newspaper field when he purchased the failing *Morning Journal* toward the end of 1895. In an attempt to gain circulation supremacy, Hearst lured some of Pulitzer's top writers away from the *World,* and soon the papers were copying each others' stories in an effort to prevent being scooped. Once the *World* reprinted a *Journal* bulletin reporting the death of one "Reflipe W. Thanuz." The next day a jubilant *Journal* exposed its competition by revealing that "Reflipe W." is "we pilfer" spelled backwards, and "Thanuz" the phonetic spelling for "the news."

Joseph Pulitzer's *New York World* had introduced the comic colored supplement just two months before George Luks joined the staff. Although at first it appeared in only black and one other color, this was sufficient to hint at its possibilities. From the outset the star attraction of the *World's* "funnies" was a yellow-nightgowned infant whose humorous prototype had been discovered in an almanac by Mrs. Pulitzer. Her husband designated staff artist Richard Felton Outcault to develop a series of amusing adventures around the youngster, and the resulting character, dubbed *The Yellow Kid,* became a celebrity overnight.

Soon Hearst cast his covetous eye toward the popular comic strip, with the result that he persuaded Outcault to join his organization. When *The Yellow Kid* began suddenly to appear on the pages of Hearst's *Journal,* George Luks was called upon to draw a competing *Yellow Kid* for the *World.* For a number of years the cartoon character led an exciting double life, while the continuing rivalry between the two papers in their quest for sensational news became popularly known as "yellow journalism."

Luks met with immediate success as Outcault's replacement. He was referred to as the "premier humorist artist" on Pulitzer's paper, drawing and entertaining with equal finesse. One staff artist recalled how

> . . . once he pictured for me, on the margin of the drawing, the huge salary he was receiving for his

work. While his right hand was busily engaged building up one of the characters in the full-page drawing, his left hand drew accurately barrel after barrel piled high up the left margin in pyramidal form labeled with dollar signs. Barrel upon barrel piled higher reaching the top edge of the paper. Then over and down as his arms crossed while still more barrels fell on the right hand margin. Not mere scratches of his pencil but any one of them good enough for a Bock Beer advertisement. When the barrels could fall no further he shifted his hand and signed his name as the right hand traced a plaid vest on the Yellow Kid.[72]

When Arthur Brisbane tired of such pretentious demonstrations, he would solemnly advise Luks to "cut out the smeary genius." Yet jest as he might, Luks now took a practical view toward his job. Acknowledging Brisbane's early advice, Luks stated: "I have utterly no patience with the fellows whose style is 'ruined' if they must make drawings for newspapers or advertisements, whose 'art is prostituted' if they must use it to get daily bread. Any style that can be hurt, any art that can be smirched by such experiences is not worth keeping clean. Making commercial drawings, and especially doing newspaper work, gives an artist unlimited experience, teaches him life, brings him out. If it doesn't, there was nothing in him to bring out, that's all."[73]

LUKS: *Hogan's Alley* comic strip, featuring the Yellow Kid. *New York World*, October 11, 1896.

CHAPTER EIGHT

BY EARLY WINTER, 1897, William Glackens and Everett Shinn had joined George Luks on the art staff of the *New York World*. Glackens had come to the *World* directly from Paris, where Luks' assurance of a position on the Sunday supplement seemed inviting to an unemployed artist. Everett Shinn, on the other hand, had to be lured away from the *Philadelphia Press*.

By 1897 Hearst's raids upon the staff of the *New York World* had forced Joseph Pulitzer to search for talent elsewhere. Often his scouts were required to travel to Philadelphia to seek out and sign up likely prospects. Luks informed his superiors of Shinn's availability if additional pay were forthcoming. As it developed, a three-dollar-a-week raise proved sufficient inducement for Shinn to leave the *Press*.

Luks and Glackens were rooming together when Shinn arrived in New York, so the newcomer settled in a flat by himself. Somehow he missed seeing the two during his first day on the paper, but on the second morning a jubilant Shinn encountered George Luks on his way to work. The chance meeting was unforgettable. As Shinn related:

> The instant we were close enough for recognition, he started one of his hilariously amusing impromptu melodramas. I braced myself against the wind and snow and felt the tears that came from laughing freeze on my cheeks. Luks, in the full flight of his exciting presentation, was frantically lashing an imaginary string of straining, wallowing huskies while he held fast to a careening dog sled.
>
> Under his power of suggestion Lexington Avenue took on the endless waste of the Yukon. Luks, with exaggerated desperation, pushed ahead, cracking his whip, answering its stinging lash with the huskies' growl of servile resentment. His hands shielded his eyes; he peered anxiously into the white world that encased him. He rode his sled, guided it through nar-

row defiles, lost its security and caught up with it again. "Mush! Mush!" he yelled.

> Suddenly he stopped, staggered, and went to his knees. Luks peered over the gutter's edge looking down. He shuddered, then whispered, "Two thousand feet." Then leaping across the sidewalk he pressed his nose close to a fish market's window where huge salmon flashed their silver sides. He cried, "The seal fisheries! Puget Sound! I must be getting close to the post." He then shifted his gaze to another window that held a shoulder of roast beef. "Ha, at last! The stockyards. I'm on the outskirts of Chicago."
>
> Then, on his feet again, thrashing the floundering dogs, he staggered across the sidewalk and straightened his body in a stiff salute in front of a dentist sign with a gigantic set of false teeth. "Captain Lancaster, Sergeant Hawkins reporting." Luks then slumped in a rubbery quiver, a travesty of superhumanly sustained endeavor. Quickly he turned his back on the dentist sign and quietly stroked a mustache that seemed to have suddenly grown from his clean upper lip. Then, in another voice, precise in an English accent, sharp with authority, "Sergeant Hawkins, the Northwest Mounted Police can well be proud of you. Wounded and alone you have brought back the stolen pelts."
>
> Luks staggered and clutched his side. "I'm done in, Captain Lancaster. Done . . . done . . . diddy done, done, done, done, done." He sang the last and fell on his face in the gutter.[74]

For a short time Luks, Glackens, and Shinn worked side by side on the *New York World*, reliving the days of pun and fun on the *Press* in Philadelphia. But when Glackens tired of the comparative tranquility of cartoon work, he moved over to the *New York Herald* to become an artist-reporter once more.

Glackens had but one interest — his art — and he was happiest when he was drawing. A perfectionist by his companions' standards, he would often redraw a sketch eight, twelve, even twenty times

BOY AND GIRL MILLIONAIRES INTERVIEWED.

Harry Payne Whitney, Who Is Going to Marry Miss Vanderbilt, Is Chiefly Noted for His Devotion to Outdoor Sports---Miss Helen Gould, the Great Heiress, Is an Enthusiastic Bicyclist.

HARRY PAYNE WHITNEY AND HIS CHIEF INTERESTS IN LIFE.

MRS. EDWIN GOULD ON HER WHEEL. MISS HELEN GOULD.

LUKS: Drawing for *The New York World,* June 21, 1896.

until it measured up to his strict, personal standards. Even so, the industrious Glackens found the rapid newspaper pace beginning to slacken. He became cognizant of the fact that the artist-reporter's days were numbered. The *Herald* had already reproduced the first newspaper illustrations from photographs, and it was only a matter of time before the camera would replace the artist-reporter entirely.

With an increasing amount of leisure time, Glackens began accepting free-lance assignments with *McClure's Magazine.* One of his first commissions involved seventeen illustrations for Rudyard Kipling's *Slaves of the Lamp.* The sparkling drawings were reproduced and drew the unanimous praise of his companions. But the art editor of *McClure's* complained. The illustrations were evoking numerous protests from subscribers. They were not sweet enough, Glackens was told — too original, too fresh, too amusing.

Yet a possible change in Glackens' style or approach to his subjects proved to be unnecessary. Just a few weeks later, on February 15, 1898, the Battleship *Maine* was blown up in Havana Harbor, taking

two hundred and sixty-six crewmen to their watery grave. Americans clamored for war. Lapel buttons, reflecting their incensed emotions, carried the slogan: "Remember the *Maine,* to hell with Spain!" And *McClure's,* acting with dispatch, designated Glackens as its special artist to the front.

William Glackens left immediately for Florida by train. There he made his first pen-and-ink drawings of an Arizona contingent arriving at Tampa, recording with realism the gentle humor of American volunteers sporting ten-gallon hats and low-slung holsters.

Glackens' instructions were to proceed to Cuba as quickly as possible. With an army of correspondents, he landed at Daiquiri, only to find that no arrangements had been made for his housing or sustenance. Glackens soon grew weak from a fruitless search for food or friends. Finally he stumbled upon the *New York Herald's* mobile kitchen, where his former associates nourished him back to health.

Unlike George Luks, who had been content to draw the Cuban uprising from hearsay, Glackens insisted on making accurate on-the-spot sketches. July 1 found him in San Juan, recording with pen-and-ink

GLACKENS: Illustration for *Our War With Spain* by Richard H. Titherington. *Munsey's Magazine,* April, 1899.

Grimes' Battery firing the first gun of the attack on the Spanish position. Glackens dug in, prepared to sketch the entire battle. He witnessed the arrival of Lieutenant-Colonel Theodore Roosevelt and the First United States Volunteer Cavalry. He saw their attack stall at the foot of San Juan Hill. Just when the American assault appeared to be stymied, a Negro regiment began to charge and the Roosevelt Rough Riders were quick to follow. Glackens, who had reluctantly abandoned his sketching for the comparative safety of a prone position, raised his head long enough to shout "Cowards!" at Roosevelt's men, then stuck his face back in the mud.[75]

Glackens' accurate and authentic war sketches lost much of their timeliness when reproduced in a monthly magazine. Similar drawings, sent from the front to the big city newspapers, followed events in Cuba by one or two weeks. But periodicals like *McClure's* observed a more leisurely schedule. Seven of Glackens' pen-and-ink sketches, showing the first hours of the Armistice in July, were included in *McClure's* October issue. Others were reproduced in the December number, months after the peace had been signed.

When the Cuban War came to an abrupt close, a weary Glackens prepared for the tiring boat trip home. All his belongings had been stolen in Cuba and he had to appropriate whatever clothing he could find. By the time he embarked for New York his makeshift get-up included a Spanish lieutenant's soiled white coat and a sombrero. To make matters worse, Glackens had contracted malaria and was seriously ill on the return voyage. At one point he feared he was going blind. Yet to George Luks and Everett Shinn even a bedraggled Glackens looked the part of the conquering hero.

During the summer of Glackens' war reporting an irresolute John Sloan was prevailed upon to move to New York and join the art staff of the *Herald.* Sloan was persuaded to take the plunge by his friend Frank Crane, himself a *Herald* artist and formerly art editor of the *Philadelphia Press.* Sloan tried to adapt himself to the new situation but he found New York lonely and large. Except for Luks, Shinn, and Crane, John

GLACKENS: Drawing entitled *Skirmishers* for McClure's Magazine, 1898.

the time necessary to turn out slick newspaper work? . . . I feel more like an artist in Philadelphia."[76]

Sloan's feeling "more like an artist in Philadelphia" could not be attributed solely to his return to the *Press.* Upon his homecoming in October, 1898, he had rejoined Joe Laub and Jimmy Preston at 806, and by the end of the month he wrote Henri with pride: "I have been painting two or three mornings a week in a class which we ('The Press Gang') have started in the studio. . . ."[77]

John Sloan had been painting seriously for nearly a year now. He had been encouraged by Henri at a time when the two were sharing 806 Walnut Street. Henri had returned from two years in France and had started an art class at the studio similar to one he had conducted in Paris. Because Sloan's day on the *Press* did not begin until midafternoon he some-

Sloan knew no one in the big city. He soon began to long for more familiar surroundings, for his family and flock of friends in Philadelphia.

After an unhappy three-month trial he was ready to leave. Sloan's salary on the *New York Herald* amounted to fifty dollars a week. The *Press,* he learned, would take him back at forty-five dollars. Readily accepting the reduced pay, Sloan executed a hasty retreat to Philadelphia.

John Sloan sent word of the unpleasant experience to Robert Henri in Paris: "Don't think that I have been unable to hold my own in the Metropolis, or that I have returned once more to sleep the sleep of Philadelphia. I have returned by my own wish. . . ." Then, as if to substantiate his statement, Sloan added: "A newspaper artist on the *Herald,* the greatest paper in the world, don't know what work is compared to the artist on the *Press.* . . . The *Herald* likes work 'tickled up' and 'finished.' . . . The *Press* cannot give a man time to 'finish.' . . . Now if Sloan *must* do newspaper work is he not better off where he is the big frog in the little puddle and where he dare not take

GLACKENS: Drawing for *The Fight for Santiago,* McClure's Magazine, October 1898.

SLOAN: *East Entrance, City Hall, Philadelphia,* 1901. The Howald Collection. The Columbus Gallery of Fine Arts

times observed the class, and was soon dabbling with oil paints himself.

His initial efforts in oil were a dozen small canvases of girls' heads, done from the models who posed for the studio class. These first paintings resembled Henri's, which had gradually grown dark in tonality through the influence of Frans Hals, Rembrandt, and Manet. Although Sloan was never actually a pupil of Henri's, the teacher gave freely of his time and instilled confidence through informal criticisms. Henri's chief complaint was that Sloan did not work fast enough. Like the Impressionists, Henri sought spontaneity in his work, while the more methodical Sloan sought solidity. When Henri's efforts failed to speed the strokes of Sloan's sluggish paintbrush, he could only conclude that "Sloan" must be the past participle of "slow."

By the spring of 1898, Robert Henri had terminated his studio art class and married one of his students, a Philadelphia beauty named Linda Craige.

The Henris were honeymooning in Paris when Sloan returned to Philadelphia in October, following his three-month hitch on the *Herald*. Without access to the models of Henri's studio class, Sloan now turned to landscape instead.

Together with Joe Laub and Jimmy Preston, Sloan began painting the city. For his first subject he chose the picturesque flower bed behind Independence Hall, rendering the tulips in subdued tones. Then he proceeded to depict the Dock Street Market, the old Walnut Street Theatre, and a night scene of Philadelphia's Washington Square. Sloan's paintings, like the drawings of the artist-reporters, were done mostly from memory. He would return to the scene again and again to observe details, but the paintings were executed in the studio. There a shy and retiring Sloan felt secure from the penetrating glances of the curious.

At one time, five years earlier, John Sloan *had* painted out-of-doors. That was in 1893, the summer

of the Charcoal Club's sad demise, when he, Glackens, and Laub would journey by bike or trolley to the outskirts of Philadelphia. Surrounded as they were by summer's carpet of green, the boys had been able to create pleasant little water colors of the suburban landscape.

But now, by not painting the city out in the open, Sloan missed the effect of direct sunlight, with its power to bring shimmering radiance to even the most weather-beaten, soot-stained building. "We were opposed to Impressionism with its blue shadows and orange lights," he said, "because it seemed 'unreal.' . . ."[78] So Sloan stuck to a palette of light red, yellow ochre, blue, and black, "safe colors," as he called them, with "no danger of losing one's place."

In this way John Sloan, left to his own devices, began observing both the drabness and the beauty which surrounded him. Like the artist-reporter he had once aspired to be, Sloan recorded the familiar sights of everyday life. Now, without the pressure of daily deadlines, he enjoyed a new-found happiness in casually painting the city.

CHAPTER NINE

WHILE Robert Henri was honeymooning in Paris, John Sloan represented his chief contact with America. "Have you heard any news of Glackens? . . ." Henri wrote in the fall of 1898. "I should like to see the veteran himself and get him in a state to spin some of his war experiences. I can imagine Glack kicking for more hardtack and objecting to bullets riddling his paper as he sketches. . . . I am working awfully hard these days," Henri continued, "never worked more in my life — and well, I have hopes to accomplish something before the winter is over."[79]

During the decade since his first Paris paintings, Henri had gradually altered his technique. The early impressionistic landscapes were always light and bright, radiating with the dazzling effects of sunlight. Now his paintings displayed a fondness for chiaroscuro instead. Henri evolved networks of dark and light patterns in his work, creating striking contrasts with cast shadows from buildings and bridges by day and the bright lights of Paris by night. Figures often become simplified areas of dark, silhouetted against a backdrop of light. A sense of monumental calm dominates his scenes of Paris sidewalks after dark and the intimate confines of café terraces, thus suggesting the static counterpart of similar subjects by Édouard Manet.

At about this time Henri adopted the "soup" method of painting, as it was called, the technique employed by James McNeill Whistler. This approach involves a preparatory covering of the entire canvas with a neutral tone, then working the scene into it. By eliminating the pristine whiteness of the canvas from the outset, the artist can apply a minimum number of brush strokes, yet create the illusion of a spontaneously completed work of art.

This "soup" method caused Henri's skies to assume a darkened appearance. The sunny warmth of the heavens disappears from his canvases and is replaced by a continually overcast grayness. The previous whiteness and brightness of new-fallen snow acquires the drabness of long-standing slush.

During the following year the Henris stayed on in Paris. They spent much of their time with Charles Grafly and his wife, who still resided there, and the Edward Redfields, who lived at Alford on the outskirts of Paris. It was like old times again. Robert and Linda Henri would visit the Redfields regularly, traveling to Alford by steamboat and staying there overnight. The men would start off early the following morning to paint the lazy river town, recording the barges and houseboats tied up along the banks of the Marne and the massive stone bridge across the river.

In April, 1899, Henri submitted his work to the annual Paris Salon and had four paintings accepted. This triumph was followed by the ultimate honor: the French Government purchased one of the canvases, entitled *La Neige* (The Snow), for the permanent collection of the Luxembourg Gallery.

News of Henri's success spread quickly to America, and celebrations were held on both sides of the Atlantic. "Of course you have heard that I sold a picture to the Luxembourg . . .," Henri wrote to Sloan in Philadelphia,[80] and Sloan replied: "When I noticed in *The Evening Call* that you had sold a picture to the French Government and (so they had it) been decorated with the Ribbon of the Legion of Honor, I honestly yelled with joy and a hot thrill of pride and triumph shot down my spine. It seemed my privilege somehow to take part of the credit."[81] The success would last Henri a lifetime.

HENRI: *La Neige* (The Snow), 1899.

Musée du Louvre — Prefiguration du Musée d'Orsay

The following spring the honeymooners embarked on their triumphal voyage home. Stopping briefly in Madrid to view an exhibition of Francisco Goya's work in the Prado, the Henris proceeded to New York City, where they decided to take up residence. Henri rented studio and living space in an old mansion at the extreme end of east Fifty-eighth Street. From his studio window he could stare out upon the East River and Blackwell's Island, gaze down upon the rock-strewn cliff which descended steeply to the water's edge.

To Henri, the East River, the Marne, and the Seine looked the same. The unifying agent was grayness. In his first New York canvases the moods of the adjacent East River became his theme. Henri painted its somber spirit in daylight and twilight. On a summer evening he viewed the skyline of murky buildings, the broad expanse of overcast sky, and the barely discernible tugboats which emitted repetitive puffs of white smoke. By winter the river became a blanket of ice with the far shore scarcely visible through a driving snowstorm and the near embank-

HENRI: *On the Marne, 1899.*

Collection of Mr. and Mrs. Ralph Spencer

HENRI: *West Fifty-seventh Street, 1902.*

Yale University Art Gallery, Mabel Brady Garvan Collection

ment embracing its series of slippery steps that
seemed to emerge from the wintry depths.

When Henri tired of the East River he turned to
the North River for comparison, sometimes noting
the similarity of its craft-filled expanse or the
stretches of irregular ice floe. The snow-ladened
thoroughfares fascinated him too. His representation
of Fifty-seventh Street makes it the American coun-
terpart of his Luxembourg painting. A hansom cab
replaces a horse-drawn wagon, shallow roofs sup-
plant the Paris mansards; yet the rapidly converging
lines of houses lining the streets, the overcast sky,
and the patterns of snow mark the unmistakable
similitude.

Once settled in his new surroundings, Henri es-
tablished contact with Luks, Glackens, and Shinn,
the nucleus of the old Philadelphia gang who already
resided in New York. Luks was still wowing the
World with his capers and cartoons; his comic strip,
now variously titled *Hogan's Alley* or *McFadden's Flats*,
perpetuated the impish adventures of the Yellow
Kid. Shinn had abandoned newspaper work for the

HENRI: *Sidewalk Café*, 1899. Museum of Fine Arts, Boston

HENRI: *East River Embankment*, 1900.

Hirschl and Adler Galleries

more lucrative field of magazine illustration and had recently crashed the big time with his first center spread in *Harper's*. And Glackens, having proved his adeptness for creating action sketches in Cuba, now saw his straightforward style adorn the pages of a dozen periodicals and books.

William Glackens' drawings were received as the antithesis of the fashionable illustrations of the day. His pen-and-ink people were natural in expression and lifelike in stance, quite different from the swan-like goddesses of Charles Dana Gibson or the effeminate males of Howard Chandler Christy.

Art editors chose Glackens' free-lance assignments with care. *Everybody's Magazine* had him illustrate an oriental war story, while his sketches of Civil War soldiers bedecked *McClure's*. For *Harper's Weekly* he drew Tin Pan Alley, for *Munsey's* the agitated action on the floor of the New York Stock Exchange. And while Howard Chandler Christy's creations adorned such books as *The American Girl*, William Glackens' commissions included volumes like *Autobiography of a Beggar*.

What Glackens could not convey in the realism of his illustrations he made known through mild-mannered interviews with the press. "He does not believe in art schools . . ." one writer noted. "He says that the academic tendency is so universal that when one goes boldly and directly to express an idea he is at once assailed as clumsy. . . ." Was Glackens' drawing clumsy? At least one reporter, as early as 1899, concluded: "As a draughtsman of force and original and unique methods of presenting ideas, Mr. Glackens is assuredly making a place for himself, and one that no other American illustrator has heretofore occupied. . . ."[82]

But though drawing was his forte, at the turn of the century, by his own admission, Glackens considered himself a painter. Like Sloan, his interest in the use of oils had been stimulated by the patient guidance of Robert Henri. Glackens had daubed his first figure paintings while sharing a Philadelphia studio with Henri in 1894. Then in Paris with Henri the following year he had turned his facile fingers from recording quick newspaper sketches in black and white to registering similar city scenes in oils. In his canvases, children sail boats in the Luxembourg Gardens or romp along the banks of the Seine. Memories of

Philadelphia are transformed into Paris. Color is superimposed over his innate sense of dark-and-light contrast and overall design.

When Glackens and Henri were reunited in New York in the year 1900, similar scenes began to flow from their brushes. Glackens recorded the East River

Gibson Girls from *Life* magazine, 1899.

GLACKENS: *La Villette* (A Section of Paris), 1895. From the Collection of Museum of Art, Carnegie Institute, Pittsburgh, Pennsylvania

from Brooklyn while Henri portrayed it from Fifty-eighth Street. The results were sometimes analogous; any difference was one of emphasis. Where Henri could depict an embankment with the impersonal logic of Claude Monet's cliffs at Étretat, Glackens used it as a setting for a human tableau, a trio of youngsters poised for a dip or couples standing near the water's edge.

Glackens made no attempt to veil his indebtedness to Henri. If he was thought of as "somewhat of a revolutionist in Art," as one writer phrased it,[83] if he considered the use of highlights in painting as vulgar, if he rated Whistler and Manet as the two great black-and-white artists of the nineteenth century: these statements simply displayed his concurrence with the older man's standards of judgment. Yet it was Glackens' early portrait of George Luks which demonstrated the painter's complete submission to the Henri methodology. Painted with a swiftness and authority which rivaled the mentor, the likeness of Luks goes farther than the "dark Impressionism" of Manet. The portrait head is encompassed by the rich, swarthy color of "darkest Henri."

At the time the portrait was painted, Luks and

Glackens were rooming together in a fourth-floor apartment on Thirtieth Street. The living room, with its unsatisfactory south light, served as their studio. Within its cluttered confines Luks had begun executing his earliest canvases of New York life.

Although it was at Glackens' suggestion that Luks started painting in 1898, George would never acknowledge that such was the case. Actually Luks had produced his first oil in 1883, at the age of sixteen. But this meticulous depiction of grazing cattle was little more than an exercise in copying a print of the Hudson River School variety, and credit for this isolated early effort must go to George's cultured parents, both of whom had already adopted painting as a hobby.

For the next fifteen years Luks confined himself to drawing in black and white. In the academies of Philadelphia, Munich, Düsseldorf, and Paris he knew no media but pencil, charcoal, and pen-and-ink. Now finally, through the quiet urging of Glackens, Luks experienced first the softness of colorful pastels, then the lush impasto of oils.

George Luks roamed the streets in search of his subjects. A dozen sketchbooks reveal his sequence of

SHINN: *Sixth Avenue Elevated After Midnight,* 1899.

Arthur G. Altschul Collection

movements about the city. He had been along the bridle path in Central Park, with longshoremen on a snow-swept dock, at the polo games on Long Island, at a music hall, an excavation, a fire. All of these were recorded by a former artist-reporter with a cultivated eye for the dramatic.

Yet the dominant theme in Luks' art is a concern with poverty and hunger. Luks observed the gutter waif, the beggar, the drunk, and painted them with the sympathy and understanding of one creating a self-portrait. He recorded shabbily dressed children standing tirelessly in a bread line, queued up on a snowy pavement before a brilliantly gaslit bakery. He pictured a once fine athlete whose thin, bleak appearance accounted for his designation as Whiskey Bill. And Luks showed an East Side child in a tattered shawl, her empty eyes and empty basket the outward signs of an emptiness inside. Luks' art was never meant to be an escape from his personal plight, for in seeking his subjects he once said: "A child of the slums will make a better painting than a drawing-room lady gone over by a beauty shop."[84]

Such an earthy opinion would find disagreement in the words and heart of Everett Shinn. From the moment he settled in New York, Luks' former Philadelphia roommate had cast covetous glances toward upper Fifth Avenue, and frankly opined that the uptown life was more glittering and more good-looking.

As such he craved the look of a woman in elegant clothes, a skirt of satin encompassing her limbs and the sweep of furs about her dovelike neck.

Shinn had his evening's work cut out for him. On his way home he purchased a fifty-cent box of pastels, then hurried to the Metropolitan Opera House to observe the architectural detail of its façade. Once home, he began to toy with the pastel chalks, a medium he had not employed since his student days at the Pennsylvania Academy.

Shinn had a gluttonous taste for achievement. In the fall of 1898, after only one year on the art staff of the *New York World,* he set his sights on the center spread of *Harper's Weekly.* This prize plum was the hallowed domain of Gibson, E. A. Abbey and Charles Stanley Reinhart. The artwork of these established illustrators alternately occupied the two most desirable pages of the magazine.

Shinn planned a patient and persistent campaign. Armed with determination and a portfolio of drawings, he haunted *Harper's* at regular intervals. Each Friday afternoon he would climb the spiral staircase to the third floor, and each Friday he would descend without having untied the strings on his portfolio. After fifty-two weeks of this ritual, even an aggressive Shinn was near defeat. As a last resort, he humbly left his drawings one bleak December day

SHINN: *A Winter's Night on Broadway,* center spread from *Harper's Weekly,* February 17, 1900.

with the request that the proper persons glance at his wares.

Upon his return the following week, the door to a hitherto forbidden sanctuary was opened. At the opposite end of a long room sat a corpulent man gazing through bifocals with the appearance of an owl. Colonel George Harvey, editor and publisher of *Harper's Weekly,* was shuffling through Everett Shinn's sketches.

"You have here such a variety of New York street scenes," the editor began, "that I was wondering if you have in your collection a large color drawing of the Metropolitan Opera House and Broadway in a snowstorm." Shinn glanced out of the window at the falling snow which would soon create the desired effect.

"I think I have," he replied hopefully.

"Good," snapped Harvey. "Have it here at ten o'clock tomorrow morning."

Shinn worked through the early hours of the morning. Shaky and pale he delivered the finished drawing at the appointed deadline. Colonel Harvey stared at the artwork in silence. He scrutinized the lights twinkling dimly through the swirling snow, the dashing hansom cabs, the scurrying ladies hoisting their voluminous skirts. "We have to decide on a price," Harvey finally announced. "How about four hundred dollars and you own the original?"

When Shinn opened an advanced copy of the February 17, 1900, issue of *Harper's Weekly,* he thrilled at his achievement. He was confident that he had arrived.[85]

CHAPTER TEN

AS A RESULT OF Everett Shinn's sparkling center spread in *Harper's Weekly*, other magazines promptly sought his talents.

One such commission involved a pastel drawing of Mark Twain for the inside cover of *The Critic*. The specifications called for the portrait to be full length. "Photographs of his lionlike head were plentiful," Shinn discovered, "but I could not find anything of his body. The structure that must carry that head, I assumed in following my idolatry of genius, must be so gigantic that no sheet of cardboard would be available to hold this literary colossus. To me he would be uncomfortable and cramped in the dimensions of a twelve-sheet poster."[86]

Shinn sketched the author's distinguished head, then created an illusory body to go with it. Longer and longer the figure stretched until Mark Twain's facial likeness was dwarfed by a body of gigantic proportions. The diminutive head assumed the appearance of a carved handle atop an umbrella. Yet apparently no one on *The Critic* staff had ever seen the great Twain, for there was no criticism of this inaccurate representation. The finished pastel drawing was accepted, and a fully seven-foot-tall literary giant was fed into the presses.

Shinn was preparing to embark on a voyage to Europe when his Twain-dominated issue of *The Critic* hit the streets. His initial sense of pride turned to dismay as he suddenly realized his representation of the writer was a ghastly caricature. The artist's proposed European trip quickly assumed the nature of an escape from the anticipated jeers of magazine editors and readers. Not until he was safely in Paris could he erase the embarrassment of the Mark Twain drawing from his mind.

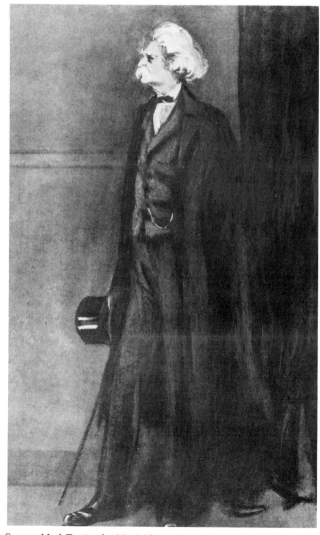

SHINN: *Mark Twain,* double-fold frontispiece from *The Critic,* March, 1900.

From his studio in the Latin Quarter, Shinn could gaze upon quaint, new surroundings. One window opened upon an enclosure, described as "the bloodiest courtyard in France during the Revolution." Through the doorway Shinn caught occasional glimpses of the Impressionist Edgar Degas strolling from his house across the street.

The romance of Paris was all around him. So was its reality. In New York, Shinn had expressed a preference for the beauty of upper Fifth Avenue. In Paris he recorded the sordid side of life instead. In pastel chalks Shinn depicted the same type of humanity George Luks revealed in his East Side paint-

ings. He represented the haggard tramp whose back is bent by a massive bundle of papers, and the scavenger who rummages through a garbage can.

Sometimes Shinn turned to the brighter side of life, sketching his subjects in a Paris music hall in imitation of Degas. The young American considered Degas "the greatest painter France ever turned out." He was captivated by his illustrious neighbor and intrigued by the French artist's reputation.

Shinn had already learned of Degas' brutal treatment of his models, how he required ballet dancers to hold difficult poses for hours on end. If they fainted they were sent away without pay. If the mod-

SHINN: *Microbe Alley*, 1909.

els endured, they received the equivalent of one dollar and fifty cents a day.

Shinn persuaded a couple of the dancers to come to his studio. Instead of having them pose, he had them dance. During their performance he would make dozens of quick sketches that were later translated into finished pastels and oils.

After nearly a year in France, Everett Shinn prepared for his return home. Standing upon the deck of the S.S. *Minnehaha* at Cherbourg, he spotted a small man with a mane of gray hair and a heavy mustache. Recognition was immediate. "My God!" Shinn said to himself. "That man is Mark Twain, and he's coming aboard this ship. But how he has shrunk!" Once

again that devilish drawing for *The Critic* cover loomed large before Everett Shinn: "I gazed down from the rail at that undersized figure shuffling toward the gangway while towering above him I saw an aura, a misty creation of my own—Mark Twain on stilts, peeking into the crow's nest."[87]

On shipboard Shinn spied on the author from the safety of his cabin. When Twain walked forward with the captain, Shinn would sneak into the lounge. He was playing a game of cat and mouse, with the mouse the sole performer. During the entire voyage the creator of the magazine cover was not discovered.

Several weeks after his arrival in New York, Everett Shinn received a message from the editor of

SHINN: *Early Morning, Paris*, 1901.

The Critic: "Mark Twain has taken a house on west Tenth Street a few blocks from you. Now you can go and apologize for making that drawing. . . ."

Shinn followed the suggestion. He called upon his supposed adversary and gained admittance to his study. The young artist cast nervous glances around the large room, his eyes coming to rest on a great desk stacked with all sorts of heterogeneous matter. Then Mark Twain entered. His small frame was overpowered by the heavy, disarranged growth of hair on his oversized head. "He twisted the stem of his calabash pipe," Shinn noted, "and narrowed his eyes. Severe misgiving seized me. Mark Twain began to rummage about in a drawer of litter resembling the contents of his desk until he held up my drawing in triumph and said, "I've got it." He brought the drawing over to his desk, cleared a space for it, and spread it out."

"I'm ashamed, Mr. Clemens," Shinn stammered. "I humbly apologize."

"For what?" he inquired kindly. "Young man, you have accomplished something that art rarely achieves. On that streaming ticker tape you have printed me for all to read. Perhaps you have offered me up to the public in the guise of a French loaf of bread. I can be sliced down to suit." He paused, then added climactically: "Yes, young man, Charles Dickens did just that."

"But Mr. Clemens," Shinn replied, half-hesitating, "Dickens drew accurately."

"Accurately, of course," the writer continued, "but with gigantic exaggeration. Would Scrooge be accurate if he were given only a few meannesses? Dickens elongates his capacity for evil. All avarice would be gone in this world if dumped into a single rascal like Scrooge. Scrooge, far from it, hasn't all of the lowdown traits of mankind, but he parades them all. Dickens made his an elongated strip of gluttony."

The writer's hypnotic utterances came to an end, and he again sought Shinn's drawing. Placing it flat on the desk, he folded it up from the bottom, turning back enough of the elongated legs to bring the feet up to the knees. "That's more normal, but less inspiring. My parents would have liked me like that." His gentle eyes sparkled as his delicate hands folded the paper again and again, always keeping the feet in view. With each fold he made some amusing comment. At last the feet were directly under his chin and stuck out like the ends of a bow tie. "Now, that's final," Twain stated triumphantly. "That's the way my wife sees me."[88]

"Of course, he let me make another drawing of him," Shinn reminisced, "and I got into the habit of dropping in every week to work on it. Sometimes when I finished drawing him I would simply say 'Goodbye' and leave, but other times he would get up and talk to me. I must confess I took as long as possible to make that drawing."

During one of the conversations, while the picture was in progress, the twenty-eight-year-old artist asked the sixty-five-year-old writer for a complete list of all the books he had written. Shinn expressed the desire to buy an entire set if Twain would personally autograph each volume.

"Young man, did I hear you right?" Twain asked abruptly.

Shinn nodded in wonderment as Twain hurried to the double doors which led to the rest of the house. "I must wake Mrs. Clemens and tell her the mortgage is lifted." Then he paused, shook his head in doubt and turned back to Shinn. "I won't disturb her that way," he mused; "it would be too upsetting. I'll save it for a surprise at dinner."

Twain returned to his desk, plucked a volume near at hand and fingered the foreleaves. "All books have a blank page in the front," Twain stated. "In order to make it worth while I will use the flyleaf of each book and write you a short story which will begin inside the cover of the first volume and end within the last. How's that?"[89]

An irresistible proposition. But the precious writing was never recorded. Shinn's drawing was soon completed, and as time passed he neglected to purchase the required volumes. A single postcard from Twain to Shinn remains as a monument to this unfulfilled literary treasure.

Upon Everett Shinn's return to New York a few months earlier, he had endeavored to arrange an exhibition of his Paris pastels. From gallery to gallery he carted his portfolio, but without success. The hushed interiors of the private salons, decorated as they were with a profusion of mid-Victorian wall hangings, were no place for his boisterous music hall crowds, much less the seamy realism of his Paris street scenes.

SHINN: *The Laundress,* 1903.

Although the artist found no ready market for his previous production, he continued to sketch and search. In Paris, Shinn had come in contact with American actress Elsie de Wolfe as she rehearsed in the gardens at Versailles for the playwright Clyde Fitch. When Miss de Wolfe returned to New York that fall of 1901, Shinn visited her at her home on east Seventeenth Street. He politely discussed the actress' November opening at the Victoria Theatre, but she preferred the preoccupation offered by his portfolio of pastels. She invited Shinn to leave his artwork. "Stanford White comes here often," the fashionable hostess declared. "He might look at them."

Several days later Shinn was summoned to the old Washington Irving mansion where Elsie de Wolfe resided. There he was introduced to the renowned architect, a tall redhead who stood gripping the drawings. This was the conversation.

WHITE: These are splendid. What are you going to do with them?

SHINN: Sell them if possible.

WHITE: Ever try to have an exhibition?

SHINN: Yes, last week at Boussod and Valadon, but Mr. Glenzer said my work doesn't interest him.

WHITE: Is that what Mr. Glenzer said? When do you want to open your exhibition?

SHINN: Where?

WHITE: There. How many pictures do you have?

SHINN: About forty.

WHITE: Go up and see Glenzer. Name your date and you will open.[90]

An astounded Shinn caught his breath and did just that. Gallery director Eugene Glenzer had been informed of Shinn's coming, for the artist was greeted with elaborate apologies for the discourtesies of the previous week. Then arrangements for his forthcoming exhibition were discussed.

Shinn kept rubbing his eyes in disbelief, yet there were more surprises in store. Stanford White and Elsie de Wolfe had invited the cream of society to the November 11 opening, and as they arrived, White promoted the pastels among his socially prominent friends. With the show rapidly becoming a financial as well as a social success, elated gallery director Glenzer extended the exhibit from its original two weeks to six. And when the exhibition finally closed just before Christmas, twenty-two of the pastels had been marked "Sold".

Buoyed by his phenomenal good fortune, young Shinn continued to produce Paris street scenes from this side of the ocean, recalling specific locales with uncanny accuracy. He now began creating New York cityscapes as well, and a number of them were immediately purchased by periodicals for use as frontispiece illustrations.

One such pastel, depicting the dense smoke discharged by tugboats and ferries as they ply the waters of the East River, was reproduced in a 1902 issue of *Harper's Weekly* over the caption: "The Soft-Coal Nuisance in New York." Though the subject reeks of an ugly, sooty realism, Shinn's sparkling technical brilliance shines through the drabness of the scene.

The same issue of *Harper's* carried a photograph of Clyde Fitch, the debonair playwright, on the cover. When Fitch noticed Shinn's frontispiece illustration, he was impressed by the artist's facility. Through Elsie de Wolfe the two met. After Fitch had seen more of Shinn's creative output, the famed dramatist proclaimed: "I am building a house and I want you to decorate it." Flattered, Shinn naturally agreed. "But I haven't any money," Fitch warned as an afterthought. Shinn accepted the commission anyway.[91]

There was no problem deciding the appropriate décor for this playwright, whose initial production had been *Beau Brummel*. Shinn thought back to his first glimpse of Clyde Fitch in the gardens of Versailles. He pictured the lavishness of seventeenth- and eighteenth-century France as captured in the charming and decorative fairy worlds created by Honoré Fragonard and Antoine Watteau. Shinn studied the Frenchmen's styles, then mimicked their scenes of carefree frivolity.

For the Fitch home, Shinn decorated several ceilings in the manner of Louis XVI, then embellished two pianos and a series of sideboards in the same style. When the job was completed the artist received a pair of stately gold chairs and a mahogany table from the pleased client. These gifts from Clyde Fitch enjoyed a place of honor in the entrance hallway of the Shinn residence on Waverly Place, there to stand as the symbol of a fleeting friendship and a brush with greatness.

By 1903, Everett Shinn, together with Glackens, Luks, and Henri, was solidly entrenched in New York, but John Sloan remained a holdout in his bastion of security, Philadelphia. Sloan's loneliness had

SHINN: *London Hippodrome*, 1902.

Courtesy of The Art Institute of Chicago
Friends of American Art Collection

been partly conquered through marriage in the summer of 1901 and sentiment eventually dictated that the couple live at 806 Walnut Street. There Sloan surrounded himself with nearly a decade of memories, yet the recollections were beginning to fade. Wallpaper hid the remnants of the wild spaghetti-throwing party and a carpet covered the stains of beer and Welsh rarebit.

Sloan had been sticking it out on the *Press*, where his full-page color drawings appeared regularly in the Sunday edition. But by 1903 the American Lithograph Company was publishing a syndicated Sunday supplement, and when the *Press* began subscribing to this service, John Sloan was out of a job. Now livable,

lovable old Philadelphia held little attraction for him, and he considered moving to New York again. The opportunity soon presented itself, for when the promise of a Manhattan magazine commission came his way, Sloan left 806 for good.

The Sloans arrived in New York in April, 1904, and during the first few weeks they were temporarily quartered in Robert Henri's studio in the Sherwood Building. There was no indecision, however, about remaining in New York this time. Sloan, amid old friends in the big city, was there for keeps.

And with his establishment in New York, the transplanted Philadelphia gang was once again complete.

CHAPTER ELEVEN

THE SHERWOOD Building, at Fifty-seventh Street and Sixth Avenue, housed the first co-operative artists' studios in New York City. Robert Henri had moved there in 1901, replacing Frank Vincent Du-Mond, who was an instructor at the New York School of Art. When DuMond abandoned his teaching position at the art school a year later, Henri replaced him there as well.

The New York School of Art was beginning its seventh season of operation the year Henri joined the staff. Located just across the street from the Sherwood studios, it was unofficially known as the Chase School after its founder and guiding spirit, William Merritt Chase. Chase had established the art school in 1896, but following two unprofitable seasons had relinquished the ownership and administrative duties to others. He remained, however, as the head instructor and chief attraction at the school.

William Merritt Chase was the American counterpart of William Adolphe Bouguereau, similar in appearance and equally successful. As a painter and teacher he had already become an institution, maintaining two New York studios and one in Philadelphia, while instructing at the New York School of Art and the Pennsylvania Academy. As a dapper dresser, Chase was second to none. From the crown of his straight-brimmed top hat to the bottom of his immaculate white spats, he was the perfect dandy. In between was a short, rotund figure replete with gold-edged pince-nez, the black ribbon of which dangled past his upswept mustache, Van Dyke beard, winged collar, jeweled cravat ring, and an always-fresh white gardenia in his lapel. His appearance was no act or disguise; to Chase it seemed natural and fitting.

William Merritt Chase and Robert Henri rep-resented absolute opposites, not merely in physical appearance and dress but in their philosophies of teaching and painting as well. According to Chase, "Delicacy of detail is the essence of art." But Henri retorted: "Never mind bothering about the detail. . . . The camera reproduces the best likeness, but it is only the artist who can produce the temperament of the model." Whereas Chase's primary consideration was visual accuracy in drawing, Henri placed a premium on emotional spontaneity. And while Chase taught technique, believing that ". . . ideas will come in time," Henri suggested: "It is useless to study technique in advance of having a motive."[92]

Robert Henri's first appearance in the men's life class at the New York School of Art was like a breath of fresh air being blown into the stifling atmosphere. "The day . . . had been like any other," one of the students later recalled, "men working carefully with a constantly resharpened charcoal upon a week's drawing of a nude figure. I shall always picture the entrance as a rock dashed, ripping and tearing, through bolts of patiently prepared lace. . . . Life certainly did that day stride into a life class."[93]

Together with his inspiring gift for gab and his warm personality, Henri brought with him a new set of values and a new approach. He opened your eyes. He moved back your horizon. He made you a liberal. His stimulating doctrines provided an exciting relief from the prevailing restrained and polished procedure. Henri admonished those pupils who painted slowly, who matched each tone of color by placing a dab on the end of a palette knife in order to hold it up to the model. "Work with great speed," he would command. "Have your energies alert, up and active. Finish as quickly as you can. . . . Do it all in one

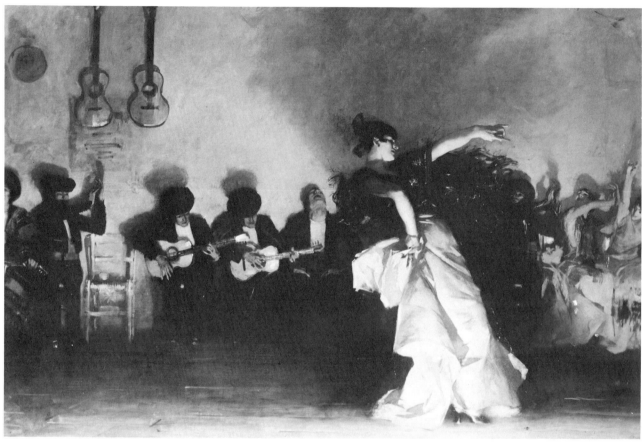

SARGENT: *El Jaleo* (The Dancer), 1882.

sitting if you can; in one minute if you can . . ."[94]

When a student became obsessed with the challenge of reproducing the swift brushwork of John Singer Sargent, Henri would commend the swiftness and condemn the motive: "Do not imitate; be yourself!!" When another sought the surface sparkle of Impressionism, Henri would urge the pupil to make "technique become a tool, not an objective."[95]

The mentor's common-sense directives were delivered with appealing vigor. According to one student, "No one who has not felt the magnetic power of Henri, when he had before him an audience of ambitious students hungry for the master's moving words, can appreciate the emotional devotion to art which he could inspire as could no other teacher. . . . It required . . . his fervor, his passion for the verbal communication of his ideas, to place before a

vast succession of eager youth the new world of vision. . . ."[96]

Like a silver-tongued Pied Piper, Robert Henri began to fashion a following. George Bellows came fresh from his junior year at Ohio State; Carl Sprinchorn direct from Sweden . . . Rockwell Kent from Columbia's School of Architecture; Glenn Coleman from a newspaper job in Indianapolis . . . Edward Hopper, Eugene Speicher, Guy Pène duBois, Julius Golz, Patrick Henry Bruce, Walter Pach, Arnold Friedman, Oliver Chaffee, Arthur Cederquist, Randall Davey . . . all sought the stimulation which Henri seemed so able and willing to provide.

In the men's life class Henri would stroll casually around the room, moving from easel to easel. He spoke clearly and softly; there was no need to raise his voice, for his mere presence in the art room oc-

casioned silence. About half the students would lay aside their brushes and trail along behind him like a brood of ducks following their leader.

Henri would pause at an easel and contemplate a painting in silence. After several hushed moments he would look up at a student and demand, "Is that all you can say about this model?"

Then he would launch into his discourse: "If you were going to have a portrait made of your mother, would you choose the artist who could make a hard, cold photographic study of her costume and likeness, or would you engage the man who, having a clear impression of her characteristic charms, drew them out on the canvas? . . . The artist who draws the spirit of his sitter accomplishes more than the man who paints a portrait. His canvas says to the people who read it: 'Look what I have to show you of this woman. She is real; there is flesh and blood back of the silken gown; she is witty and sunny, and her spirit is to wholesome.' "[97]

Henri would speak as the spirit moved him, at times passing by three of four canvases before commenting on a single work. His small, piercing eyes would gaze directly at the student he addressed, purposely oblivious to the assembled classmates huddled around him. "Sometimes he would just dribble along," one of his pupils observed, "and then, suddenly, Henri would hit upon an idea and golden moments would follow."[98] Once begun, he might spend twenty or thirty minutes on a single painting.

After a student had been thus stimulated, little else was necessary. Yet sometimes Henri would substantiate his remarks by making quick thumbnail sketches to reveal the distribution of highlights and shadows flickering over the model. On a few rare occasions he would request a new canvas and a clean set of brushes and proceed to work from the model himself. But such demonstrations were never completed, for just as the painted figure began to emerge, Henri would reach for a palette knife and scrape the canvas clean.

Left-over paint was not disposed of in the usual manner. A "paint wall" had been designated along one side of the room's dark-green interior, and it was on this wall that palette and canvas scrapings were thrown. The mass of oil pigment soon reached a thickness of several inches, and before long the boys'

proficiency at casting paint could easily rival an expert's aim at a polished spittoon.

The gang of boys in the men's life class led a happy and carefree existence, missing none of the fun of freshman hazing or art school pranks. New students were solemnly informed of an entrance requirement which demanded that they treat the entire class to a beer and cheese party. If the neophyte was suspected of wealth, the required menu became all the more elaborate. Once a nattily dressed newcomer entered the shabby artroom accompanied by the odor of perfume. At a given signal the entire class fell flat on the floor in a well-staged faint. Sometimes a fire was started under a new student's chair, or a caricature portrait mysteriously appeared superimposed over his art. But the antics were all in the spirit of fun, and the boys learned to give and take with equal finesse.

Henri encouraged such rough-house behavior when he advised: "Be a man first, be an artist later."[99] His raucous ruffians reveled in the colorful character of their President, Teddy Roosevelt, whose devotion to physical fitness manifested itself in wild-game hunting in Africa and tennis on the White House lawn. Soon the rough riders of the life class were taking up basketball, handball, and boxing in their spare time, and chinning themselves above the door lintels of the classroom whenever the model rested.

No physical effort proved too great for Henri's he-men. Organizing their own baseball team, they challenged similar aggregations from the much-larger National Academy of Design and Art Students League. Despite the relatively small student body from which they had to draw, the New York School of Art never lost a game. It boasted the most boisterous rooting section of all, and the star shortstop, George Bellows.

Sometimes their baseball diamond in Bronx Park became the site of fisticuffs which broke out among the rival players. But when a Henri student suffered a black eye or if a bloody nose stained his borrowed Y.M.C.A. uniform, he displayed his injury with pride. Such battle scars were physical evidence of an adherence to their teacher's admonition that a full and strenuous life is of utmost consequence in producing a vital work of art. The public, after a taste of the healthy-looking specimens in the Henri class,

would never again label all male artists as sissies.

Robert Henri became a friend and associate of his students. Unlike William Merritt Chase, whose formal appearance was sufficient to suggest a certain desired aloofness, Henri possessed a warmth of personality and a down-to-earth manner which drew his pupils to him. He ate lunch with them in the basement of the art school. He smoked cigars with them after class. He would even cross a crowded room at an art lecture or exhibition just to shake hands with one of them.

Henri's personal touch received its reward, for even his shortcomings were memorialized instead of becoming sly gossip among the student body. In his attempt to heap praise upon the shoulders of the successful, Henri perhaps bestowed the label of "genius" a bit too frequently. The class accepted the idiosyncrasy in fine spirit, however, commemorating it by composing their own lyrics to a top vaudeville hit of the day:

> Mr. Henri for many years
> Would look at my work and then shout cheers,
> I didn't know where I was at
> For all of my genius I couldn't tell that.
>
> (Refrain)
> I am a genius
> I am a genius
> I am a genius man.[100]

By 1905 Robert Henri's highly spirited classes at the New York School of Art were at fever pitch. Having begun just two years before by instructing a single life class, Henri now presided over the men's life class in the morning, portraiture in the afternoon, another life class in the evening, and a Saturday class in composition.

Despite his increased number of students, Henri's unceasing devotion as a teacher did not slacken. It was not unusual for a morning session to continue past lunchtime, or for an afternoon class to terminate at six o'clock instead of the usual four-thirty. The evening class contained mainly workingmen and those students who pursued other studies by day. But Henri's magic spell had no less effect upon them. "He'd fire up everyone," an evening student recalled, "and after he left we would discard our old work and start again."[101] Although the class was

scheduled to end at ten-thirty, it often lasted long into the night. When the management complained about the added expense of burning a battery of gas lamps until midnight and beyond, Henri would lead his aroused pupils across the street to his studio, where the discussion of Art and Life would continue.

Henri sought to stimulate your thinking, "to produce mental activity," as one student put it. Whereas William Merritt Chase's favorite subjects were unemotional still lifes of dead fish, Henri encouraged his pupils to formulate their own ideas of the world they saw around them. "Stop studying water pitchers and bananas and paint every day life . . .," he demanded. "Each man must take the material that he finds at hand." And they did.[102]

Soon no spot on God's green or soot-stained earth was forbidden subject matter for Henri's spirited charges. He sent them into hitherto forbidden retreats where they gazed with curiosity into lighted windows and darkened doorways. Now saloons and cheap music halls were approved habitats for aesthetic scrutiny. Although Henri advocated that *all* life was acceptable subject matter, his philosophy resulted in the belief that dilapidated slums and the nonprivileged working classes were nearer to reality than the lush and extravagant existence uptown. A number of Henri's earnest pupils rented rooms in Greenwich Village for four or six months at a time in order to live and paint among the humble, the poor, the huddled masses of the Village and the mile-square East Side of New York.

Each Saturday morning Robert Henri's ardent following would gather in the Composition Class, at which time their week's work would be displayed before the scrutinizing eyes of their mentor. Simultaneously, William Merritt Chase would be conducting lectures and demonstrations in the next room, open sessions which were free to all the students. Although a moderate crowd always congregated before the entertaining Chase, who enthralled them with his showmanship, his step-by-step construction of still-life painting was no match for the hypnotizing verbal outpouring of Robert Henri. "It was the Composition Class that was the essence," a Henri student remarked. "It was simply breathtaking!"[103]

The areas of discussion in most composition classes of the day centered around the application of

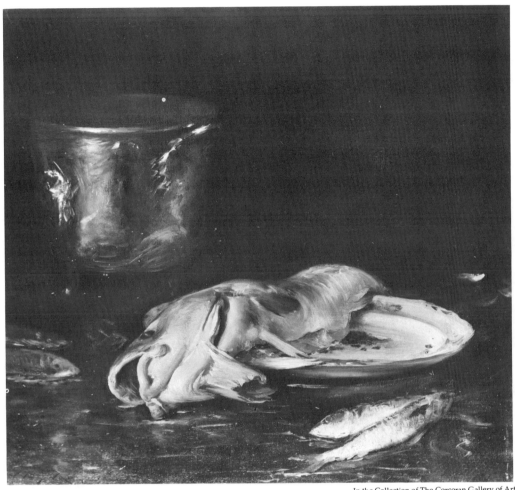

CHASE: *An English Cod*, 1904.

design, chiaroscuro, and color. Henri touched upon these, but his colorful delivery always made them appear to be much more than the mere dry-as-dust elements of art. The massed assemblage visually followed in silence as he assessed the collection of forty or fifty cityscapes and figure paintings. Willowy wisps of smoke from his Ricoro cigar curled upward past the heavy-boned cheeks and slim, tapering eyes of his small, oval head. His sallow complexion showed a faint trace of the prominent pockmarks of his youth as Henri turned from painting to painting, shifting the weight of his lean, six-foot frame from one side to the other, meditating on a theme which might allow comparison of the diverse, heterogeneous works.

One Saturday morning both George Bellows and Carl Sprinchorn were represented by paintings of the Hudson River. There were also several canvases of the same subject by others in the class. Henri took his cue from them and talked for nearly an hour about the varied sweep of the shoreline, the diverse proportions of land to water, the appropriate placement of boats along the river. Finally he pointed dramatically with a three-foot maul stick to one of the larger canvases. "All of you have shown boats going up and down the river," Henri observed. "Only this painting demonstrates that they go *across* the river as well." [104]

Henri would often sharpen the students' sense of observation by transforming inanimate objects into vivid, living analogies. Turning once to a Whistler-

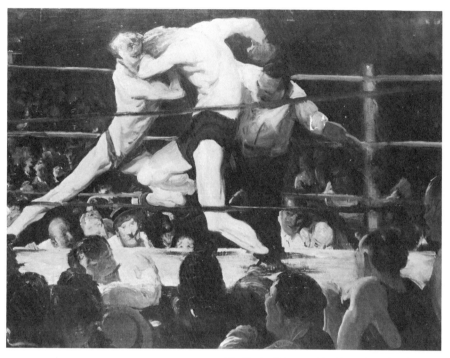

BELLOWS: *Stag at Sharkey's*, 1907.

The Cleveland Museum of Art, Hinman B. Hurlbut Collection

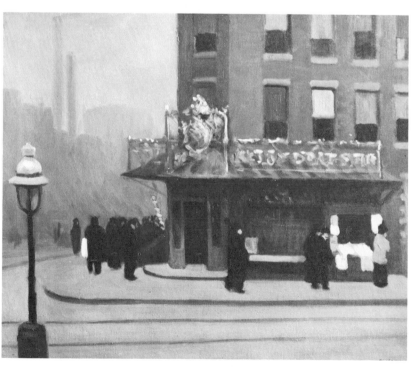

HOPPER: *Corner Saloon*, 1913.

Collection, The Museum of Modern Art, New York
Mrs. John D. Rockefeller, Jr., Fund

like Brooklyn Bridge, he commented dryly: "It is a painting. It has paint quality. But a bridge isn't like that — a bridge is like a great big dark animal which crouches on one side of the river and then jumps across."[105]

Many of the young art students in the composition class first heard the names of Daumier, Manet, Degas, and Goya issue forth from Henri's lips. But what is perhaps more important, they heard of Emerson and Whitman, Balzac and Rabelais, Shakespeare and Dickens, Tolstoi and Dostoievski. Henri would often appear in class with a worn volume of Whitman tucked under his arm — perhaps the same volume John Sloan had given him a decade before in Philadelphia. Turning to the assemblage, Henri would say: "Walt Whitman was such as I have proposed the real art student should be. His work is an. autobiography — not of haps and mishaps, but of his deepest thought, his life indeed . . ."[106] Then Henri would turn to the often-read pages, and read a portion from *Leaves of Grass*.

Robert Henri was constantly encouraging his pupils to see certain plays, to hear concerts. On rainy days, when the lighting was too poor to paint by or to view the compositions, he would accompany them to the Lincoln Square Theatre to see Harry Lauder or Vesta Tilley, or the Moscow Art Players staging Ibsen or Chekhov. [107] Actor Clifton Webb was an impressionable teen-ager in Henri's class at the time, and a twenty-five-year-old named Vachel Lindsay was there too. Lindsay, a would-be painter-poet, came to Henri indecisive about which career to follow. But after Henri read his poem "The Tree of Laughing Bells," he advised Lindsay to abandon painting for poetry. "He certainly gave me a big brotherly boost," the poet recorded in his diary, "and braced up my confidence a lot. . . ."[108]

In just three short years of teaching at the New York School of Art, Henri had fashioned a following of vigorous young artists, inspired by him to record the life of the city. Each chose his own approach. Glenn Coleman saw New York with affection; Guy Pène duBois reflected upon its satirical nature. George Bellows was captivated by its vigorous side, Edward Hopper by its loneliness. Yet whatever their preference, the Henri men unleashed the power of the paintbrush to challenge the firmly entrenched position of the popular painters of polished pictures.

As the rebellious force grew larger, an armed conflict was inevitable. And time for the showdown was not far off.

CHAPTER TWELVE

WHILE Robert Henri was establishing himself as the most influential teacher at the New York School of Art, he was also busily engaged in developing his reputation as an artist.

Henri had already held his first one-man show at the Pennsylvania Academy in the fall of 1897, displaying a collection of eighty-seven drawings and paintings. This initial exhibition, the artistic output of two years spent in France, had been arranged at the request of Alexander Harrison, the Philadelphia-born painter whom Henri had encountered at Concarneau. Now, five years later, Robert Henri was invited to stage a second one-man exhibit at the Academy, but this time the overture was made without solicitation. This second show included scenes of winter in New York and spring in the Forest of Fontainebleau, cumulus clouds over the East River and nimbus clouds over the Marne.

A segment of the press responded favorably toward Henri's growing stature as an artist:

> . . . Among our many landscape painters Mr. Henri stands as one of the few who has a definite attitude toward nature, the majority being engaged in the translating business, or rather in the adaptation of foreign ideas to their own purposes. . . . The common run of hackney painters . . . are content to make a formula out of the interpretations of other and abler painters. Now, this method does not happen to suit Mr. Henri's more personal standpoint; in dealing with nature he is in the habit of making a version of his own, and the results seem to be rather disconcerting to many minds. . . .

Then, echoing Robert Henri's own sentiments, the critic continued:

> It is a curious thing that a certain mechanical polish is commonly associated with the idea of finish, and from a few remarks dropped by casual visitors to Mr. Henri's exhibition, it is evident that his landscapes are regarded by many as sketches, or thoughts half-expressed. What does not seem to be understood, is that the eye that saw "The Hill-Top" and the mind that grasped and realized so vividly the idea of "A Sudden Shower" . . . are worth all the hands that ever niggled over a surface for the sake of explaining and polishing what from the first conception was meaningless and worthless. The truth being that in comparison with Mr. Henri's work, most of the landscapes commended for their completeness and finish have, in reality, never even been begun[109]

Together with the exhibition of landscapes, Robert Henri displayed a number of his earliest portrait and figure paintings. The inclusion of portraits proved unwise in the opinion of at least one newspaper writer, who observed: "Of the pictures now shown, the landscapes are so superior to the portraits that it is rather a pity that these latter appear at all. . . ."[110] Yet despite this unfavorable reception, Henri's figure paintings were to be produced in ever-increasing numbers.

The choice was one of necessity on the part of the artist. Henri sought speedily to depict the scene before him, yet there were limited vistas to be viewed from the windows of his studio. He was unable to set up his easel in midtown Manhattan as he had done in the fields and forests of France. Furthermore, lacking the creativity of the artist-reporter, he found painting from memory difficult. As Henri began to exhaust the available subject matter near at hand, the successful completion of cityscapes became more and more troublesome, with the result that he intensified his interest in portraying the posed model.

Henri never completely abandoned landscape

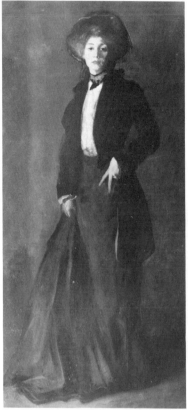

HENRI: *Young Woman in Black,*
1902.

WHISTLER: *The White Girl,*
1861-62.

painting, however, for he found in it the same qualities which he sought in his animate sitters: "Houses, housetops, like human beings have wonderful character," he declared. "The lives of housetops. The wear of the seasons . . . The majesty of trees. The backs of tenement houses . . ."[111] Yet this love for the city could not woo him from his newly chosen goal — "to paint the greatest portrait in the world in thirty minutes."[112]

Henri's handsome full-length portraits of women bedecked in gowns of white or black are testimonials to his efforts in this direction. In technique and pose his figures sometime resemble those by Chase or Anshutz, Whistler or Sargent. The truly distinctive feature in Henri's art comes not from his interpretation of the female form but from his treatment of the background. Where other artists neglected this subordinate area or simply used it to display their skill at painting detailed knicknacks and cluttered in-

teriors, Henri demonstrated that he had learned the lesson set forth in Manet's *Fifer* and Goya's *Maja.* "Remember that your model is not *against* space but in it," Henri would say. "What is real to us and what we enjoy is the space, not the walls of a room. . . ."[113]

When Robert Henri posed slender Jesseca Penn as the sophisticated *Young Woman in Black* or plumpish Zenka Stein as a *Young Woman in White,* he placed them in a timeless, all-encompassing space, a void without subject matter or even the suggested dividing line between floor and wall. In these works the background is not distracting; its ever-presence is sensed unconsciously.

Following the opening of Henri's second Pennsylvania Academy exhibition, John Sloan sought to promote the event through the Philadelphia papers. Sloan, still employed at the time by the *Press,* suggested that a full page in the Sunday edition be devoted to Henri's paintings. But when his editor fi-

MAURER: *Evening at the Club,* circa 1904.

Addison Gallery of American Art, Phillips Academy, Andover

nally rejected the proposal, Sloan relayed the reason to Henri in New York: "The trouble with a page on the exhibition is that there is no excitement to hang the 'story' on. Your achievement has nothing yellow in it. If you were only twenty-one years old and had suddenly jumped into frame, there'd be a story. . . ."[114]

Sloan's own deliberate approach to painting had not yet produced the quantity of work necessary for a one-man show. In the meantime he had been submitting his earliest paintings to the large national exhibitions, where they were accepted with uncanny regularity. Sloan had shown single works in both the 1900 and 1901 Carnegie and Chicago Art Institute annuals, and in January, 1901, his *Tugs, Independence Square,* and *Old Walnut Street Theatre* were all accepted for the seventieth annual Pennsylvania Academy show. Bursting with pride, Sloan wrote to Henri: "You will be able to appreciate my joyful feelings all around."[115]

Henri's answer came back in the form of an invitation to exhibit with him in a small group show at The Allan Gallery in New York. Glackens was also to

be included, as was Ernest Fuhr, an artist known to Glackens through their association on the *New York Herald*. The work of three other painters — Alfred Maurer, Van D. Perrine, and Willard Price — also decked the walls when the exhibition opened without fanfare on April 4, 1901. "The gallery is a nice little one but with dark ends and corners. . . ." Henri informed Sloan. "Everyone is equally arranged, half in light and half in dark. Think you will be pleased to see us all in a little exhibition of our own."[116]

The drawings and paintings which hung for three weeks in the small rooms at 14 West Forty-fifth Street hardly stirred the public or the press. Instead, attention was focused upon the seventy-sixth annual exhibition being pompously staged by the National Academy of Design in their superior galleries.

Only the *New York Evening Sun* dared draw a comparison in favor of the smaller show: "At Mr. Allan's . . . the exhibition is the more interesting because the pictures are mainly the work of painters seldom seen at the regular annual shows, and espe-

cially because among these painters are two or three of the too-small number of our younger men whose work is at all encouraging. The attention paid to the larger exhibitions of the year is commonly out of all proportion to their value; as a rule they are little more than repetitions of last year's. . . ."[117]

By 1904 the *New York Times* was taking a similar stand: ". . . Regular exhibitions must demand certain standards, from which they cannot derogate at the peril of their own existence as organizations. Therefore it is that we must look to private, one-man shows or to club exhibits for the work that we miss at the annual gatherings because they fail, must fail, to find favor in the eyes of Acceptance Committees for some technical quality which the committees miss. . . ."[118]

The occasion for these remarks was a second group show held at the National Arts Club on West Thirty-fourth Street in January, 1904. This time the work of Henri, Sloan, and Glackens was shown with that of George Luks. Only the pastels of Everett Shinn were missing, and their absence was attributed to Shinn's forthcoming one-man show at the Fifth Avenue galleries of Durand-Ruel.

The National Arts Club exhibit caused a mild sensation. Here, for the first time, the Realists' art collectively dominated an exhibition. Reactions were strong whether pro or con. The dignified *New York Times* announced the show with the honkey-tonk headline: "Startling Works by Red-Hot American Painters," then went on to state: ". . . If the end of the month is reached without duels, the club is in luck."[119] The *New York Commercial Advertiser* reacted quite to the contrary when it referred to the exhibition as : "A Most Lugubrious Show . . . where joyousness never enters . . . and where unhealthiness prevails to an alarming extent. . . ."[120]

Influential art critic Charles FitzGerald of the *New York Evening Sun* came out strongly in favor of the men and their work, labeling the National Arts Club exhibit "the most significant as representing current production that this city has seen in recent years."[121] FitzGerald was one of the first to praise their efforts. Although his approval was undoubtedly sincere, it could be anything but objective, for he was soon to become William Glackens' brother-in-law when the two men married sisters. The critic's closeness to the group was confirmed by a full-length

likeness of him which appeared in the show.

Such encouragement as was afforded by FitzGerald's somewhat biased review of the exhibition nevertheless did much to boost the morale and aspirations of the Henri group. By 1905 the New York Realists, as the transplanted Philadelphia gang had now become known, were painting some of their very best pictures. Laughable, lovable George Luks was whipping out paintings — and good ones — at an accelerated rate. His canvases of *Hester Street* and East Side Docks date from that year; so do the romping *Spielers* and the sad-eyed *Sand Artist*, the red-nosed *Old Duchess* and the dressy *Little Milliner*. No one dared questions Luks' brazen technique, for he had already announced to the world, "I can paint with a shoestring dipped in pitch and lard. . . . Technique do you say? My slats! Say, listen you — it's in you or it isn't. Who taught Shakespeare technique? . . . Guts! Guts! Life! Life! that's my technique."[122]

George Luks had come to accept Frans Hals as his master, often visualizing himself as one of the Dutch painter's jovial, beer-drinking portraits come to life. "Look at Frans Hals and look at me," he would exclaim. "The two greatest painters this world has ever seen." But Hals was never Luks' equal as a pugilist. Luks, the would-be fighter, was in the habit of pounding his chest, then murmuring apologetically: "Sorry, Hals, you couldn't take one of Chicago Whitey's taps, hey?" Turning to his confused audience, Luks would announce: "You see, I just struck Frans Hals. He's always hiding around in me somewhere. . . . Frans Hals moved into me on the day I was born. Wanted me to smooth out some of his crudities. And I've done it!"[123]

John Sloan's tribute to Hals was far less dramatic. In 1904 he had painted his *Boy With Piccolo*, a canvas whose subject is reminiscent of Manet's *Fifer* but whose quiet color and fluent brushwork is "the kind that Hals achieved," as Sloan himself stated.

After John Sloan settled permanently in New York City, his subject matter changed. No longer hampered by a long workday such as he had known on the *Philadelphia Press*, Sloan could now observe the life of the city. From the rear window of his top-floor studio apartment on West Twenty-third Street he could view the backs of a long row of tenements. It was here that Sloan witnessed the lives and loves of

LUKS: *The Spielers,* 1905.

Addison Gallery of American Art, Phillips Academy, Andover

Luks: *Closing the Café*, 1904.

his neighbors: women hanging out wash on the roof-tops by day and sleeping or smooching there by night; a girl in her nightgown washing dishes at noon and a woman fully dressed sipping coffee at 3 A.M.

Like the cop on the beat Sloan also roamed his particular domain, becoming the pictorial historian of lower Sixth Avenue and its environs. He painted the unobstructed view through a hairdresser's window and the entrance to the Haymarket, a notorious dance hall where stags mingled with streetwalkers. He observed the Flatiron Building during a dust-storm, with women's skirts being blown above their knees and a policeman gallantly trying to discourage curious males from loitering. These were the sights and scenes which Sloan saw and painted. These were his "love letters to the great lady of his heart — Manhattan."

In November, 1905, Robert Henri was on the jury of the Carnegie International, which awarded honorable mentions to William Glackens' *Chez Mouquin* and John Sloan's *The Coffee Line*. The double triumph, together with the Chicago Art Institute's recently

awarded prize for Henri's *Lady in Black*, marked the real arrival of the Realists. One critic began referring to Henri and his companions as "a little coterie in New York," prophesying that "these men will come to their own finally. . . ."[124]

Spirit among the group was running high. When a new art gallery opened the following February, paintings by Henri, Sloan, Glackens, and Luks were included in the premier showing. Art critic Charles FitzGerald recorded the event with these encouraging words: "Mr. Sigmund Pisinger's experiment at 11 East 34th Street will be worth watching. Under the title of Modern Art Gallery he has opened a shop filled with the works of painters who, for the most part, have been overlooked by the dealers of Fifth Avenue. . . ."[125]

Robert Henri was rallying his forces. While his confreres were exhibiting at Pisinger's, his students were holding a man-size show of their own at the New York School of Art. The Art Spirit was everywhere. Robert Henri's presence was being felt and acknowledged, the crowning oracle coming from the influential magazine *The Critic* when its pages pronounced: "Mr. Henri is certainly to play a very serious part in the history of American art."[126]

And so he was.

CHAPTER THIRTEEN

ON FEBRUARY 16, 1904, William J. Glackens, age thirty-four, married Edith Dimock of Hartford. "Glack" was the last of the group to utter the nuptial vows and his fellow artists looked upon this event as the fall of the final eligible bachelor from among their ranks.

The wedding was held in the Dimocks' sumptuous mansion situated atop Hartford's Vanderbilt Hill. A special Pullman car was chartered to transport family and guests from Philadelphia and New York to the ceremony, and included in the entourage were Mr. and Mrs. Everett Shinn, George Luks, Charles Fitz-Gerald, and Mrs. Jimmy Preston.

Although the wedding ceremony was to have had top billing, the merrymaking of George Luks stole the show. With both walls and upholstered furniture lavishly covered in pink brocade, Luks stuck a matching pink rose petal on his nose, acting the part of head usher in urging everyone present to make himself at home.

Luks' ensuing imitation of financier J. Pierpont Morgan could hardly have impressed Miss Dimock's sedate parents. The bride, however, was probably more tolerant of the raucous Luks as a result of her attendance at the New York School of Art, where she had been conditioned to such horseplay.

Following the marriage, the newlyweds settled in New York, temporarily setting up housekeeping in a one-man studio in the Sherwood Building. "Glack" had searched in vain for a larger place that would serve as both apartment and studio, but he had found nothing suitable. Yet the inconvenience of cramped quarters was compensated for by companionship, for within a few weeks after the Glackenses settled there, John Sloan and his wife, Dolly, moved over from

Philadelphia and took up residence in Henri's studio in the same building.

With living space at a premium, the group began holding their nightly gatherings at Mouquin's, a restaurant at Twenty-eighth Street and Sixth Avenue. Glackens had been a regular diner there for several years, having once occupied a studio nearby. Now he and his wife, together with the Sloans and the Henris, made the restaurant their rendezvous. Often they were joined by George Luks, Jimmy and May Preston, or Frederic Gruger, all of the old Philadelphia gang.

A major attraction at Mouquin's was the lively discussion on art between critics Charles FitzGerald and Frederick James Gregg, held almost nightly at John Flanagan's table. Both men hailed from Dublin and both penned their literary efforts for the *New York Evening Sun*. On some nights the critics and the artists would gather at the restaurant without their wives and hold pleasurable discussions right up to the 2 A.M. closing time. "It was at Mouquin's that the crowd really became intimate," Everett Shinn once recalled. But Shinn himself missed most of the nightly camaraderie, for "being a teetotaler, I didn't go there much"[127]

By the summer of 1904 the Sloans had moved from their temporary quarters in the Sherwood Building to a top-floor apartment on West Twenty-third Street. The Glackenses, too, had found a place of their own, locating in Washington Square. The artists continued their regular patronage of Mouquin's, which was closer to their new homes than before. Now another painter began making frequent appearances at their table. He seldom talked above a whisper and was frequently all but unnoticed amid

SHINN: *Mouquin's*, 1904.

Courtesy of The Newark Museum, Newark, New Jersey

the clamor of the group. The stranger's name was Ernest Lawson.

The newcomer usually arrived in the company of William Glackens, for when Glackens had moved to No. 3 Washington Square he had met and became friendly with Lawson, whose studio on MacDougal Alley was just one block away. Lawson's quiet manner was not unlike Glackens', and at Mouquin's, where the rumble and hissing steam of the elevated railroad right outside was heard with monotonous

regularity, Lawson's voice often seemed to subside to a faraway murmuring sound. It was once observed that "many a companion had his legs barked by Lawson's energetic shoe as he drove home his opinions under the table."[128]

Ernest Lawson was no newcomer to art. Though two years younger than Glackens, he had already been singled out and labeled as "America's greatest landscape painter" by no less a personage than William Merritt Chase. Yet in his landscapes Lawson

LAWSON: *Winter on the River*, 1907.

Collection of Whitney Museum of American Art, New York

embraced neither the pomp of Fifth Avenue nor the drama of the slums. His inspiration came, instead, from Washington Heights, that part of upper Manhattan that was then merely a sparsely settled area of woods and farmlands stretching out from the banks of the Harlem River.

When Ernest Lawson and his family had moved there in 1898 they found themselves in the semi-seclusion of rural 155th Street, surrounded by a field of oats. Around them also were the subjects soon to

become his favorites: the lofty sweep of High Bridge and the gentle waters of the Harlem River dotted with houseboats and edged with an occasional small pier or shack. Lawson's pictures formed a procession of lonely vistas devoid of people. He often painted a silent blanket of snow encompassing the rugged landscape and allowed only occasional spots of delicate color to shine through the pristine whiteness.

The painter's impressionistic outlook had first found direction in 1890 at New York's Art Students

League, where his teachers included the American Impressionists John Twachtman and J. Alden Weir. Lawson's initial canvas there was a complete failure, a long panel crowded with hills and valleys and rivers and everything he felt belonged in such an effort. "By jove, I have never seen so bad a picture!" instructor Weir exclaimed. [129]

The boy was shaken. A conference with his teacher, and the teen-age Lawson suddenly saw painting in a completely different light. His next at-tempt drew high praise from his mentor and initiated the student's journey along the road to success.

Prior to enrolling at the League, Lawson's art experiences had been meager and varied. In Kansas City at the age of fifteen he had studied art for a brief period, then was apprenticed to a demonstrator who taught housewives how to stipple designs on table-cloths. The youngster soon became more proficient than the professor at copying the dogs of Rosa Bonheur. The next year, 1889, found Lawson with his

LAWSON: *Spring Night, Harlem River*, 1913.

The Phillips Collection, Washington

father in Mexico City, employed as a draftsman making detailed cross-sections of a proposed canal. There, too, he studied art, this time at the Santo Carlos Academy. But the student was taught only to copy engravings at the rate of one square inch a day, a routine which he could endure for only a month. Then to New York and the Art Students League.

Despite the stimulation of his later instructors, Lawson did not forget his first art teacher in Kansas City. She had been eighteen-year-old Ella Holman and only three years his senior. In 1895, seven years after those initial lessons, the two were married.

During the evening get-togethers at Mouquin's, Lawson seldom spoke of his past, for he was usually an attentive listener. But one night he dramatically rolled up his sleeve and suddenly announced with pride: "Here is my first work of art, this tattoo on my left arm. I was about ten years old and had a nurse whose husband I admired very much. He was literally covered with tattoo designs.

"I got some gunpowder and a needle," Lawson continued, "and started with a small anchor. But that did not suit me so I went on to this star. I thought it was quite fine and proudly showed it to my father. 'Come upstairs with me,' was all that Father said. . . . At this time Father had discarded the old-fashioned birch rod and used either a brush or his bare hands. I think he used the brush then. I tried to make no noise at all and I think I succeeded. And so a spanking was my reward for my first work of art."[130]

Then the rumble of an elevated train served conveniently to allow the shy speaker to relinquish the floor.

The happy times at Mouquin's did not go unrecorded. In 1905 William Glackens painted what is now perhaps his best-known work, an intimate glimpse of *Chez Mouquin*. Long after the famous eating place had passed from the New York scene the canvas would serve as a monument to its hospitality. For once Glackens abandoned his usual stand-offishness and depicted a close-up view of an elegantly dressed couple seated at one of the restaurant tables, with glasses of wine set before them.

Could this have been meant as a sophisticated counterpart of Degas' *Absinth Drinkers* or Lautrec's *Worthless*? Or perhaps the American equivalent of Renoir's *The Loge* or Manet's *At the Café*? Whatever

influence pervades the work, for Glackens the representation had special meaning: Seated here at Mouquin's is the wealthy bachelor James B. Moore with one of his "daughters," as he preferred to call his female companions. In the wall mirror behind the couple can be observed the reflected faces of Glackens' wife Edith and future brother-in-law Charles FitzGerald.

James B. Moore was himself a restaurateur, operating his competing Café Francis at 53 West Thirty-fifth Street. As Moore was independently wealthy the restaurant business was merely a hobby with him. For this reason he did not mind being seen in Mouquin's, or even having his likeness painted in the rival owner's camp. However, soon after the Glackens canvas was completed, the two restaurant proprietors had a misunderstanding. Out of spite the ruffled Mr. Moore lured Mouquin's chef to his own establishment, and subsequently the Café Francis began enjoying the patronage of the artists who had previously frequented Mouquin's. Soon James B. Moore was advertising his Café Francis as "New York's Most Popular Resort of New Bohemia."

More often than not the artists held their nightly gatherings in Moore's home on West Twenty-third Street rather than at his restaurant. The gracious host referred to the hidden confines of his four-story brownstone mansion as "The Secret Lair Beyond the Moat," perhaps an appropriately romantic designation from the grandson of Clement Moore, author of " 'Twas the Night Before Christmas."

The first-floor parlor resembled a museum, housing paintings by Lawson and Shinn and other contemporaries, together with a vast collection of bronzes, tapestries, cut glass, and the finest examples of Sheraton and Chippendale furniture.

Yet it was the sub-basement that held the greatest interest, and was often referred to as "the most remarkable cellar in New York." The walls of this subterranean retreat had been covered with bare canvas from floor to ceiling in hopeful anticipation of some spontaneous artistic efforts. And Mr. Moore's guests did not disappoint him.

Within six months the room decorations were all but complete, even though attempting to view them through the continual haze of cigar smoke and past the huddled forms around the shuffleboard and rifle

GLACKENS: *Chez Mouquin* (At Mouquin's), 1905.

range was sometimes quite difficult. On one wall was painted a sequel to Glackens' *Chez Mouquin*, a nearly life-size representation of James B. Moore and one of his "daughters" walking away from a restaurant table. But this time the background of the composition was different and the masterpiece was clearly labeled *At the Café Francis.* In the lower right-hand corner it was signed in an oversized scrawl *George B. Luks.*

On another wall Everett Shinn had painted a theater scene in which he featured a captivating dancer caught in a shimmering spotlight. Henri's contribution consisted of a portrait of Jim Moore with a group of his friends, while John Sloan depicted the host being enticed by the devil. Other wall space featured a variety of subject matter, ranging from river scenes by Ernest Lawson to the Katzenjammer Kids by Rudolph Dirks.

The paintings created an air of frivolity along the walls of the shooting gallery and in the areas designated for shuffleboard and "frog," a then-popular game similar to quoits. On one occasion when Moore was absent, Sloan, Glackens, and Shinn collaborated on a particularly humorous decoration which represented the host in high hat and ladies' lingerie playing "frog" with feminine accessories. Bizarre caricatures of the rest of the crowd were included in the background of this "masterpiece," with each shown gawking at the strangely attired Mr. Moore. "James

says it is too bad it will have to be painted out," Sloan wrote to Henri in March, 1906. "I hope this doesn't happen before your return, for it is a funny thing."

Henri was in Aiken, South Carolina, at the time, spending five leisurely weeks painting the portraits of three children. Although grateful for news from New York, he was in no mood for frivolity. His trip to the South was not occasioned by the lure of the portrait commission but rather as an escape following the untimely death of his wife Linda. Henri was terribly shaken by the loss of his companion of only eight years. Sloan's letter, written in a light vein, had been calculated to cheer his despondent friend, but Henri could only write back about the melancholy tranquility of the South, the softness of summer with birds singing all about and the air laden with fragrance.

When Henri returned to New York in April, he seemed lost without his wife. His studio served to bring back haunting memories and he had no desire to paint. Sloan and Glackens opened their homes as well as their hearts, taking turns inviting the lonely widower to spend a night with them.

This was a difficult period in the life of Robert Henri, but his lethargy was not of long duration. New problems developing in the art world around him would soon serve to reawaken an interest in his other love, Painting.

CHAPTER FOURTEEN

WHILE Robert Henri was in South Carolina mourning the loss of his wife, John Sloan was witnessing the sad demise of the Society of American Artists in New York City.

The final, doleful exhibition of the once-proud Society had opened on March 17, 1906, at the American Fine Arts Society galleries. There followed the customary month-long display of nearly five hundred works of art, after which the Society was to pass into limbo. By prearrangement, the National Academy of Design, the staid Academy from which the Society had once seceded, would obligingly absorb its members.

John Sloan recorded the event in his diary with an obvious note of regret: "It seems to me that it narrows things down," he said, then added hopefully, "until a large new gallery is built."[131] The dissolution of the Society meant that there would now be one less organization to which the growing horde of artists might submit their work in the hope of having it accepted and hung, one less outlet through which the artist might hope to reach out and touch the vast, unenlightened public.

The history of the Society of American Artists is the story of a vital art movement, founded by vigorous youth and allowed to die by the growing conservatism of middle age. It is the story, perhaps, of the rise and fall of progressivism in art and typical of most avant-garde movements.

In the decade following the Civil War, American art students flocked in ever-increasing numbers to the art centers of Europe. Whereas prior to 1860 Americans had turned mainly to Düsseldorf for study, a decade later Munich was their goal. The loss of prestige at Düsseldorf was largely due to the death, in 1862, of Wilhelm Friedrich von Schadow, the Düsseldorf Academy's influential director, plus the transfer of one of the foremost German picture collections from Düsseldorf to Munich.

In the Düsseldorf school, as in the ateliers of Paris, a premium was placed upon competence in drawing — meticulous, carefully measured drawing. Such was not the case in Munich, however, where emphasis centered around the skillful and speedy manipulation of paint and the practice of drawing directly with the brush. Utilizing this approach, the Munich men, as they were called, produced paintings that embodied a great deal of spontaneity and bravura, just the opposite of the slick, formless finish inherent in the work emanating from Düsseldorf.

The Royal Academy in Munich was housed in a converted monastery. Cubicles, formerly monks' cells, were used as studios. Under the poor lighting conditions in such quarters, students found it difficult to duplicate the effect of daylight in a painting. Consequently, one marked characteristic of the Munich school was the predominant use of dark colors, with landscapes and interior scenes assuming a similar swarthy tonality.

In 1870 there were only forty Americans studying in Munich. But the number quickly doubled, caused, in part, by the waning interest in Düsseldorf and in larger measure to the then-current siege of Paris, which city found itself in the throes of the Franco-Prussian War. Before long many of the Munich men were returning to America, full of the confidence and vigor that the Munich approach to painting was bound to instill in its devotees. The Munich men expected to be greeted with open arms. They had high hopes of setting up studios, being swamped

with commissions, and becoming rich and famous overnight. But many were quickly disillusioned.

The National Academy of Design in New York was obviously no haven for them. Its members jealously guarded their right to place their own paintings along the limited wall-space available for annual exhibitions. The academicians preferred to ignore these young upstarts and so prevent the possible competition they might represent. Since the National Academy's yearly shows guaranteed the inclusion of at least one jury-free work by each academician, the Academy annuals were of necessity conservative and nearly always retrospective in nature. For this reason, creative and experimental works were almost invariably shunned.

Yet the Munich men were encouraged by the initial successes of some of their colleagues. William Merritt Chase and Walter Shirlaw, for instance, had submitted paintings to the Philadelphia Centennial Exposition of 1876 while both were still in Munich. Not only were their canvases accepted, but they were awarded medals in competition with the best the United States had to offer. Similarly, Frank Duveneck had won numerous prizes at the Munich Academy, and when he exhibited five of his canvases in Boston in 1875 his work received overwhelming applause.

It was in the spring of 1877 that about a dozen of the European-trained artists hopefully submitted their work to the annual exhibition of the National Academy of Design. According to established prac-

Cincinnati Art Museum

DUVENECK: *Whistling Boy,* 1872.

tice, a jury would vote to determine the acceptable entries, after which a three-man committee would decide where each work was to be hung.

In those days of flickering gaslights, when it was the custom to arrange pictures in a number of tiers from eye level up to the ceiling, the placement of a painting in a chosen spot was as much an honor as the actual inclusion of the work in an exhibition. Dark corners were naturally shunned, and having a work "skied" was most undesirable.

It had been a time-honored tradition at the National Academy for the paintings of academicians to be placed in the choice locations, at eye level "on the line," with the remaining wall space available for the work of outsiders. In this particular year, 1877, a Munich-trained artist named Charles H. Miller was a member of the Academy's influential Hanging Committee. Though a conservative painter himself, Miller was much impressed by the work of the Munich men — so much so, in fact, that he arranged for the paintings of the younger generation to be placed "on the line."

The academicians were furious. A special meeting was held and a resolution was promptly approved: "That in our Annual Exhibition hereafter each Academician shall be entitled to have two pictures hung on the line (excluding the corridor) provided the space occupied thereby shall not exceed eight feet."[132] This decision, formulated in haste by aroused and offended academicians, proved to be their undoing. In June, Augustus Saint-Gaudens, incensed at the rejection of one of his sculptures, met with Walter Shirlaw, Wyatt Eaton, and Helena DeKay to form an association "with the object of advancing the interests of Art in America."[133] This meeting marked the founding of the Society of American Artists.

Within a year the new group could boast of twenty-two members and within a decade the hundred mark had been passed. The Society's success was due in large measure to its open-armed welcome to all comers, for even though members paid annual dues of ten dollars, their work was not exempt from jury action. The democracy of the Society's jury system was further emphasized by the practice of concealing all artists' names before the paintings were presented for judging.

In 1878, National Academy president Daniel Huntington noted the absence of some previous exhibitors from the Academy annual. In his official report he questioned the fairness of the recently invoked "eight-foot rule" and acknowledged that "the absence of the new and perhaps stormy element has undoubtedly caused some stagnation and weakened the exhibitions. . . . If we have been slow to acknowledge the merits of the younger men, if we have barred the door of entrance too obstinately, let us correct the error in a magnanimous spirit." Then the Academy president suggested his solution: "Among the younger men whose works for years have proved talents, there are several that we should welcome into our body. Let us in the elections today show a discriminating liberality, be generous as well as just and thus send some new and hot blood through our old veins."[134]

The Academy was quick to accept its president's advice. Among others, it singled out Walter Shirlaw, president of the Society of American Artists, and bestowed upon him the honor of becoming an associate member. Within a year, however, Shirlaw had divested himself of the title as a protest against the Academy's continued lack of progressive vision. By hurling this rebuff at the Old Guard, Shirlaw served to give strength and a sense of distinction to the infant Society.

In the years immediately following its founding the Society of American Artists was the most vital art force in America. Although it was never to enjoy the aura of social prestige that had formed around the National Academy, the Society nevertheless attracted the attention of all by its great and wonderful deeds. In 1879 the young organization demonstrated an early appreciation for Mary Cassatt when she was invited to show her work at its second annual exhibition. Three years later the Society's exhibit included Whistler's *Portrait of the Artist's Mother*, the first New York showing of this now-famous painting.

By so focusing attention on these two American expatriates the Society suggested that this country's art collectors might consider the merits of their fellow countrymen, already accepted abroad, instead of continuing to patronize their English, French, and German contemporaries. The Society's European-trained members found it difficult to reconcile themselves to

WHISTLER: *An Arrangement in Black and Gray* (Portrait of the Artist's Mother), 1872.

The Louvre, Paris; Giraudon Photograph

America's barren artistic temperament. On the Continent painting was a lucrative profession while in America its practice could not even earn daily sustenance.

The Society of American Artists had not been the first to recognize the overwhelming patronage of European art. In Philadelphia nearly a decade before the Society's founding a lone American had seen the threat and, what is more, had done something about it. Edward Moran, a Pennsylvania Academy

graduate, took issue with the school's directors in 1868 when they flooded the Pennsylvania Academy's annual exhibition with their own collection of German paintings. Worse yet, most of Moran's six entries had been hung in inconspicuous positions while the imported works were prominently placed "on the line." To show his contempt for the directors' action, Moran gained entrance to the gallery prior to the show's opening and completely covered his works

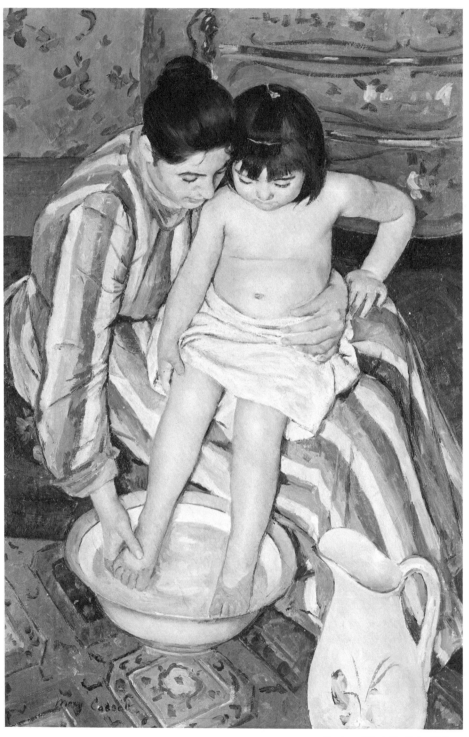

CASSATT: *La Toilette* (The Bath), 1891.

Courtesy of The Art Institute of Chicago
Robert A. Waller Fund

with bright red paint. His brazen conduct was justly rewarded when a local patron, realizing that the newly applied coating could be readily removed, bought the entire lot and later exhibited them prominently in a downtown store window as "expatiated pictures."[135]

Thirty years later a chorus of ten artists' voices would rise in unison against the continued patronage of European art by American collectors. "The American Ten," as they were patriotically dubbed, banded together in 1898 for the purpose of mutual advancement. Among their number were Childe Hassam, J. Alden Weir, and John Twachtman — not young upstarts, these, but men of middle age who were identified with this country's foremost artists. * Several of The Ten had gained some recognition as Munich men in the seventies, but by the 1890's they had removed from their palettes the somber gravy-brown Munich colors in favor of the dazzling brightness of Impressionism. In so doing they envisioned themselves as America's daring innovators. Yet in the eyes of this country's public and press their work rated only second-best in competition with the approved style of the European Impressionists.

WEIR: *Green Bodice.*

The Metropolitan Museum of Art
Gift of George A. Hearn, 1906

As early as 1893, Twachtman and Weir had experienced firsthand the public's expression of favor for foreign art. In that year the two exhibited their paintings at the American Art Galleries beside canvases by French Impressionists Claude Monet and Paul Albert Besnard. The Frenchmen's works were included solely for the purpose of illustrating the origin of the style, yet the influential art critics applauded the sparkling foreign pictures to the neglect of the Americans'. As a result, the Monets and Besnards were acquired by American patrons while the native artwork of Twachtman and Weir went unsold.

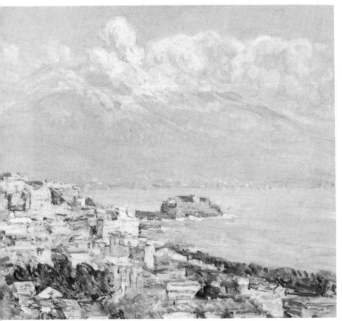

HASSAM: *Mount Vesuvius,* 1897.

Hirshhorn Museum and Sculpture Garden,
Smithsonian Institution

* Besides Hassam, Weir, and Twachtman, The American Ten consisted of Frank W. Benson, Joseph De Camp, Thomas W. Dewing, Willard Metcalf, Robert Reid, Edward Simmons, and Edmund C. Tarbell. Upon the death of John Twachtman in 1902, William Merritt Chase was chosen to take his place.

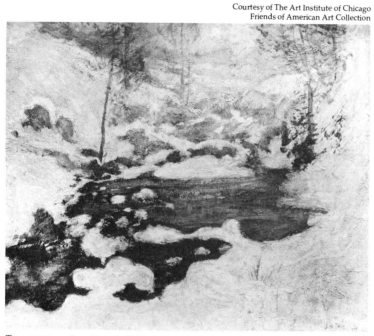

TWACHTMAN: *Snowbound*, 1885.

An embittered Twachtman told a group of young art students of their inevitable plight: "You are studying Art here now, and some day some of you will become painters, and a few of you will do distinguished work, and then the American public will turn you down for second- and third-rate foreign painters."[136]

In an attempt to create a market for their work, The American Ten inaugurated, in 1898, the first of some twenty annual exhibitions. In so doing they offered the first competition to the National Academy and Society of American Artists annuals. The Ten gradually grew in stature so that by 1907 their collective canvases were being proclaimed as "the most complete display of modern American work." But even The Ten's annual exhibition could not immediately turn the tide of European patronage. In 1905, seven years after their first annual show, Sir Caspar Clarke came from England to assume the directorship of the Metropolitan Museum of Art. After an initial look at what New York's private collections and galleries contained, he expressed complete surprise at what he found: "Americans appear to be concerned with the art of every land save that of America."[137] And Clarke was not to witness any im-

BENSON: *Portrait of a Lady*, 1901.

TARBELL: *Josephine and Mercie,* 1908. In the Collection of The Corcoran Gallery of Art

REID: *Fleur-de-lis.* The Metropolitan Museum of Art
George A. Hearn Fund, 1907

mediate change in the situation.

Meanwhile, the Society of American Artists' first fires of revolt had begun to burn themselves out. By the 1890's the organization was assuming a course that nearly paralleled that of the Academy, for the youthful revolutionaries had now become middle-aged conservatives. Thomas Eakins, one of the first to join the new movement, had his monumental *Agnew Clinic* rejected from the Society's fifteenth annual exhibition. Disappointed and disillusioned, Eakins was determined never to submit his paintings again. And yet this was the same Society which, just thirteen years before, had threatened to withdraw its entire exhibition from the Pennsylvania Academy unless Eakins' *Gross Clinic* was included.

From the beginning, the Society had recognized that certain members of the National Academy were in sympathy with its cause, and as these men's feelings were assured, academicians like John La Farge and Louis Comfort Tiffany were allowed to join the new without abandoning the old. Soon the Academy inaugurated its own campaign of electing members of

the Society to its ranks. Eventually the two groups became so intertwined that by the turn of the century the National Academy had elected to membership all but two of the twenty-two artists who had been represented in the Society's initial exhibition. By the time of the Society's twenty-third annual show it was not surprising to learn that one of the jurors chosen to select the paintings was an instructor at the National Academy. The breech was finally and completely sealed in the year 1900 when Frederick Dielman, one of the Society's founders, was elected president of the National Academy of Design.

From the outset of Dielman's tenure in office there was talk of reuniting the two groups, and within a few years Robert Henri lent his support to the movement. Although he was regularly represented in both the Society and Academy annuals, the academicians, those guardians of American Art, nevertheless saw to it that as little attention as possible was paid to his work. Together with other paintings which lacked academic comformity, Henri's canvases were placed high on the wall or were exhibited in inadequate light, rather than under the choice illumination of the prominent locations.

Charles FitzGerald of the *New York Evening Sun* had recorded the inequities in his art column: "In April, 1901 Henri sent his lovely 'Figure of a Girl' in a white blouse, since unfortunately destroyed. It was one of the most notable contributions, and the hanging committee put it in a wretched little side gallery where its strength and beauty were dwarfed so as to escape the observation of all but the most observant. . . ."[138]

In 1903 FitzGerald reflected on the previous season's exhibition, when he had again taken exception to the placement of a Henri canvas: "Last year we had the misfortune to disagree with the Society of American Artists. . . . The picture was thrust into an impossible corner and quite innocently we found fault with the hanging committee, an indiscretion which was duly rewarded with a furious letter of eight pages from a member of the committee. . . ."[139]

Charles FitzGerald observed in his column that other artists were being similarly slighted. In the 1903 exhibit William Glackens' painting of a ballet dancer was assigned to a side gallery, where it "shares the skyline" with George Luks. "Are the

makers of public exhibitions officially blind," Fitz-Gerald expostulated, "are juries constitutionally incapable of recognizing what is vital, or is it that societies are intended primarily as hospitals for the sickly or moribund in art?"[140]

In 1903 Robert Henri became a member of the Society of American Artists, and in each of the following two years he was elected to its thirty-man Committee on Selection, a deliberately heterogeneous group whose duty it was to choose the paintings for the annual shows. The persuasive Henri made his preferences known and his influence felt, for in 1904 works by Sloan and Shinn were included for the first time. By the following year, paintings by Sloan, Glackens, Luks, Shinn, and Henri had all gained admittance.

Despite Henri's place on the Committee on Selection, he could exercise no control over the favorable hanging of his confreres' work. Moreover, in years when he was not a member of the jury, his friends were at a decided disadvantage, as evidenced by their smaller representation in the shows. In the final exhibition in 1906, the names of John Sloan and George Luks were noticeably absent from the list of exhibitors.

By that year the Society of American Artists and the National Academy of Design had become almost analogous, to the extent that three-quarters of the Society's membership had been elected to the Academy. Moreover, the two groups were governed as one. Nine of the eleven-man Academy Council belonged to the Society, while three of the Society's four-man Advisory Board also belonged to the Academy. Robert Henri was included among the latter group, having been elected to the Society's Advisory Board in 1905, the same year the Academy saw fit to bestow upon him the honor of being an associate member.

In January, 1905, the administrative body of each organization appointed a three-man committee to discuss the advisability of amalgamation. Henri, Kenyon Cox, and Samuel Isham represented the Society, and Frederick Dielman, Charles Yardley Turner, and Harry Watrous were delegated by the Academy. All six men held dual memberships so that, in reality, they each represented the interests of both groups.

The joint report this committee submitted out-

lined certain changes necessary in order to effect the merger. As it developed, the most important among these was the Academy's acceptance of the Society's more liberal jury system and the election of Society members to the National Academy. Under the plan all artists who belonged to the Society but who had no affiliation with the National Academy of Design would automatically become associate members. Similarly, Society members who had previously been associates would be elevated to the rank of academician. Among the former group was William Glackens, who had just recently joined the Society; included in the latter was Robert Henri, an associate since 1905 who would now gain academician status.

In February, 1906, the National Academy voted thirty-five to one in favor of the merger. The following month the Society agreed unanimously to the plan. The Society's financial holdings were then transferred, the action legalized, and on April 7, 1906, three weeks before the close of the Society's final exhibition, the amalgamation was consummated.

Robert Henri was enthusiastic about the new plan, visualizing in it an opportunity for his colleagues, his students, and all other deserving artists to share in the Academy's prestige. In the fall of 1906 Henri stated his position in these words: "Change opens chance; as things were they stood still. Better take the chance of moving either right or wrong than to stand still. This rearranged Academy will be equal to the stuff of which it is made, no more, no less, and it will receive the chastisement of its rebels, or those outside, according to the stuff there is in the rebels."

Then he added emphatically: "I am for the institution in so far as it is useful, and when it is in the way I am for removing it." And before six months had elapsed, Robert Henri would have the opportunity to show that these were not mere idle words.[141]

CHAPTER FIFTEEN

AS THE New York Realists' accumulation of unsold canvases grew larger in the corners of their studios, they joined the ranks of a host of other American painters who vainly sought a market for their art.

The established annual exhibitions were not the answer, for even the inclusion of a canvas or two did not alter the fact that the chance of a sale was practically nil. By 1906 John Sloan, then a man of thirty-five, had not sold a single painting, and another half dozen years were to elapse before his first purchaser appeared. George Luks' prolific output had resulted in a stockpile of nearly two hundred paintings, which were stacked along the walls of his studio.

At the turn of the century there existed only a handful of private galleries in New York City, and most of these confined themselves to handling European imports. But a very few, such as Kraushaar's and Knoedler's, were also showing the works of America's "old masters" as well; yet even they only occasionally allotted wall space to a living American painter. The lone exception to this general exhibition policy was a basement gallery on lower Fifth Avenue, the pioneering effort of William Macbeth.

From the day the Macbeth Gallery first opened its doors in 1892, its sole concern was for "the permanent exhibition and sale of American pictures." The public sensed little significance in this departure from tradition, yet Macbeth's quickly became a haven for the more individual among the American painters.

Almost from the outset the reputation of the gallery was associated with the success story of a tall, solemn upstate New York artist by the name of Arthur B. Davies. Macbeth offered initial encouragement by exhibiting a few of the artists' strangely placid yet captivating landscapes. Next, the dealer enlisted the aid of merchant Benjamin Altman, who financed a trip to Italy for the artist. Then, in 1896, Macbeth gave Davies his first one-man show, an event which the gallery owner labeled as having "excited more interest and comment than any of my previous exhibitions. . . ."[142]

Such a pleasant reception called for another solo exhibition the following year. By this time, 1897, the fame of both gallery and artist had spread sufficiently to cause Robert Henri, then still living in Philadelphia, to make a one-day jaunt to New York for the express purpose of visiting the show. Henri missed meeting the exhibiting artist that trip, but Davies wrote him suggesting that they might attend a Carnegie Hall concert together when Henri next came to Manhattan.

After Henri had settled permanently in New York City he became better acquainted with Davies, who by 1900 was living upstairs from the Macbeth Gallery. Sometimes Henri and Davies shared the same model, the future Ziegfield Follies dancer Jesseca Penn. Henri preferred to pose the red-haired beauty as a statuesque young woman dressed in a flowing black gown while Davies would have her dance, then hold exaggerated positions just long enough for him to capture the momentary attitude in pastel.

In 1902 Henri held his first one-man exhibition in New York City at the galleries of William Macbeth. On that occasion only a few of the critics saw fit to applaud Henri's artistry. Many, however, were openly critical, citing his spontaneous effects as "mere child's play" in comparison with painting carried out "to a sober logical finish." One review lampooned the choice of Macbeth's small gallery "for the

DAVIES: *A Line of Mountains*

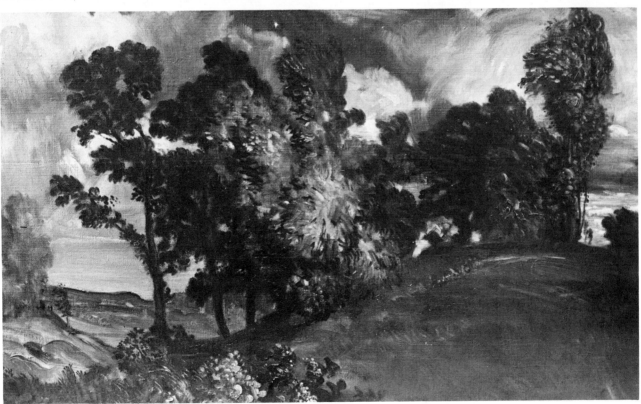

DAVIES: *Night's Overture–A Tempest*, 1907.

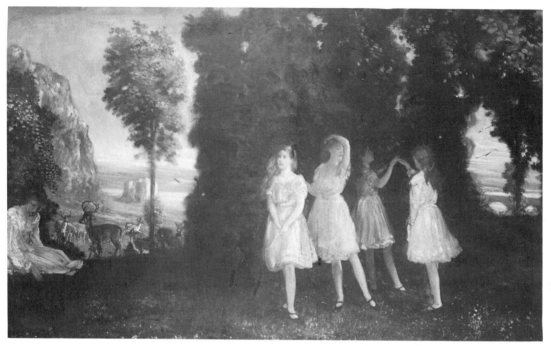

DAVIES: *Dancing Children*, 1902. In The Brooklyn Museum Collection

DAVIES: *Nudes in a Landscape*. Courtesy of The Newark Museum, Newark, New Jersey

work of a man who does much of his painting with a varnishing brush four or five inches in breadth."[143] Soon the representations of slum children by George Luks also began appearing on the Macbeth Gallery walls, and these subjects met with remarks equally uncomplimentary.

In the first years of the twentieth century it took daring and courage for a gallery owner to display such wares. One of the leading magazines of the day had already taken its stand against such subjects as Luks' dirty-faced urchins by forbidding the portrayal of men in rags on its pages. Another periodical had established a similarly prudish policy which prevented it from reproducing any picture of a girl displaying gleaming white teeth for a toothpaste ad.

On all sides one found that stark realism in art was seldom tolerated, much less extolled. This era witnessed the emergence of Anthony Comstock and his "Purity League," the so-called League of Decency, whose escapades in the name of Justice supplied front-page fodder for the newspaper presses. In the summer of 1906 Comstock was busily engaged confiscating all copies of an Art Students League publication because it contained reproductions of the undraped female form. League students retaliated by hanging the vice-hunter in effigy from a window of the art school. One of the League's instructors was sufficiently incensed to suggest publicly that Comstock's next raids be focused on stores selling *Gray's Anatomy*. Yet this was Comstock's day to howl and the "obscene" issue of the League publication was the last to appear.

The New York Realists were having their troubles in this prim and strait-laced society. A few years before, William Glackens had been approached to illustrate an ambitious fourteen-volume edition of the novels of Charles Paul de Kock. Glackens called in his associates as collaborators, and subsequently Sloan, Everett Shinn, Ernest Fuhr, and F. R. Gruger all contributed to the enterprise.

Glackens soon learned that while spicy stories about the intriguing triangles of nineteenth-century Parisian life were permissible as reading matter, they were much too suggestive to be illustrated. The artist happened upon a dramatic passage in de Kock's *Friquette:* ". . . But at this instant the portière was thrust rudely aside and the Baron Spiterman ap-

peared at the entrance to the boudoir; when he saw Belatout at the feet of Ethelwina, who had one arm around his neck and seemed to be about to kiss him, the German uttered a formidable oath and advancing toward Belatout he knocked him over so that he rolled five feet away from Ethelwina. . . ."

Glackens' completed illustration was a masterpiece of dramatic art, picturing the noble German interloper, the startled female poised on the edge of her bed, and the nightshirted lover sprawled on the floor, the object of gaping glances from a crowd which had gathered in the doorway. But this, thought the publisher, was too extreme. Glackens was instructed to revise the drawing, to eliminate the floored lover and put an overturned armchair in his place.

But now, in the toned-down version, the ranting baron raves and the gaping crowd stares wide-eyed at having found the lady with a chair! So Glackens' realism had to be discarded altogether, and another artist, Louis Meynell, was called in to produce a more readily acceptable, if less accurate, illustration.

The de Kock commission had provided John Sloan with an opportunity to produce his first serious efforts in the graphic arts. In 1902 he created a series of three illustrations for *Monsieur du Pont,* the first of the fourteen de Kock volumes to appear. The capable etcher sent a set of proofs to Robert Henri in New York. Henri acknowledged their receipt with a letter of praise: "Saw Glack on Saturday. He said the limit about your etchings. . . . I also showed the etchings to Davies, who was in to see me a couple of days ago. He said, 'Nothing better has ever been done.' . . ."[144]

Sloan's immediate mastery of the etching needle led him, in 1905 and 1906, to produce a series of ten prints of New York City life. From the inked surfaces of his copper plates emerged the pompous ladies in *Fifth Avenue Critics* and the unashamed embrace of *Man, Wife and Child,* the barefoot, indigent female of the slums reading of her uptown counterpart in the *Women's Page* and the snobbish, know-it-all *Connoisseurs of Prints.* Sloan had created these dynamic etchings without the necessity of pleasing a newspaper or magazine editor, yet they were still honest reporting, sometimes witty, sometimes acid, but always realistic slices of life.

In April, 1906, the artist exhibited all ten of the etchings at Pisinger's Modern Art Gallery. That same

Collection of the Author

SLOAN: *Memory*, 1906. *From left:* Robert and Linda Henri, Dolly and John Sloan.

SLOAN: *Fifth Avenue Critics*, 1905.

Sloan Collection, Delaware Art Museum

month the American Water Color Society invited him to display the set at their annual exhibition. Sloan was delighted, but almost immediately his sense of achievement turned to dismay when he learned that only six of the ten etchings would actually be hung at the exhibition.

When the Water Color Society's preview showing took place on the evening of May 2, Sloan approached a committee member to ascertain the reason for their not exhibiting four of his prints. He was informed that, upon close examination of his work, the committee had found the particular prints in question "too vulgar" for a public exhibition. "I asked the chairman to be introduced to some of these sensitive souls," Sloan reported, "but he would not comply. I was 'madder' than I can describe. . . ."[145] When the indignant artist demanded that his six acceptable etchings be withdrawn from the show, he was told that such action was against the rules of the Water Color Society.

"That Society has gone to seed," Glackens wrote in a letter two days later. "Another watercolor, pastel, etching and lithograph society has been formed. Consists of sixteen. J. Alden Weir, Winslow Homer, Sloan, Glackens, Henri, Childe Hassam, A. Sterner, A. B. Davies, Prendergast, J. Myers, Metcalf, Smedley, R. Reid, E. Lawson, E. Shinn, G. Luks, a fine mixture. They are to give a show in the autumn. No juries. Hang what you please. Place to be allotted by drawing a number from a hat."[146]

But this proposed exhibition, so distinguished in character, never materialized. The show had been slated to open that fall at the Pisinger Gallery, but on May 22 Mr. Pisinger sent the artists word that he was selling his interest in the gallery.

In the meantime, John Sloan had shown his "vulgar" etchings to the proprietor of a bookstore a few doors from his studio, and on May 24 the first of his series of ten etchings was prominently displayed in the bookstore window. Each day a different print appeared beside a neatly lettered sign which read: "An incomplete set was shown at the American Water Color Society Exhibition."

Sloan made the rounds of the print dealers, but he was unable to arouse their interest in his New York series. They were reluctant to harbor these outlaw works, even on consignment. When he returned to the bookshop in midsummer to claim his unsold etchings, he was confronted with the entire set. Resigned to such disappointments, the artist recorded in his diary: "None sold yet — Only appreciable effect being soiled mats from a leak in a heavy rain."[147]

For Sloan disappointment was suddenly coupled with loneliness. His wife Dolly was off spending the summer in Philadelphia, the Glackenses were vacationing in Paris, and Henri was in Madrid with his students from the New York School of Art. As the sweltering days wore on Sloan systematically revisited his old Manhattan haunts, spending long hours alone observing the drama of everyday life. During the day he would often loll in Madison Square, his eyes fixed in a half-hypnotic stare at the pulsing jet of water surging forth from a decorative fountain. At night he would gaze upon the rooftop activities of couples who sought open-air relief from the sweltering summer sun.

Finally one summer afternoon Sloan's solitude came to an end when a vacant studio across the street from his was rented by artist Jerome Myers. Sloan and Myers had been slight acquaintances previously but now they quickly became close friends. As Sloan confided in his diary: "He is certainly a good kind fellow and likes me."[148]

Myers was himself a Realist painter, but of the sentimental variety. In a self-portrait his physiognomy appeared not unlike that of Rembrandt, while in real life he was constantly being accosted by autograph seekers who mistook him for the pianist Paderewski.

Myers' art was that of the ghetto and Little Italy, the lower East Side. There his particular brand of Realism transformed the misery of the beleaguered masses into poetry and beauty. The street urchins of George Luks were made to appear more respectable in Myers' canvases, where they consistently emerged dressed in their Sunday best.

For Jerome Myers summer in New York was a joy. When the mercury soared it was certain to bring his tenement subjects swarming out into the streets and parks of the city. Sloan purchased a wooden sketchbox and together with Myers tried painting out-of-doors. For Sloan this was a new experience; ever since his first Philadelphia canvases he had been creating cityscapes in the studio from memory.

MYERS: *The Tambourine*, 1905.

The Phillips Collection, Washington

One morning when Myers set out to sketch the city Sloan remained at home, glued to his accustomed perch at his studio window. As he observed the waning summer he spotted first a wisp of smoke, then fire, issuing forth from a building across the street which adjoined the Myers studio. "Sloan came over to rescue my family," Myers later recounted, "remaining a calm hero when I returned."[149] For Sloan the impulsive act and ensuing excitement became the most stimulating event of the summer.

With the advent of fall John Sloan was abruptly jarred from his lethargy. Henri was still in Spain when classes at the New York School of Art were scheduled to resume, and the school's director invited Sloan to substitute for the errant mentor. Sloan found teaching very demanding and exhausting

work. When he wrote Henri to learn the date of his return, Sloan conceded: "Your 'states of collapse' will be forgiven by me in the future . . ."[150] to which Henri sympathetically replied: "I am so sorry, John, that so short a professorship should have given you such a severe look."[151]

As a weary Sloan relaxed in his studio one mid-October evening, a shuffle was heard in the darkened hall outside; then a voice spoke out: "Have you heard that Henri's back?" It was Henri! And in a matter of seconds his six-foot frame was sprawled upon the couch in its accustomed position.

Sloan proved to be an eager and attentive audience when Henri produced the results of his summer in Spain. He surveyed with admiration a number of small, sketchy landscapes of Segovia and larger can-

Arthur G. Altschul Collection

GLACKENS: *The Boxing Match, July 4, 1906*, 1906.

vases of a bullfighter, a Spanish officer, and an impressive full-length likeness of a gypsy strumming his guitar. Then Henri leafed through a hundred photographs of paintings by Goya, Velásquez, and El Greco. And as these reproductions were enriched by his illuminating commentary, they seemed to radiate the verve and excitement that must have been inherent in the originals. Finally Henri brought forth a group of Goya etchings, a gift to his stay-at-home confrere.

On the day following, the two visited Glackens and viewed his impressive summer output, which included youngsters flying kites above the rooftops of Montmartre and bathers and strollers loitering along the beach at Dieppe. In addition to showing eight or nine handsome oil paintings, Glackens thumbed through a number of humorous sketches to the amusement of his guests.

The results of Henri's and Glackens' European sojourns were now thought of as likely entries for the National Academy of Design's Winter Exhibition, which was slated to open in December. At Thanksgiving dinner Glackens, Henri, and Sloan toasted to each other's success in the show, the first to be held since the Academy's amalgamation with the Society of American Artists. But after the judging the following week, the trio pondered the sad outcome: Sloan had but two of his five paintings hung, and both were "above the line"; only three of Henri's works were displayed (one was accepted jury-free because of his status as an academician); while all works by Glackens, as well as those of Luks and Shinn, had been rejected.

The sense of disappointment was keenly felt. Their pipe dreams of a liberalized, rearranged Academy had suddenly gone up in smoke. One newspaper review of the exhibition seemed to express their feelings accurately: ". . . The expected has happened, for the show takes on the qualities of both the old and the new societies, looks in short much as the recent Academy displays looked, with its sprinkling of good and bad, the artistic things being placed cheek by jowl with inanities by the older academicians who have the divine right of wall space." Then, as if resigned to these ossified artistic specimens forever, the article summarized: "While there are no new names to startle us, the older men are well represented."[152]

The National Academy's Winter Exhibition had opened just three days before Christmas. When the academicians welcomed in the New Year there was as yet no indication that it was to be the last before their selfish and dictatorial policy was forced to relinquish its stranglehold over public taste.

As the leader of a horde of nonconforming artists, Robert Henri had stated: "Change opens chance." The new year, 1907, was to offer him the chance he had long sought.

CHAPTER SIXTEEN

ON JANUARY 19, 1907, the hushed and hallowed halls of the National Academy of Design received the last reverent visitor who had come to pay homage to the institution's Winter Exhibition.

The dignity of a funeral parlor was no match for the deadened atmosphere. An occasional arrival would tiptoe through the somber rooms, hesitating to speak above a whisper for fear the Fates themselves would emerge from the walls to place a curse upon his soul.

When the final vestige of humanity filed past the carefully tiered display of pictures, they were witnessing, unaware, the proverbial calm before the storm. For the inevitable storm, Robert Henri, had been elected to the Jury of Selection for the Academy's Spring Exhibition, to be held the following March.

The choice of the thirty-man jury for this particular annual show was something special, for as a final tribute to the now-defunct Society of American Artists the entire panel was composed of Academy members who had also once belonged to the Society. Like Robert Henri, one-third of the thirty jurymen had just been elected academicians the preceding year as one of the conditions of the amalgamation.

Robert Henri an academician! How ironic that he should have gained admittance to the select inner circle, to be placed in company with the aged gentlemen, the same pompous personages with whom he had argued for two years on the Society juries. Time could not dim their deeds. In 1905, for instance, Henri had witnessed the rejection of a Glackens canvas from the Society's portrait show on grounds that, because the model was seated beside a table containing a bowl of fruit, the work was somehow removed

from the realm of portraiture. Over Henri's objection the painting had been labeled a still-life and thus eliminated from any further consideration. Henri smarted under such despotic decisions, yet it was inevitable that he bow to the will of the majority.

In mid-February, two weeks before the jury convened, Robert Henri was invited by several of his female students to attend a sort of Salon des Refusés, a private viewing that was announced as a "collection of paintings not shown at the National Academy show."[153] An afternoon tea held in conjunction with the one-day exhibition evoked typical adolescent inanities, yet when the mentor studied the work rejected from the Academy's Winter Exhibition he could not help but sense the seriousness of the situation.

At the New York School of Art, Henri always encouraged his students to submit their work to the Academy, acknowledging that "it's a good thing to send." But he entertained no delusions of grandeur for them, for he would quickly add: "Don't worry about the rejections. Everybody that's good has gone through it."[154]

At last March 1, the day for the Academy judging, was at hand. The thirty-man jury faced an arduous task, for stacked against the walls of the Academy's huge Vanderbilt Gallery were nearly 1,500 works of art, each awaiting careful scrutiny and a decision. As the stately gentlemen entered the room they exchanged pleasantries, adjusted their cravats and posed for a photographer who recorded them in a group portrait. Then they tackled the job at hand.

The thirty jurors sat on long, uncomfortable wooden benches or stood erect in small groups as three shirt-sleeved workmen commenced to feverishly parade the paintings before them. Each

The Jury of Selection for the Annual Spring Exhibition at the National Academy of Design, 1907.
Front row: Samuel Isham, Robert Henri, Francis Luis Mora, Kenyon Cox, Frederick Dielman, Irving Ramsay Wiles, Hugh Bolton Jones, and Charles Yardley Turner. *Back row:* Edward Henry Potthast, William Henry Howe, Henry Bayley Snell, Carlton Theodore Chapman, Elliott Daingerfield, Frederick George Richard Roth, Louis Loeb, Edwin Howland Blashfield *(behind Mr. Loeb)*, Ben Foster *(seated)*, William Thomas Smedley, John White Alexander *(seated)*, Frederick Weller Kost, Henry Willson Watrous, Francis Coates Jones, John Francis Murphy, George Willoughby Maynard, Emil Carlsen, William Sergeant Kendall *(seated)*, Herbert Adams, and Leonard Ochtman.

canvas was properly placed upon a studio easel to be appraised. After the jurymen indicated their votes by a show of hands, the paintings were marked with a number 1, 2, 3, or the letter R. A number 1 rating indicated unanimous acceptance; number 2 denoted that a majority voted for the work, and number 3 that at least one-third of the jury had voted favorably. The letter R, which stood for "Rejected," resulted when a negative vote was cast by more than two-thirds of the jurors. Following the first viewing all works awarded a 1, 2, or 3 rating were re-examined, with a two-thirds vote required either to raise or to lower the previous rating.

As the jurymen settled down to the monstrous task, the workmen continued their methodical routine of displaying the paintings. The hours dragged on and fatigue overtook the jurors, whose eyes grew weary from the reflected glare of a large battery of lights shining down upon the varnished canvases.

The paintings were brought forward in alphabetical order, and Henri experienced an early sense of pride when works by George Bellows and Homer Boss, the first of his students to be considered, received majority votes. Yet as the day wore on, Henri became chagrined at the fate of paintings by Glackens, Luks, Shinn, and his students Rockwell Kent

and Carl Sprinchorn. Their artistic efforts had either barely gained a number 3 vote or else had been rejected outright. John Sloan, too, caused him some concern, for although one of his entries was voted number 2, another was excluded altogether.

On some occasions Henri sensed an honest difference of opinion, but he also witnessed the ruthless decisions of the narrow-minded among the group. George Luks' sole entry, *Man With Dyed Mustachios*, had presented such an opportunity to the bigots. As the vigorous, rough-hewn portrait was headed toward the easel not a word was spoken. Facial expressions told the story. The canvas had barely been placed upon the accustomed perch when Academician Kenyon Cox shouted, "To hell with it"; then there was silence.[155]

Henri rose to meet the challenge. He expressed the opinion that some of his fellow jurors were apparently reluctant to set aside their conventional convictions about art in order to yield to innovations. As one canvas after another had failed to please the jury he had sensed that a number of the more progressive artists, older men as well as youngsters, were not receiving an unbiased consideration. Originality in their work seemed to be the chief cause for rejection, since such creative and experimental efforts appeared

all the more conspicuous when viewed in company with more readily acceptable conservative pieces. Henri's appeal did not go unheeded, for when the vote was taken on the Luks canvas it won a number 3 standing.

After the initial viewing of all the entries, Henri requested that certain rejected works be reconsidered. This was his prerogative, for a recently amended jury rule stated that "at the request of any member of the Jury, made immediately upon taking of the vote, works marked R may receive a second vote. . . ."[156] But Henri's demand went further. He insisted that the recalled paintings be placed in an adjoining room amid different surroundings, and there viewed separately prior to the second balloting. This procedure was contrary to the usual practice, which called for each reconsidered work to be appraised individually on the easel. A momentary hush pervaded the room, but soon heads began to nod and voice halfhearted approval of Henri's suggestion, and the suggestion was adopted.

Henri recalled several rejected pictures; another juryman requested one. These works were then removed to the next room and placed in a line along the wall. Henri followed. But none of the other jurors stepped forward to re-examine the paintings in their new surroundings. When the vote was finally taken, the verdict remained unchanged.

During the first viewing, Henri's own entries had fared well. His portraits of *Colonel David Perry: 9th U.S. Cavalry, Spanish Gypsy and Child,* and *The Matador Asiego* had received ratings of numbers 1, 2, and 1, in that order. On the second round the first two decisions remained unchanged. Then, when *The Matador Asiego* was reconsidered, it dropped to number 2.

Henri, obviously ruffled by the slight, arose and acidly requested that both of his number 2 entries be withdrawn. Another juror made light of the overture and suggested that a further vote be taken on the Henri canvas in question. But the irate Henri remained resolute and the jurors finally yielded to his demand.

That evening Henri dined with John Sloan and related the day's happenings. "The puny puppy minds of the jury," Sloan angrily recorded in his diary, "were considering *his* work for #2, handing out #1 to selves and friends and inane work and presuming to criticize Robert Henri." Then John Sloan prophesied: "I know that if this page is read fifty years from now it will seem ridiculous that he

should not have had more honor from his contemporaries."[157]

Of the nearly 1,500 entries submitted, more than 600 paintings had been accepted by virtue of a number 1, 2, or 3 rating. Yet the Academy galleries could accommodate only three-fifths of the accepted work. It was this lack of exhibition space that continually disturbed Robert Henri, the teacher, who was all the while encouraging his flock of vital young painters to greater accomplishment. Where could they display their work? The Academy virtuously threw up its hands. Had it not been pleading with the City of New York to finance the building of a more spacious edifice? Was it not even now negotiating with Columbia University for the establishment of a fine arts school?

The jury was now confronted with the annual problem of eliminating the surplus of already accepted works. To cope with this dilemma a three-man Hanging Committee, composed of Frederick W. Kost, Frederick G. R. Roth, and Charles Yardley Turner, was selected from the larger body of jurors to arrange the show. This influential trio then proceeded to scale down the number of paintings, and so, in essence, became a second jury. By virtue of this power, they screened the works and were successful in eliminating all but the most conventional canvases. The exhibition, as hung, consisted of 378 paintings; the other 250 originally accepted works were not included.

But the Battle of the Judging was not yet over. Prior to the reception and formal opening of the show on March 15, the full Jury of Selection convened once more in order to review the work of the Hanging Committee. Robert Henri was quick to observe that several of the paintings by his protégés which had been voted number 3 had not been hung. He promptly pointed out to Charles Turner of the Hanging Committee that there were two available spaces where George Luks' *Man With Dyed Mustachios* and Carl Sprinchorn's *A Winter Scene on the East Side, New York,* might be conveniently placed.

But by existing standards more than mere space was required. The precise task of the Hanging Committee involved the harmonious arrangement of pictures along the wall, the all-important wall. The paintings were not considered entities in themselves; each had to present a decorative amity with others around it, a homogeneity not only in size but in color and tonality as well.

Charles Yardley Turner questioned Henri as to

ARTHUR B. DAVIES: *Canyon Undertones,* circa 1905.
Oil on canvas, 26 x 40".

ROBERT HENRI: *Jesseca Penn in Black*, 1908. Collection of Helen and David Pall
Oil on canvas, 77″ X 38″

ROBERT HENRI: *Blue-Eyed Man*, 1910.
Oil on canvas, 24 x 20″.

JOHN SLOAN: *Boy with Piccolo*, 1904.
Oil on canvas, 24 x 22".

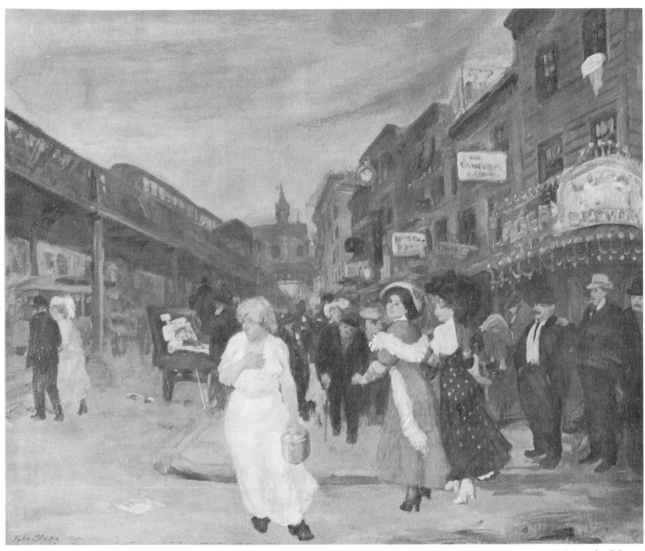

JOHN SLOAN: *6th Avenue at 30th Street*, 1907.
Oil on canvas, 25½ x 35½".

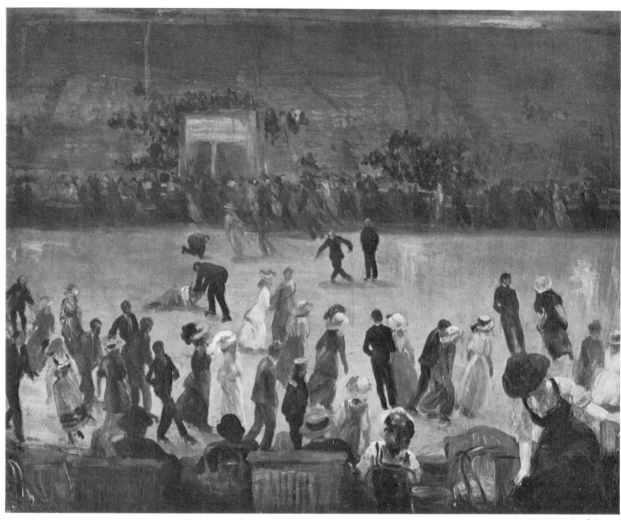

WILLIAM J. GLACKENS: *Roller Skating Rink,* 1906.
Oil on canvas, 25 x 31½″.

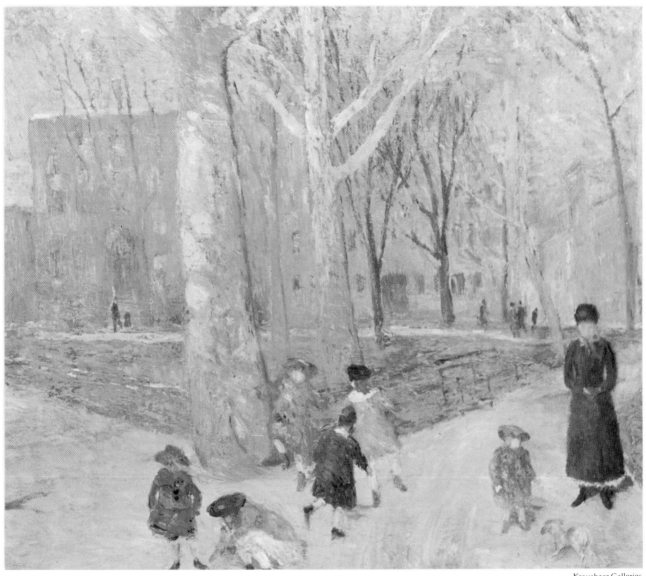

WILLIAM J. GLACKENS: *29 Washington Square,* circa 1912.
Oil on canvas, 25 x 30″.

GEORGE LUKS: *The Sand Artist*, 1905.
Oil on canvas, 30 x 29″.

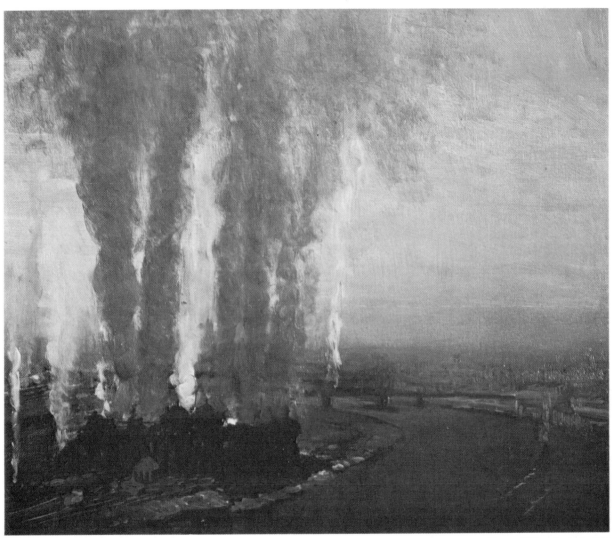

GEORGE LUKS: *Roundhouses at Highbridge,* 1909.
Oil on canvas, 30⅜ x 36⅛".

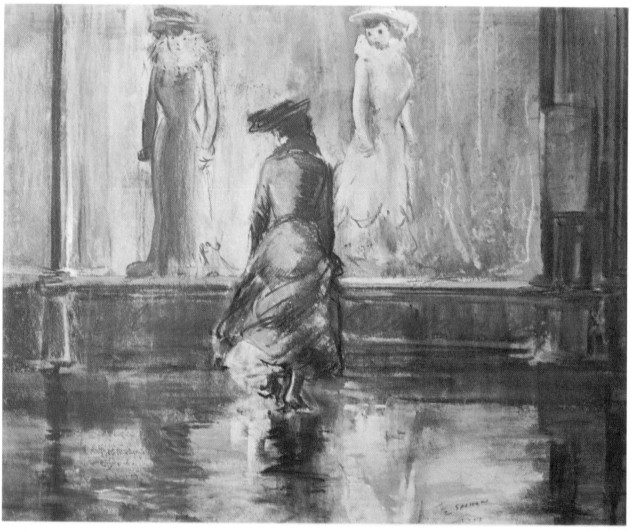

EVERETT SHINN: *Window Shopping*, 1903.
Pastel on paper, 15 x 19".

Graham Gallery

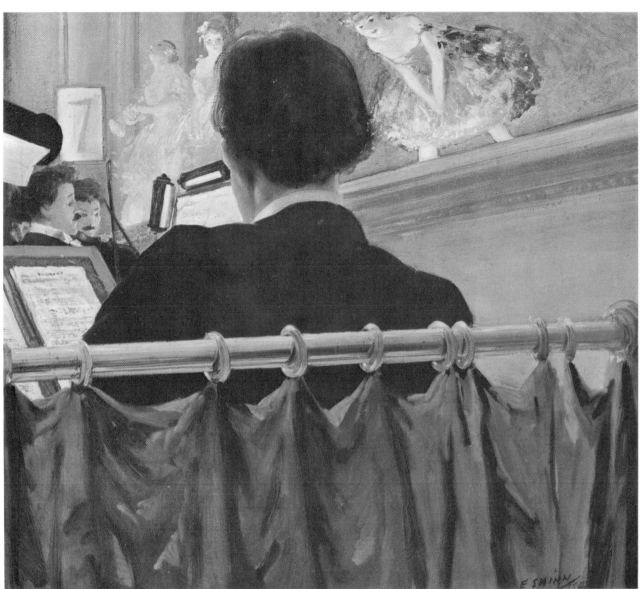

EVERETT SHINN: *The Orchestra Pit, Old Proctor's Fifth Avenue Theatre*, 1906-7.
Oil on canvas, 17 7/16 x 19½″.

ERNEST LAWSON: *Cathedral of St. John the Divine,* 1903-4.
Oil on canvas, 36 x 40".

Collection of Mr. and Mrs. George Arden

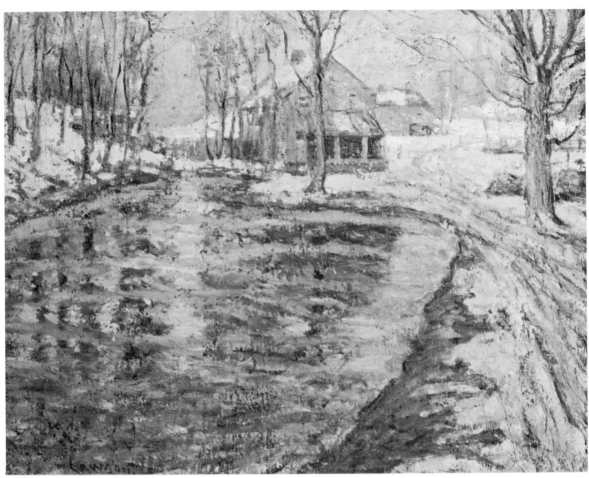

ERNEST LAWSON: *The Pond in Winter*, circa 1909.
Oil on canvas, 14½ x 18½″.

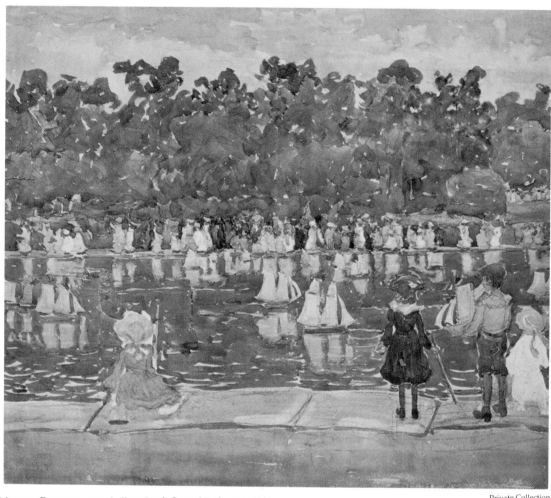

MAURICE PRENDERGAST: *Sailboat Pond, Central Park,* circa 1902.
Watercolor on paper, 19 x 22".

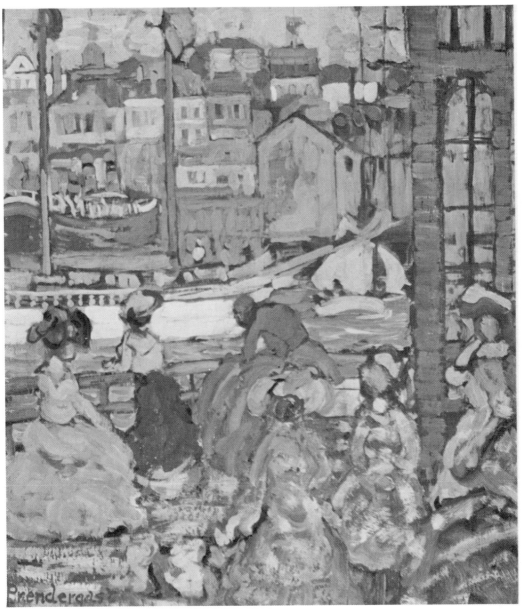

MAURICE PRENDERGAST: *East Boston Ferry*, circa 1908.
Oil on panel, 12½ x 11¼".

M. P. Potamkin Collection

ARTHUR B. DAVIES: *Facades*, 1913.
Oil on canvas, 23 x 28".

Graham Gallery

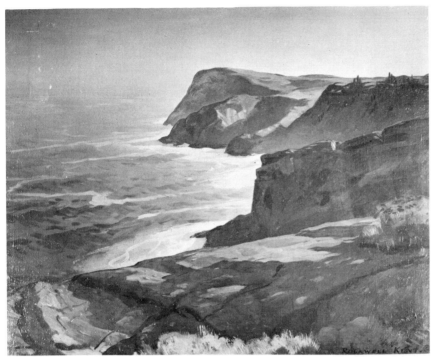

KENT: *North Atlantic Headlands,* circa 1909.

The Hans Hinrichs Collection

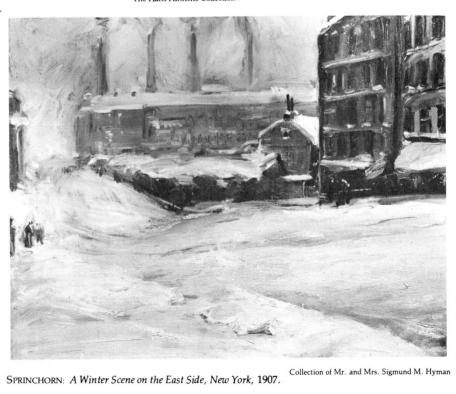

SPRINCHORN: *A Winter Scene on the East Side, New York,* 1907.

Collection of Mr. and Mrs. Sigmund M. Hyman

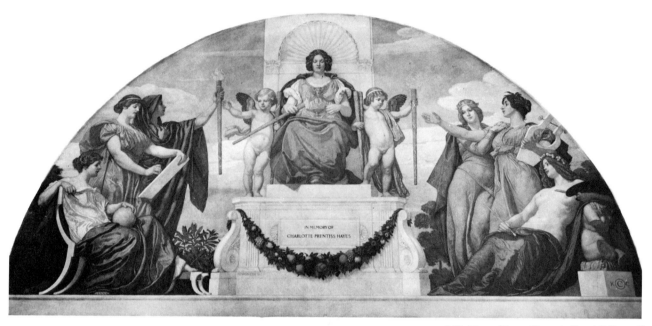

COX: *The Light of Learning*, 1910-13.

his intent. Did he mean to improve the wall, or was his motive simply to hang the work of certain men? Henri's reply was elementary and to the point. "I don't care for the wall," he declared. "I only care for the men."[158]

Perhaps the Henri request to hang the two canvases was so sensible and so forthright that even the dogmatic decisions of the Hanging Committee could not deter its fulfillment. The paintings were subsequently hung. But the following day brought about a change of heart. The committee had the Luks and Sprinchorn canvases eliminated once again on the pretense that "the two paintings in question spoiled the mural effect of other pictures hung near by."[159] And this time the paintings stayed removed.

The withdrawal of Henri's two canvases and his disagreement with the Hanging Committee might have remained but a topic of studio conversation, had he not discussed the matter with several sympathetic art critics, including Charles FitzGerald, who had the story publicized. Rival metropolitan papers were soon providing sufficient space to properly air the controversy.

The public first read of it in the pages of the *New York Post* on March 9, 1907, six days before the opening of the exhibition. Articles, both pro and con, appeared daily, then intermittently for weeks. When reporters questioned Henri about the withdrawal of

his two paintings, he stated that his purpose was to impress upon his fellow jurymen that they were "placing a premium upon the commonplace to the exclusion of work of higher conception, work not necessarily his own, but of all who had come before the jury with something vital to say and had been cast out."[160] Henri readily admitted that there were frequent differences of opinion among the thirty-man jury, that few paintings were, in fact, accepted unanimously.

"Thus it appears," rebuked Academican Kenyon Cox, "that there are many dissenters to almost every selection made by the thirty. Mr. Henri's case is not unique; it differs from others in that it has been made public."[161]

Statements were forthcoming from the other principles involved. Charles Yardley Turner saw the controversy as a clear case of loyalty, for he dismissed the entire affair with the summary statement: "We all gave Henri credit for standing by his men."[162]

The attitude of Academy president Frederick Dielman was forgiving, yet sarcastic: "It looks to me like the insistence of one man as against twenty-nine, probably just as well qualified as he, on his judgment as to matters of art. He seemed to show some personal spirit when he withdrew his pictures, but as far as I and the other members of the jury are concerned,

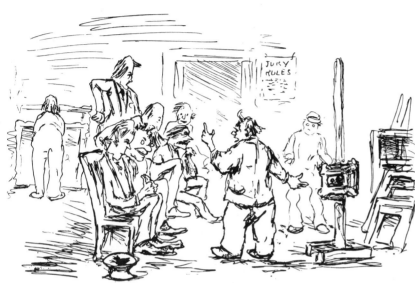

HENRI: *The Art Jury,* circa 1907.

Sloan Collection, Delaware Art Museum

I don't believe there was any personal feeling at all. It was a matter of judging paintings, pure and simple, without regard to who had painted them.

"Of course," Dielman added, "the twenty-nine may have been wrong and Mr. Henri right, but we did the best we could according to our individual judgment."[163]

And what of George Luks? The laughing philosopher was willing to forget the entire matter: "I don't look on this thing from a personal point of view . . ." he stated generously. "I am trying to do things; if they don't understand them, I don't care any more than I do for a bottle of turpentine. I don't propose to berate them. After all, it's a question for Father Time."[164]

Soon the monthly periodicals were also featuring the feud, and in an interview for *Putnam's Magazine,* Henri elaborated upon the principles at issue in these words:

> Life's philosophy can be expressed as strongly in art as through any other medium, and the painter who does this faltering at first, perhaps, and yet with the assurance of definite aim and purpose and future triumph, is the man to uphold, to encourage, and a National Academy in fact as in name would inevitably so uphold and so encourage.
> Carl Sprinchorn — to select an incident that comes to mind — goes down into a grimy, squalid side street in the slums of New York, with a blizzard rag-

HENRI: *On Being Interviewed on the Future of Art in America,* circa 1907.

Sloan Collection, Delaware Art Museum

ing, catches a big new note and places it upon canvas with haunting effect. But placed before the Academy jury, does it receive the slightest recognition? Quite the contrary; it is rejected.

Sprinchorn is young and has never been honored by the admission of a painting in the Academy, yet I know of few more promising painters. His story is the story of every man of whatever calling who has brought with him something new. Wagner, expressing great life-thoughts through music, was pronounced a mere maker of noise; Walt Whitman, whose book of poems Whittier cast into the fire, sent a similar chill down the spine of conventional culture; Degas, Manet and Whistler and their academy of the neglected; Puvis de Chavannes — oh, ever so many despised and laughed at at first, but later recognized as dreamers of fresh dreams, makers of new songs, creators of new art. [165]

After the initial exchange of words Henri held his silence. He avoided the possibility of further friction by staying away from the Academy's annual meeting on the evening of April 10. But the academicians were unwilling either to forgive or to forget.

One of the first items of new business at the meeting was to revoke the jury rule that had permitted Henri to review certain rejected paintings at the previous month's judging. A new amendment was agreed upon which forbade the reconsideration of rejected work in the future. Then the membership nominated the two thirty-man juries that would select next season's winter and spring exhibitions. Robert Henri's name was made conspicuous by its absence.

Academy president Dielman had set the revengeful tenor of the meeting in his annual report read earlier that evening. Obviously piqued by the boomeranging of events and no longer able to conceal his wrath, Dielman suddenly lashed out at the open hostility of local art critics toward the Academy: "In the expression of disappointment and discontent that reached them, certain laborers of the press saw grist for their own mill. . . . Is it anything less than unblushing impudence that emboldens any newspaper writer on art and miscellaneous topics to set his individual judgment against that of thirty professional painters and sculptors and to represent that body as incompetent, ignorant, or jealous and afraid to encourage new genius?" [166]

Any among the members present who *had* hoped to ignore the incidents of the previous month were

now caught up in the surging undercurrents of anger. In an unparalleled show of temper, the academicians swiftly disposed of a list of thirty-six nominees being considered for associate membership by rejecting all but three! Although every one of the thirty-three excluded artists had the required endorsement of seven Academy members, each was systematically blackballed.

The three artists honored by acceptance were the expatriate etcher Joseph Pennell and the now long-forgotten painters Robert Brandegee and Frederick Ballard Williams. Among those rejected: Ernest Lawson, Arthur B. Davies, and Jerome Myers.

Of all the artists voted down, Lawson's exclusion was the most inexplicable. Employing the Impressionistic technique which had long-since gained popular acceptance in America, he had just recently been awarded a medal at the 102d annual Pennsylvania Academy exhibition for the "best landscape" in the show. And at the very time of the nefarious voting, he had been holding a highly acclaimed one-man exhibit of his work at that Philadelphia institution.

Henri had publicly sung Lawson's praises: "This man is the biggest we have had since Winslow Homer." [167] Perhaps this endorsement had proved to be the kiss of death.

"Doors Slammed on Painters" screamed a *New York Sun* headline. "Honest stupidity," proclaimed an irate John Sloan. "The Academicians produce what you might call high-class American potboilers," he asserted vehemently; "they have a keen resentment for anything that is inspired by a new idea, and have an equally keen appreciation for everything that follows the old hide-bound conventions." Then he quipped with obvious disdain: "The National Academy is no more national than the National Biscuit Company." [168]

"Perhaps rejection isn't just the word . . ." the unruffled Henri was quoted as saying. "Some of those who failed of election would not have accepted if the Academy had voted to make them associates. . . . The list was the best, in quantity as well as quality, that has come before the Academy in a long time. . . . The wholesale rejections last night show, I'm afraid, that a large part of the Academy is against all that is real and vital in American art."

Then, reflecting on the recent jury squabble,

Henri added: "You know how George Luks is rejected time and again. Look at this reproduction of one of his pictures I have here. Why, it might have been done by one of the masters, but the Academy won't let him even exhibit. A splendid painter like Arthur B. Davies has been so badly treated that for years he has refused even to submit pictures to the jury."

And then Henri philosophized: "It's hard to foretell just what will be the result of the Academy's rejection of painters. What the outsiders ought to do is to hold small or large group exhibitions so that the people may know what the artists who have something important to say are doing."[169] This idea, long germinating in the minds of Henri, Sloan, and the Realists, was at last to have an appropriate outlet. And American Painting would never be the same again.

The National Academy had inadvertently lit the fuse of devastating self-destruction. The aura of its pompous prestige was being exploded. And when the explosion finally occurred and the smoke cleared away, a truly indigenous American Art would emerge triumphant from the rubble.

CHAPTER SEVENTEEN

EVEN PRIOR TO the National Academy's annual meeting on April 10, 1907, Robert Henri and his associates had begun to explore the possibility of staging a group exhibition of their own.

First mention of such a united effort had come on March 11, the day of the altercation over the hanging of the Luks and Sprinchorn paintings in the Academy's Spring Exhibition. That evening Henri, Sloan, and Glackens met to discuss "the advisability of a split exhibition from the National Academy of Design since," as Sloan observed, "they seem to be more and more impossible."[170] While earlier group exhibitions at the Allan Gallery in 1901 and the National Arts Club in 1904 had not been motivated by a particularly anti-Academy sentiment, the reason for a group show now was quite clear.

On April 4 the idea was again propounded. Another meeting was held to plan an exhibition for the following season. Henri, Sloan, Glackens, and Luks were present, as were Ernest Lawson and Arthur B. Davies. "The spirit to push the thing through seems strong," John Sloan noted joyfully in his diary.[171] He was appointed treasurer for the group and directed to collect fifty dollars from each of the six in order to inaugurate an exhibition fund. Three days later the first check arrived from Davies.

Their exhibition idea, having suddenly emerged from the talking stage, now concerned itself with the practical business of finding a gallery. On April 9 Henri contacted the American Art Galleries in an effort to schedule a show but arrangements were not feasible. Then Glackens reported a vacant store on West Twenty-third Street not far from Sloan's studio. On April 15, Henri, Glackens, and Sloan visited the unoccupied location. They inspected the dusty premises, then agreed that the large front room and smaller one in the rear would provide sufficient wall space for a group display. "The West Twenty-third Street Gallery" was promptly decided upon as a name. The possibilities looked promising enough to warrant calling a meeting for that very night. Lawson and Davies were contacted, and the gathering set.

Henri and Sloan dined together early that evening and Sloan acknowledged: "Excitement is high with us over the possible venture into a Gallery of 'the crowd,' our crowd."[172] Then the two returned to Henri's studio to await the others. First to arrive was Glackens, and along with him came Everett Shinn, the former associate of the group whose outside interests had kept him preoccupied for many months. Shinn described his involvement in a myriad of undertakings, which included the decoration of fashionable homes in Connecticut, mural commissions for the Stuyvesant Theatre and the Plaza Hotel, and the invention of a novel pair of eyeglasses outfitted with tiny windshield wipers for use in inclement weather.

Because of Shinn's long absence the feeling of intimacy which had previously existed between him and his former associates had been all but lost. Now Shinn sought to re-establish the bonds of friendship. Stepping briefly out into the hallway, he re-entered the room toting a bucket of cold water, which he solemnly presented to Henri and Sloan. It was intended to be thrown on the exhibition idea. The prank broke the ice, invisible barriers melted in the face of common interests, and it seemed like the same old Philadelphia gang once more.

Now a serious Shinn spoke of an empty auctioneer's gallery on Fifth Avenue which he suggested as worthy of investigation. Davies, who had

volunteered to contact William Macbeth about his gal-
lery, reported no success to date. Then John Sloan
stated that the rent for the vacant store on West
Twenty-third Street would amount to $1,500 a year.
At the mention of such a considerable sum William
Glackens expressed a note of skepticism as to
whether he could affort to participate at all. His wife
was pregnant and, what with the baby expected in
July, the frugal artist had to exercise extreme caution
in money matters. But Sloan's enthusiasm reassured
him and the meeting adjourned on a harmonious note.

Three days later Davies contacted Sloan. The
Macbeth Gallery was theirs for two weeks that fall or
winter! The good news spread like wildfire. Lawson
visited Sloan and voiced approval of the choice of
Macbeth's. Luks, reported ill by his wife, submitted
an affirmative vote by proxy. The location for their
proposed exhibition met with the enthusiastic
sanction of all.

William Macbeth was the logical dealer to permit
the use of his gallery for such an independent group
show. He had aided most of these artists in their first
attempts to exhibit. He was in sympathy with their
art. In fact, when George Luks' *Man With Dyed Mus-
tachios* had been eliminated from the National
Academy's Spring Exhibition just the previous
month, Macbeth offered wall space and displayed the
notorious canvas.

Mr. Macbeth demonstrated a keen understand-
ing of the exhibition situation when he compiled a
lengthy list of artists whose works were missing from
the Academy show. This list he recorded in a small
pamphlet he edited under the title of *Art Notes*. ". . .
These absentees," Macbeth wrote, "could by them-
selves make a stunning good exhibition, and the
necessary steps should be taken to insure the co-
operation of every one of them in the future. . . .
Some of them are probably hostile to the Academy,
others indifferent, but a little well-directed diplomacy
ought to be effective in removing these hindrances
and in bringing about concerted action both within
and without the Academy ranks." Among those who
Macbeth cited were George Luks, Arthur B. Davies,
and a Boston painter named Maurice B. Prendergast.

Tall, lean Maurice Prendergast was a close friend
of Davies and had been an acquaintance of Henri and
Glackens since 1896, when the three had met in Paris.

In the French capital Prendergast, like Henri, had
studied at Julian's, then returned to the comparative
artistic seclusion of New England. There among the
seaside resorts along the Massachusetts coast he
created his joyous carnivals by the sea, his crowds of
female vacationers wearing voluminous, gaily-col-
ored dresses of varied hues and patterns which he so
loved to paint.

His passion for feminine wearing apparel had
found its origin in a Boston drygoods store, where
the artist had worked as a youth. There he once tied
and wrapped bolts of brightly-colored cloth and, in
his spare time, sketched dresses draped over man-
ikins that stood about the premises. Yet Prendergast
was a confirmed bachelor, a shy and retiring artist.
He never mixed paints and women, but constantly
quoted and heeded a passage from Rudyard Kipling's
"In the Pride of His Youth":

> If a man would be successful in his art, art, art,
> He must keep the girls away from his heart, heart, heart.

Somewhat isolated from the outside world by
partial deafness, Prendergast disliked his further ar-
tistic isolation from New York City. In March, 1900,
Davies introduced him to Manhattan by arranging for
an exhibition of his water colors and monotypes at
the Macbeth Gallery. At that time also, Prendergast be-
gan to make frequent sojourns to New York, where he
would remain for several days at a time, familiarizing
himself with the new developments in the art world.

Accompanying Davies to Mouquin's one even-
ing, Prendergast had renewed his friendship with
Henri and Glackens. Soon he was painting alongside
them on the banks of the East River and the paths of
Central Park. Although Prendergast's subject matter
sometimes approached that of the Realists, his paint-
ings usually possessed a tapestry-like quality more
akin to the painted pageantry of Carpaccio, the
fifteenth-century Venetian master.

In May, 1907, Arthur B. Davies wrote to Maurice
Prendergast, describing the forthcoming group exhi-
bition at Macbeth's and extending an invitation to the
Bostonian to have his work included in the show.
Prendergast wrote back promptly that he strongly fa-
vored the idea.

The list of exhibitors was now complete: Henri,
Sloan, Glackens, Luks, Shinn, Lawson, Davies, and

PRENDERGAST: *Revere Beach,* circa 1896.

The White House Collection, Presented in Memory of
Stephanie Wagner Altschul

Prendergast. Another meeting was held at Henri's, and before it adjourned, all of those present who had not already done so agreed to pay their fifty dollars. Whereas the original purpose of the exhibition fund was to provide for renting a building, it now constituted a guarantee for the gallery. At the meeting Davies disclosed William Macbeth's terms: A guarantee from the exhibitors of $500 plus 25 per cent of the sales. The proposal was briefly discussed and quickly accepted.

With the basic plan for the exhibition set, the story was given to the papers. On May 15 headlines blared: "Eight Artists Form Association in Opposition to the National Academy of Design," "Eight Independent Painters," and, as James Huneker of the *New York Sun* labeled them, simply "The Eight." The local press called attention to the uniqueness and democracy of the new organization: that except for a secretary-treasurer there would be no officers; that each man was to be represented equally by his own selections, without having to submit to the rigors of a jury; and that as for a hanging committee, it would consist of the entire group of exhibitors!

The Eight were labeled "men of the rebellion" by the *New York Herald*, and the *Sun* pointed out that they "have been referred to often as 'the apostles of ugliness' by a larger group of brother artists who paint with a T-square and a plumb line. . . ."[173] The articles reflected sympathetic understanding.

Virtually all the art critics had chosen up sides eight months before the exhibition was to open. Two of the most prominent among them, James Huneker and Frederick James Gregg, stoutly defended the artists whom they had come to know so well through the frequent get-togethers at Mouquin's. Guy Pène duBois, a Henri student, was editing the art column for the *New York American*; his loyalty also was unquestionable. On the other hand, there were several dissenters, such as Ben Foster of the *Post* and Arthur Hoeber of the *Globe*, academic painters who were

PRENDERGAST: *May Day, Central Park*, 1901. The Cleveland Museum of Art, Gift from J. H. Wade

PRENDERGAST: *Central Park*, 1901. Whitney Museum of American Art, New York

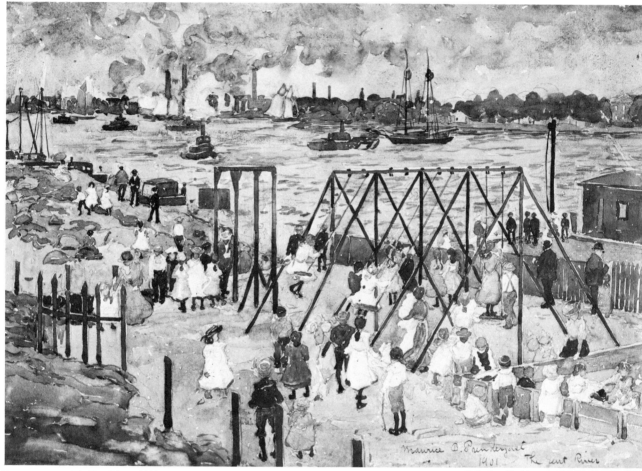

PRENDERGAST: *The East River*, 1901.

Collection, The Museum of Modern Art, New York
Gift of Mrs. John D. Rockefeller, Jr.

writing art criticism in their spare time. They fought The Eight in their articles as in their art. And Royal Cortissoz, of the *New York Tribune*, constituted the greatest opposition of all. An arch-conservative, his sensibilities could not reach beyond the popular aesthetic taste of the day.

New York Times art critic Charles De Kay was the most sarcastic in writing about The Eight. He even failed to list two of its members. An equally sarcastic John Sloan observed: "His patronym (De Kay) is a compliment to him, for decay implies some original quality gone by."[174]

Although four of The Eight had been former newspapermen themselves, their supporters in the struggle for independence were not limited to friends on the daily papers. Mary Fanton Roberts, for exam-

ple, writing under the pseudonym of Giles Edgerton in the magazine *The Craftsman*, had been pleading a like cause for years. She appealed to all artists to choose the course of The Eight, to look upon "our towering, crude, vibrating, nervous, uncertain civilization," and to paint "our East Side polygot populace."[175]

Though it was the biting realism and the slashing brushwork of the Henri men which was largely responsible for their encountering exhibition barriers, it was the individuality of all The Eight which had caused them to band into a group. "We've come together because we're so unlike," was their statement to the press. "We don't propose to be the only American painters by any means, but we do say that our body includes men who think, who are not aca-

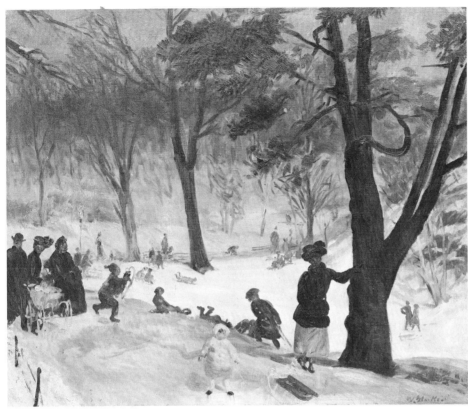

GLACKENS: *Central Park–Winter*, 1905.

demic . . . and who believe above all that art of any kind is an expression of individual ideas of life.''[176]

This freedom of the personal style and approach to art was what the National Academy, in its narrow-minded policy, had lost sight of. The Eight promoted a liberal movement, free from the desire to have others paint as they did. Not only was Robert Henri fighting for his associates and students; he expounded the cause of freedom for all artists. Yet, because the New York Realists made up five-eighths of The Eight, the entire group was referred to as ''the Black Gang'' by the academic artists, and the whole question of painting realistic city scenes entered into the controversy.

''We often are called devotees of the ugly,'' one of The Eight said with pride. ''Well, the trouble with a lot of artists, so called, is that they draw an arbitrary line across God's works and say: 'In this half of His works He has been successful, but over here in the shadows and the misery of life, the seamy side, He has failed.' We mustn't paint that seamy side. It's vulgar. Your portraits, for instance, must be only of the rich, and always see to it the lady is seated on a gold chair. Ever notice the gold chair in those pretty portraits? That's part of the formula.''[177]

After the initial publicity the summer months rolled by with little thought given to preparation for the forthcoming show. Sloan was busy commuting between New York and western Pennsylvania, an arrangement that enabled him to instruct each week at the Art Students League of Pittsburgh. Henri was spending the summer in Holland with his class from the New York School of Art. And Glackens was practicing the art of folding diapers for the recent addition to his family, born on the Fourth of July.

To all outward appearances the National Academy of Design had reconciled itself to the group's forthcoming exhibit with unbelievable grace. No attempt had been made to counteract the publicity of The Eight; in fact, the Academy's secretary,

Harry Watrous, wished the artists all kinds of good luck: "All the men who have been mentioned have originality and force," he acknowledged. "They are certainly individual in their expression and the more exhibitions the better."[178]

The Eight were equally felicitous: "Please let it be understood," one of them announced, "that those of us in the habit of sending to the Academy will continue to do so."[179] Whereas the group known as The American Ten, under similar circumstances, had boycotted the Academy, The Eight believed in coexistence.

In October the National Academy distributed the usual prospectus for its Winter Exhibition. Shortly thereafter, at Henri's urging, John Sloan wrote to the other members of The Eight advising that the projected exhibition at Macbeth's should in no way preclude further attempts to be included in the Academy shows. So the men naively submitted their work to the Academy.

But as they were soon to learn, the National Academy's outward calm did not reflect its true sentiment. Academicians were more dogmatic than ever. When the results of the judging were made known, Henri's *Girl in Yellow Satin Dress* was the sole canvas by a member of The Eight to gain admittance into the Winter Exhibition and that one, of necessity, was accepted jury-free because of Henri's status as an academician. The Academy was apparently in no mood to permit comparisons between the artistic output of The Eight and its own members, especially on its own home ground.

When the seemingly innocuous Academy show opened on December 15, 1907, the Henri painting stood out symbolically like a beacon shining forth from a sea of dark despair. On the evening following the opening night Henri and Sloan visited the desolate Academy galleries. Even the walls seemed hostile. "Awful," was Sloan's curt appraisal. The Eight had not even been allowed to compete!

Eleven o'clock that evening found Henri and Sloan in low spirits at a table at Mouquin's. A dejected Sloan composed the following letter:

To the Editor of The Evening Sun – SIR:
 I visited the winter exhibition of the National Academy of Design. During my stay, from 8 o'clock to the time of closing, the galleries were visited by no more than a dozen persons.
 I have read that the Academy desires to secure funds for the erection of galleries two or three times the size of the present.
 If they succeed I suppose they would attract two or three dozen out of a population of 3,000,000. But it's so lonely! So lonely now! I know that I could not endure the vast vacancy of the galleries of that future day.
 Oh no! Croesus, hold the purse till the *Visitors* demand more space; heed not the plaintive cry of those who sit behind such unattractive wares.[180]
<div align="right">CITIZEN</div>

Without benefit of a painting in the show to voice his point of view, John Sloan had employed the only other weapon he knew — the pen. A week later, in another letter to the editor of the *Evening Sun*, Sloan wrote under the pseudonym of John Cupeo, identifying himself as "a chauffeur in the delivery department of a very exclusive Fifth Avenue shop." With a touch of typical Sloanian humor he gibed:

. . . I liked nearly every picture in the whole three rooms, where they are hung with the finest taste, the large ones on the bottom and the smaller ones higher up, except where the large ones are not as pretty as some smaller ones or do not match the others in color shades, which is a very good arrangement, it seems to me.

Truck drivers who acknowledge that they are ignorant, and persons who come in and forget that they are looking at pictures and can't appreciate that these pictures are refined, had better stay away and let intelligent people with money enjoy these beautiful art works.[181]

And Mr. William Macbeth contributed his share of fuel to the fire by increasing his customary half-page ad in the Academy's Winter Exhibition catalogue to a regal full page. It proclaimed:

CATALOGUE OF *THE EIGHT* EXHIBITION, 1908:

EXHIBITION
OF
PAINTINGS

BY

ARTHUR B. DAVIES

WILLIAM J. GLACKENS

ROBERT HENRI

ERNEST LAWSON

GEORGE LUKS

MAURICE B. PRENDERGAST

EVERETT SHINN

JOHN SLOAN

FEBRUARY THIRD TO FIFTEENTH
MCMVIII

MACBETH
GALLERIES

450 FIFTH AVENUE
NEW YORK

EVERETT SHINN

1 GAIÉTÉ, MONTPARNASSE
2 REHEARSAL OF THE BALLET
3 THE WHITE BALLET
4 LEADER OF THE ORCHESTRA
5 THE GINGERBREAD MAN
6 THE ORCHESTRA PIT
7 GIRL IN BLUE
8 THE HIPPODROME, LONDON

4

ERNEST LAWSON

9 SWIMMING HOLE
10 ABANDONED FARM
11 EARLY SUMMER
12 FLOATING ICE

6

JOHN SLOAN

13 EASTER EVE

14 HAIRDRESSER'S WINDOW, SIXTH AVENUE

15 THE COT

16 SIXTH AVENUE AND THIRTIETH STREET, 1907

17 ELECTION NIGHT

18 NURSE GIRLS, SPRING

19 MOVING PICTURES, FIVE CENTS

8

MAURICE B. PRENDERGAST

10

GEORGE LUKS

37 STREET SCENE

38 MACAWS

39 THE DUCHESS

40 PIGS

41 THE PET GOOSE

42 MAMMY GROODY

12

ROBERT HENRI

14

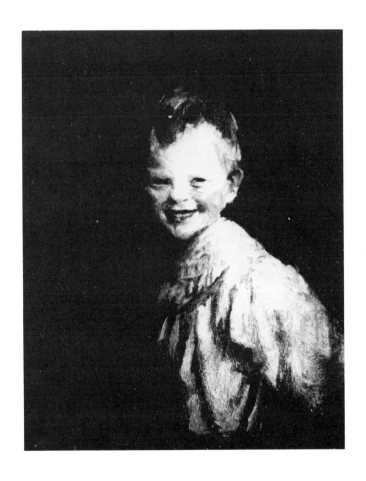

WILLIAM J. GLACKENS

52 THE SHOPPERS

53 AT MOUQUIN'S

54 GREY DAY, CENTRAL PARK

55 BRIGHTON BEACH, RACE TRACK

56 COASTING, CENTRAL PARK

57 BUES RETIRO, MADRID

16

ARTHUR B. DAVIES

18

A page from the Macbeth Gallery scrapbook,
showing The Eight catalog and reviews.

CHAPTER EIGHTEEN

THE TIME was fast approaching for the forthcoming exhibition of The Eight and preparations for the February 3 opening were now underway.

In order to expedite obtaining illustrations for the catalogue and at the same time to keep down costs, John Sloan offered to photograph one painting by each of the artists. Henri, Davies, and Lawson brought their canvases to his studio for this purpose, but when the others failed to do so Sloan visited them, camera in hand.

At Luks' studio he found the artist in an inebriated condition and sporting a black eye. According to George, the college athlete responsible for the unsightly decoration had been properly annihilated. No sooner had Sloan set up his camera than the tipsy Luks plunged headlong into it and, *crash!* the lens was broken. Sloan's anger was immediate but short-lived, for as he paced the studio in disgust he spotted a recently completed Luks masterpiece, *The Wrestlers.* "A magnificent picture," he exclaimed, "one of the finest paintings I've ever seen."[182] Then, to his dismay, Sloan learned that the work was not one of those which Luks intended to exhibit at Macbeth's. "I'll keep it 'til I'm invited to send to some big exhibition," the unsteady Luks announced. "Then this will show Kenyon Cox and the other pink and white painters that we know what anatomy is. I painted it to vindicate Henri in his fight for my work on the National Academy juries."[183]

Sloan purchased a new lens and made another attempt at photographing a Luks canvas. But this time the resultant picture turned out blurred because George insisted on pacing about the room. "It shows constant vibration as though taken during a mild earthquake," Sloan explained.[184]

Obtaining a photograph of a painting by Glackens proved even more troublesome. Glackens was living at No. 3 Washington Square because his wife and infant son were spending the winter in Hartford. This enforced loneliness had a noticeable effect upon his work. Although he painted and repainted his canvases, the perfectionist could not achieve the desired results. "I am already sick of the damn exhibition," Glackens wrote to his wife on January 17. "I will probably fall very flat. In my effort to fix my pictures up so far I have only succeeded in spoiling them. *The Race Track* has gone by the board. Shall substitute the one I painted in Hartford Christmas week. *The Shoppers* I can do nothing with. It is now minus Mrs. Shinn's and Mrs. Travis's heads."[185] Then, completely dejected, he surmised: "I can neither paint nor draw any more."

Sloan found it necessary to return at a later date to take the appropriate photograph.

While Glackens' frustration submerged him in the gloom of dark despair, Everett Shinn anticipated the exhibition in quite a different light. In mid-January he mailed Sloan a postcard on which he had sketched The Eight marching majestically along in parade style. Each carried a pole to which was nailed one of his paintings. "Why not go up Fifth Avenue like this?" Shinn wrote, only half in jest.

Davies and Sloan assigned themselves the task of selecting the type and designing the general format for the catalogue. The cost, estimated at $200, created a new problem because no money had been collected for this purpose, or for the printing of invitations, for that matter. In addition, $100 of the guarantee money was still owed to Mr. Macbeth.

A meeting was called in order to collect an addi-

LUKS: *The Wrestlers*, 1905-7. Museum of Fine Arts, Boston

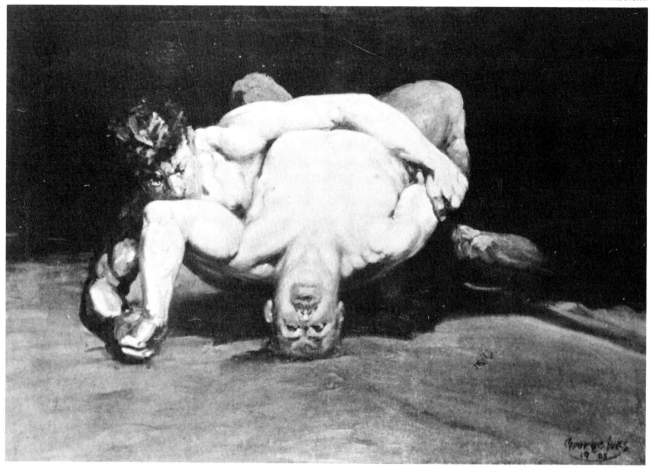

tional $45 from each man, but nearly all resisted so high an extra assessment. The financial crisis resolved itself, however, when Macbeth generously offered to lower the guarantee figure from $500 to $400. This allowed the individual assessments to be reduced from $45 to $30, an amount agreeable to the artists and sufficient to pay all bills.

During the last hectic days of preparation Robert Henri was in Wilkes-Barre, Pennsylvania, where he was painting two portrait commissions. Originally Henri had planned to do only one and agreed to produce the other just a week before the show's opening. "I feel that I am missing some of the fun of our exhibition by being away,"[186] he wrote to Sloan. But he was missing the work as well. When the catalyst finally returned to New York just two days before the opening he was quick to voice disappointment over

the quality of the reproduction of his painting in the catalogue. "It is not very good," Sloan readily admitted in his diary, then added reluctantly on those hidden pages: "But as usual in these affairs, one or two do the work and the rest criticize."[187]

On Saturday morning, February 1, all of the paintings were delivered to Macbeth's. Glackens narrowly avoided chaos, for his *Brighton Beach Race Track* and *The Shoppers*, both already listed in the catalogue, were completed to his satisfaction just shy of the deadline. Saturday evening found the men gathered at the gallery to install their exhibition. They discussed the possibility of hanging the paintings in a single row, an arrangement which would eliminate the discriminatory tiers of pictures that had become a major bone of contention at the National Academy shows. Excitement accompanied the unpacking of

Postal card from Everett Shinn to John Sloan: *Sloan. Why not go up Fifth Avenue like this. E. Shinn*, 1908.

Postal card from George Luks to Robert Henri: *Henri and his 8,* 1908. *Front row:* Henri conducting, Sloan beating the drum. *Back row:* Glackens, Davies, Prendergast, Lawson, Shinn, and Luks.

each of the paintings. Picture hooks were rehung. Then the canvases were put in place, mounted upon friendly walls. The work completed, the artists stepped back, gazed admiringly at their handiwork, and expressed satisfaction over the appearance of the show. "What the critics and art reporters may think will probably be another matter,"[188] Sloan prophesied. And Glackens predicted: "We are going to get an awful roasting from some of the papers."[189]

Twenty-five hundred invitations had been sent out. All of the newspapers contained announcements of the forthcoming show, the first notices having appeared a full two weeks before the opening. Now the Eight uneasily awaited the verdict.

Monday, February 3. The opening. A surging, searching crowd. Three hundred people an hour shoving gently in a refined way. Necks stretch up and out. People peer over and around heads and hats which block the view. Opinion is sometimes indicated by a nod, sometimes by a smile — often a frown or a sneer. Piercing glances scrutinize the varnished surfaces of the sixty-three works of art. The second day, the third day, and the crowds continue in a steady stream. A snowstorm and a week of slush, but the curious keep coming.

Each morning the narrow corridor outside of the gallery's upper-floor entrance at 450 Fifth Avenue is filled with people before the 9 A.M. opening. A shop-worn elevator operator already wears a harassed expression, the result of the previous day's labors. Gallery employees elbow their way through the crowd and approach the locked door. As one enters, Henri's *Laughing Boy* faces the unsuspecting gallery-goer, who either laughs along with him or at him. Once inside, the jam continues unabated until 6 P.M.; four or five dozen people are always roving the two small rooms.

The supply of catalogues is gluttonously consumed. Davies suggests that more might be needed. Prendergast writes from Boston that the reprint should be more elegant, even if a ten-cent charge is deemed necesssary. Not until the third day did Sloan make his initial appearance at the exhibition. He readily explained his absence from the opening: "I felt that my clothes were not of the prosperous aspect necessary in this city," he said. "The appearance of poverty is the worst possible advertising these days."[190]

William Macbeth, dazed and overjoyed, lauded the show as "a remarkable success." Sales amounted to nearly $4,000. Henri and Davies had sold two paintings each; Luks, Shinn, and Lawson one apiece. Four of the seven purchases had been made by sculptor-socialite Gertrude Vanderbilt Whitney, who maintained a studio on MacDougal Alley only a stone's throw from Lawson's. Despite her support, the exhibit appeared in an unfavorable light in the eyes of most of the carriage trade, who threatened to boycott the dealer because of the show's apparent lack of refinement. Macbeth acknowledged "a loud chorus of disapproval . . . was heard every day,"[191] representing a majority opinion.

Unlike the Academy annuals, where paintings were grouped according to color, subject matter, or size, at Macbeth's the artists' styles became the sole unifying factor. Pictures by each of The Eight had been hung together as a unit. But this departure from tradition evoked a chorus of outspoken disapproval. "When fairly within the Macbeth Galleries," one critic reported, "you are appalled by the clashing dissonances, by the jangling and booming of eight differently tuned orchestras. . . . There is a muscularity and outdoor atmosphere in many of the canvases — none of them suggests studio lighting — that seems to demand a ten-acre field. Mr. Macbeth did not hang the pictures. If he had we might have been spared some noisy contrasts, some glaring spots. . . ."[192]

Official sentiment regarding the exhibition was divided. On the one hand, the show was censured: "Bah!" exclaimed one art critic disparagingly, "The whole thing creates a distinct feeling of nausea."[193] On the other hand, The Eight were praised as being "so excellent a group" whose paintings "escaped the blight of imitation."[194]

The *New York Sun's* James Huneker came out in favor of the men, as did Frederick James Gregg of the *Evening Sun.* Guy Pène duBois wrote enthusiastically as critic of the *New York American.* But there was strong hostility from the opposition. A review in *Town Topics* signed "Charles DeKay" led the rival camp in its bitterness:

> . . . Vulgarity smites one in the face at this exhibition, and I defy you to find anyone in a healthy frame of mind who, for instance, wants to hang Luks' posteriors of pigs, or Glackens' *At Mouquin's* or John Sloan's *Hairdresser's Window* in his living rooms or gal-

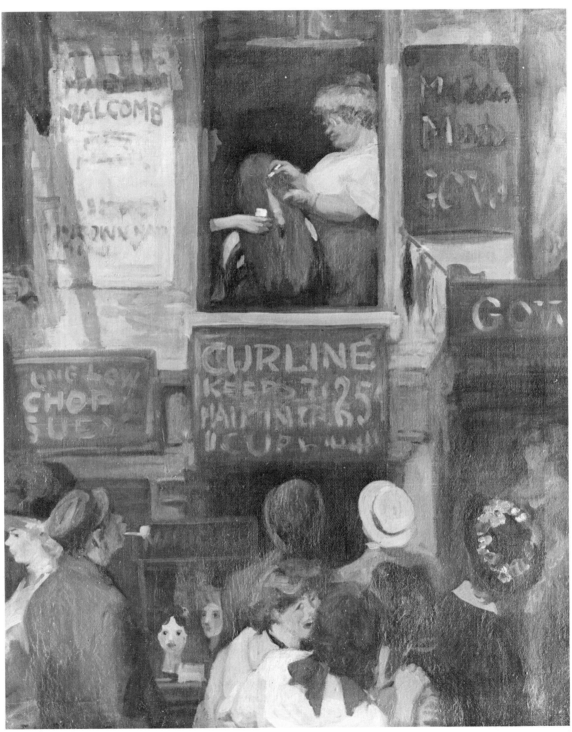

SLOAN: *Hairdresser's Window*, 1907.

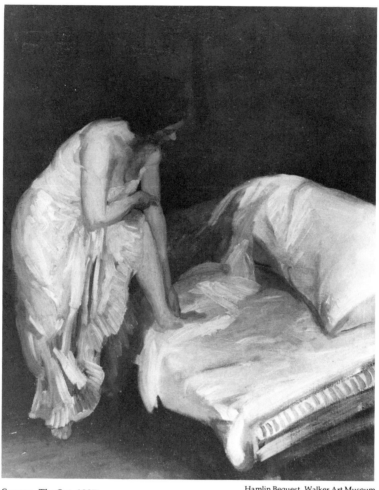

SLOAN: *The Cot*, 1907.

Hamlin Bequest, Walker Art Museum
Bowdoin College

lery, and not get disgusted two days later. . . .

As for Prendergast, his work is unadulterated artistic slop, and Shinn's is only several degrees better. . . . Arthur B. Davies is on a slightly different plane, that place which leaves you in doubt between genius and insanity. . . .[195]

None of The Eight escaped the critics' tongue-lashings as specific paintings were called to mind. One writer labeled Lawson's impressionistic landscape *Floating Ice* "provocative," displaying "a wilful lack of design."[196] Another observed that Sloan's nightgown-clad woman in *The Cot* "shows neither good taste nor originality." Robert Henri's group of portraits was likened to "a collection of masks." Glackens' *Shoppers* lacked distinction because of "the

anemic color scheme and the dreariness of his personages,"[197] while George Luks' *Macaws*, one writer warned, "will stab you in the optic nerve."[198] And as for Maurice Prendergast, his beach scenes of Saint-Malo were derisively described as "crazy quilt sketches," "blotches of paint on canvas without harmony of color or tone,"[199] and "a jumble of riotous pigment. . . like an explosion in a color factory."[200]

How ironic, yet typical of the history of art, that these same canvases, unchanged by the passage of time except for the collected dust film of a few decades, should, little more than half a century later, seem strangely placid and often romantically sentimental as they hang in honored locations upon museum walls . . . these same canvases which in

February, 1908, evoked such offensive and blasphemous comments.

Only one reviewer, James B. Townsend, was sagacious enough to sound a note of caution to his fellow critics and the public. The advent of The Eight, he pointed out, was

> . . .reminiscent to older art writers and lovers of that fateful day, thirty years ago—my, how time flies—when the Society of American Artists astonished the then smaller Metropolis at the American Art Galleries.
>
> The present writer recalls too well his youthful and harsh criticism of the "Munich Men" of that day, as they were called, and his predictions of their dark future—predictions which were not in most cases fulfilled—to rashly animadvert upon the present advent of "The Eight," or to predict either future success or oblivion for their members. He has seen the despised "Munich Men" of 1878 develop, with few exceptions, into our sanest and strongest painters of today, and the movement they instituted change and better the conditions of American art to a surprising degree.
>
> That "The Eight" have among them strong painters cannot be denied, and the impulse and impression their first show may have upon present art conditions who can say? . . .[201]

This profound statement must surely have served as unsavory food for thought for even the most opinionated academician.

CHAPTER NINETEEN

NO SINGLE exhibition of American art has ever produced such widespread consequences. For many years after The Eight exhibition, painters were considered avant-garde and unacademic if they only condoned the art of The Eight. The Henri associates became the crusading leaders of what some were quick to label as a newly found American school of painting.

The National Academy admitted its inability to cope with the situation. In an attempt to stem the tide, it called a convention in Washington, D.C., for the expressed purpose of improving art conditions in America. The meeting was attended by representatives of some eighty art societies and institutions and dealt with such problems as molding public taste, organizing exhibitions, and sending art lecturers around the country. Of course, most of their proposed program had been of utmost concern to the Henri group for years.

The immediate repercussions of The Eight show, however, were most noticeable within the hallowed halls of the National Academy of Design itself. There some serious stock-taking brought about a sudden awareness that the furor created by The Eight threatened to steal the spotlight from the Academy's Spring Exhibition, slated to open on the heels of the Macbeth Gallery show. In desperation, frenzied academicians voted to abolish the time-honored Hanging Committee and in its stead appoint a one-man organizer for the forthcoming exhibit. The new post went to Harrison S. Morris, the former director of the Pennsylvania Academy.

In a few short weeks Mr. Morris achieved the impossible. "Although his task was arduous," as one reviewer of the Academy annual later pointed out, "and though such a torpid and hieratic organism [as the National Academy] cannot be vitalized in a single day, Mr. Morris literally accomplished wonders in the way of rehabilitation. . . ."[202] One novel innovation consisted of borrowing a number of paintings from other public and private collections for the occasion, and interspersing these jury-free canvases among the usually monotonous output of the local academics. Another involved the resolute "skying" of all inferior works, regardless of whether they were the productions of academicians or not. Finally, in a bold and graciously hospitable gesture, Harrison Morris sanctioned the reappearance of The Eight, whose work, together with that of a number of Henri students, was hung as a group in one of the Academy galleries. Less sympathetic academicians jocosely labeled this outlaw area "the freak wall," but even name-calling from the diehards could not lessen The Eight's sense of triumph.

When the Spring Exhibition first opened in mid-March, 1908, the favorable reception of both The Eight and Henri's students seemed almost too good to be true. A disbelieving William Glackens proclaimed: "The Academy has turned over a new leaf and has accepted everybody this year."[203] Then the prizes were announced. The First and Second Hallgarten awards were bestowed upon Ernest Lawson and Henri-student George Bellows, both of whom were elected associates the following month. Lawson, who just the year before had been denied Academy membership, was now welcomed into the fold as the least objectionable of The Eight. And the acceptance of Bellows, who at twenty-six became the Academy's youngest member, was devised to give credence to the institution's oft-repeated assertion that it sought to encourage budding young talent.

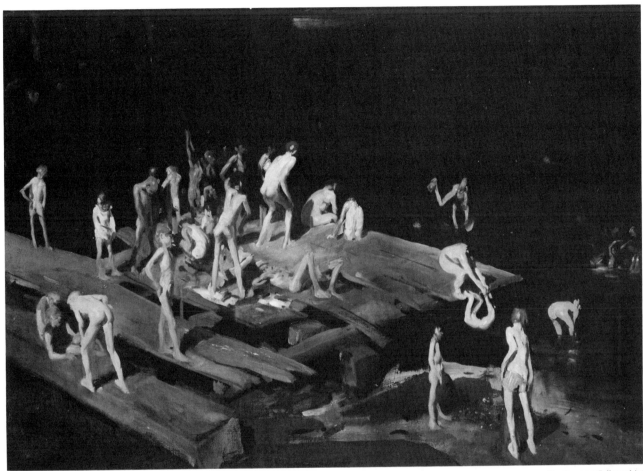

BELLOWS: *Forty-two Kids*, 1907.

These peace gestures were calculated to erase the stigma of past errors of judgment, yet who could forgive or forget that such a giant among artists as Thomas Eakins had not been elected an associate until he had reached his fifty-eighth year? And what of the deeds as yet undone? It was not until 1910, for instance, two years later, that Thomas Anshutz would be belatedly elected to Academy membership just months before his sixtieth birthday.

When The Eight show closed at Macbeth's on February 15 it was anything but over. An initial offer to take the exhibit to Boston had come from that city's Rowland Galleries during the first week of the exhibition, but transportation costs posed a problem, for the artists were not anxious to shoulder the additional financial burden. Before an agreement could be reached with the Boston gallery, the Pennsylvania Academy asked for the exhibition, offering to pay half the expenses. Sloan polled the rest of The Eight and found them receptive to the proposal. "Oh, fine!" he jubilantly recorded in his diary, "what joy to say that 'pictures sold, will make some substitutions necessary.' "[204]

The revamped Eight show opened triumphantly in Philadelphia on March 7, a week before the National Academy annual in New York. But even with The Eight on the road the Academy's Spring Exhibition was still to face a challenge in Manhattan, for on March 9 fifteen Henri students proudly inaugurated their own independent show in a loft on West Forty-second Street. Announced simply as an "Exhibition of Paintings and Drawings by Contemporary Ameri-

cans," it was held in the unpretentious upper floor of the old Harmonie Club facing on Bryant Park. The building had fallen into disrepair, and Arnold Friedman, one of the organizers of the exhibit, noted that "the walls, floors, and ceiling were in an awful state.

"The ceiling, grotesque in design, flaked and ugly watermarked, but too high to be reached, was covered by fastening unbleached muslin a few feet above the picture line and gathering it in the center to form a great festoon attached to the ceiling." At times the numerous preparatory details seemed almost too burdensome for the Henri men, but a word of encouragement from their mentor and the pioneering effort "assumed the proportions of a warrant, a death warrant to the Academy, no less,"[205] as Friedman later phrased it.

The young exhibitors' finances were sufficient to permit the printing of a catalogue which listed these names:

PAINTINGS — George Bellows, Guy Pène duBois, Laurence T. Dresser, Arnold Friedman, Julius Golz, Jr., Edward Hopper, Rockwell Kent, Edward R. Keefe, Howard McLean, George McKay, Carl Sprinchorn, and LeRoy William.
DRAWINGS — Glenn O. Coleman, Harry Daugherty, and Stuart Tyson.

Like crusaders of old the artists fashioned a sign in the form of a crest which was prominently displayed in front of the building. On it were emblazoned the names of the fifteen set to do artistic battle. But the exhibit went unnoticed by most of the strollers along Forty-second Street, and a number of those who did visit it evidenced more interest in George Bellows' decorative treatment of the window screens than in the unpopular, true-to-life subject matter of the art students' cityscapes.

Guy Pène duBois, publicist for the show and art critic on the *New York American,* reviewed the exhibition with enthusiasm, while Mary Fanton Roberts, a friend of Henri's who had adopted the pen name of Giles Edgerton in articles in *The Craftsman,* wrote admiringly of the "strong work that smacked decidedly of the ideas and ideals of 'The Eight' . . . full of the New York of today."[206] But most of the critics treated it merely as another assignment to cover, and the independent exhibition, without fanfare, passed into limbo on March 31, 1908.

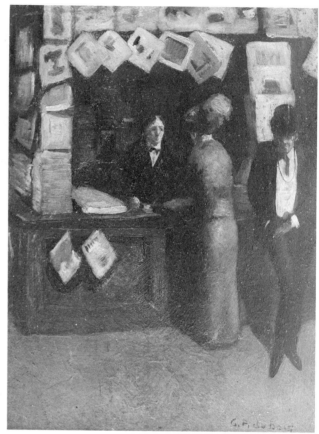

DuBois: *Newsstand,* 1908. Mr. and Mrs. C. James Fleming, Jr., Collection

When Henri and Sloan visited the student exhibition, the mentor glanced about, proud as a mother hen. Sloan rated the collection as "a very good lot of stuff and full of interest."[207] Arthur B. Davies also viewed the display. On the day after it closed he told Sloan he favored launching The Eight traveling show on a full circuit of cities and including paintings by some of the Henri men, such as Julius Golz and Laurence Dresser.

At Davies' suggestion Sloan wrote to the Chicago Art Institute about the possibility of scheduling The Eight show there. The Institute's reply advised that their exhibition calendar was complete until July, after which time the show would be welcomed. Contact was made with the Toledo museum, which responded with a telegram: "Sorry but are full. Could take exhibit in fall gladly."[208] The Detroit Museum of Art indicated that they were faced with a similar situation.

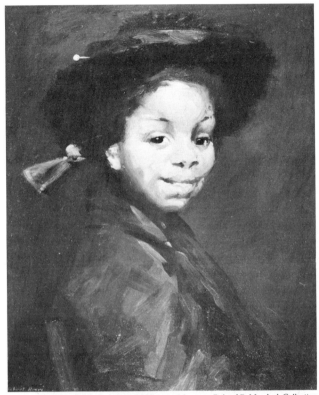

HENRI: *Eva Green*, 1907.

By mid-April it was generally conceded that an Eight traveling show would have to wait until fall, when museum schedules, as well as the country's financial climate, might be more favorable. The Panic of 1907 was still exerting its influence upon the nation's economy in the opening months of the following year. William Macbeth had noted this fact in February, 1908, when, commenting on The Eight show, he said: "Had this been a normal financial year there would have been a landslide your way."[209]

In April, Jim Moore's Café Francis went into receivership and the ensuing auction included the restaurateur's collection of paintings. Despite The Eight's recent prominence in the news, there was little bidding on their works. A small Henri seascape brought only $16, while a painting by Ernest Lawson went for half that amount. Furthermore, most of the works were purchased by the artists themselves, suggesting a gesture of friendship for the despondent Moore. Glackens and art critic Frederick Gregg each bought a Lawson canvas, while James Preston and

Frank Crane of the old Philadelphia gang acquired six of his works between them. And John Sloan, still seeking the first sale of a painting, recorded dolefully in his diary: "I myself am too liable to worry when there is not bread and butter coming in — but to paint at such times is a great relief."[210]

Even Everett Shinn, the perennially prosperous member of The Eight, was feeling the financial pinch. Preoccupied since the first of the year with a mural commission for David Belasco's Stuyvesant Theatre, Shinn received notice on April 1 that no further payments would be forthcoming until the fall. He now had visions of an impoverished summer, but his fears never materialized, for Shinn turned his inventive genius toward the fertile field of politics and conceived a plan that would allow him to cash in on the notoriety surrounding The Eight.

In the months immediately preceding the Republican National Convention in June, 1908, a nation's curiosity had been aroused by the possibility that President Theodore Roosevelt might break precedent and seek a third term in office. Rising to the occasion, Shinn devised an ingenious "Third Term Puzzle" consisting of a small round box with celluloid cover through which could be viewed a striking likeness of the president. Teddy Roosevelt's grinning face contained large, sightless eyes, the pupils for which, in the form of two lead balls, rolled around inside the box. The trick was to place the pupils in their eye sockets, with the resultant presidential facial expression calculated to answer the query neatly lettered below: "Can He See a Third Term?"

Shinn employed a publicity agent named George Calvert, "the last of the line of Lords of Maryland," according to Everett, to assist in promoting the gimmick. Together they conceived a mythical "Theodore Roosevelt III Club" whose membership was to consist of the painter's associates in The Eight. Shinn revealed his political puzzle to Sloan, Glackens, and Luks, but withheld any suggestion of the big-time promotion he and his publicity man had conjured up. The painters were as shocked as the public was surprised when, on May 11, 1908, the *New York Times* announced in a thundering headline: "Artists Drop Work to Boom Roosevelt." Then the *Herald* picked up the story and reported Shinn's fictitious account of a formal meeting at his studio:

"Mr. Glackens is one of the most forcible speak-

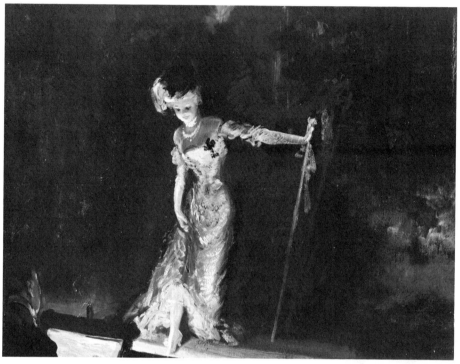

SHINN: *Revue,* 1908.

Collection of Whitney Museum of American Art, New York

The Phillips Collection, Washington

SLOAN: *Wake of the Ferry, Number 2,* 1907.

Artistic lllllll Now Declare for Theodore lll.

HEADQUARTERS OF 'THE EIGHTS' THEODORE III CLUB.

Cartoon by J. Norman Lynd in the *New York Herald,* May 17, 1908. "Theodore III Club," *from left:* Club secretary George Calvert (*at desk*), Shinn, Sloan, Davies, Luks, Lawson, Prendergast, and Henri. *Inset,* Glackens.

ers,'' Shinn was quoted as saying, ''but he was away last week . . . and the oratorical part of the propaganda was neglected. Nobody understands why Mr. Glackens acted that way when there was so much need for the silvery beauties of his rhetoric.'' What a mockery to picture the retiring, soft-spoken Glackens as a dynamic public speaker!

"However,'' Shinn continued, ''Glackens has been working very hard about the Theodore III Club, and I guess he needs a little rest. He'll be back, though, before long, and well before you write anything you must hear Glackens talk. Don't you miss it.''[211]

William Glackens was enraged by the newspaper account. Lacking ability to display his wrath verbally, he wrote in a letter to his wife that ''the stories published in the papers about it make first-class idiots of the whole lot of us. Everett has certainly taken advantage of his friends for advertising purposes.''[212] But John Sloan, appreciating the subtle humor underlying the project, took a less critical view: ''It's all very amusing, Shinn making hay out of his associates in the Exhibition.''[213]

The hoax was finally and completely exposed on May 29, when the *New York Evening Sun* categorically denied the existence of a Theodore Roosevelt III Club. Just the day before a rival paper had reported a unanimous decision by The Eight to send Shinn to Washington to see ''the idol of the club.'' The *Evening Sun* disclosed that three of The Eight had been out of town at the time of the supposed meeting. George Luks was quoted as saying: ''There is no Theodore III Club that I know of, unless it exists in Mr. Shinn's imagination. . . .'' And Lawson denied any anxiety over the Republican President's third-term aspirations by simply stating: ''I am a Democrat and take no interest in practical politics.''[214]

Undaunted by his colleagues' repudiations, Shinn continued his advertising campaign. Posters were placed throughout the city. His studio on Waverly Place became crowded with shipments of the puzzles, which were being delivered from the manufacturer by the gross. Not even Teddy Roosevelt's refusal to run could dampen the enterprising artist's spirits, for after the President announced his intentions in mid-June and the Republican and Democratic nominees were selected, Shinn quickly replaced his first puzzle with two new ones — this time utilizing the faces of William Howard Taft and William Jennings Bryan.

During the several weeks of excitement over the ''Third Term Puzzle'' Robert Henri had remained aloof from the controversy, busying himself with his customary preparations for a summer in Spain. When he embarked on June 1, with an entourage of his art students, no one noticed the casual intimacies which passed between him and a twenty-one-year-old pupil — a beautiful girl with rich auburn hair. But on the first day at sea Henri penned the following letter to his closest friends:

DEAR SLOANS:
Forgive silence but a bargain is a bargain and we

their work was arranged beside that of Hartley, Marin, and Maurer, together with half a dozen Henri students whom Kent had corralled.

Even though this second Independent show did not materialize as such, the need for another large-scale exhibition was being felt. And the Henri associates and students did not monopolize all of the thought in this direction. In December, 1911, Jerome Myers, Walt Kuhn, and Elmer MacRae were included in a group show at the Madison Gallery. As they were sitting in the empty room discussing their show with Henry Fitch Taylor, the gallery director, Kuhn suddenly asked: "Myers, . . . why can't we get together on a scheme for a large exhibition?"[254]

The spark had been ignited. The four men retired to Myers' studio near by, where they set about preparing a list of artists who might be willing to sponsor such an undertaking. Within a few days these were approached, additional meetings were held, and soon a twenty-five-member organization was incorporated as the Association of American Painters and Sculptors. With the sole exception of Everett Shinn, all of the Eight were represented, as well as former Henri students George Bellows and Guy Pène duBois.

Although more than one-third of the group was composed of Henri associates, conservative artists were also represented. One of the first orders of business was to elect J. Alden Weir, then head of the National Academy of Design, to the presidency. This action would serve to suggest that absolute harmony existed within the Association. And for the Academy, which had been considerably shaken by The Eight and the 1910 Independent shows, this guaranteed the inclusion of academicians in any new revolt.

The Association's only aim was to increase the opportunity for exhibiting American art, so the big problem was that of locating sufficient space to accommodate a large independent show. But the membership soon realized that no easy solution presented itself, for adequate facilities could not be readily found. Furthermore, because a sizable segment of the Association was composed of progressive artists, the group was promptly branded as being anti-Academy. One day a reporter approached President Weir and asked him how, with the reputation the new group had acquired, he could remain as the guiding spirit of both the Association and the

Academy. In the light of possibly unfortunate publicity, J. Alden Weir was forced to resign.

Weir's withdrawal came as a severe blow to the new organization, which had been making negligible progress toward its announced goal. When it was decided that there was apparently no location in New York City suitable for a large-scale display of art, hope for the floundering group was nearly abandoned.

Upon leaving one of the discouraging meetings, Jerome Myers suggested to Elmer MacRae that they offer the presidency of the Association to Arthur B. Davies. Davies, with all of his personal reserve and stand-offishness, seldom attended the group's gatherings, yet Myers felt that his established reputation would bolster the strength of the Association's leadership. When Davies reluctantly accepted the abandoned post, most members must have thought that their new, unpretentious president would be merely a fugurehead. The strange Davies, who had always worked behind the scenes, had never before displayed any physical exertion in the cause of art. But now he suddenly came to life. His new responsibility jolted him into action.

Arthur B. Davies had accepted the presidency on one condition: that the exhibition which was contemplated for the work of living American artists exclusively be expanded to include all contemporary art, as well as examples that had been executed as far back as the end of the French Revolution in 1799. Davies felt that by incorporating nineteenth-century, in addition to present-day, art, the evolution of various modern styles could be effectively illustrated.

The request seemed fair enough to the liberal-minded members of the Association. After all, when The Eight had originally planned a large independent show for 1909, the New York Herald reported: "It is likely . . . that they may ask several English artists to send over their paintings from London to be exhibited with the American group."[255] But this had been only the verbal spirit of freedom.

Davies, on the other hand, was quietly absorbed by the exciting effects of modern art. Although no sign of this knowledge revealed itself in his own painting prior to 1913, he alone of The Eight paid frequent visits to 291. At the Photo-Secession Gallery he expressed an admiration for the Rodin water colors and Matisse drawings, and occasionally acquired

LUKS: *Roundhouses at Highbridge*, 1909.

Munson-Williams-Proctor Institute

LAWSON: *The Old Grand Central*, circa 1910.

Arthur G. Altschul Collection

the works of other artists. As early as 1909, this painter of lyrical landscapes purchased two canvases by the American Modern Max Weber, at a time when Weber's work was almost completely ignored. And, as if still dissatisfied with the education in modern art which he could derive from America, Davies would purchase current French publications and send them to a friend for translation.

These little-known facts regarding Davies' intelligent understanding and promotional activities in the interest of modern art caused Jerome Myers to state regretfully many years later: "Thus it was that I, an American art patriot, who painted ashcans and the little people around them, took part in inducing to become the head of our association the one artist in America who had little to do with his contemporaries. What I did not know was Davies' intense desire to show the modern art of Europe to America."[256]

By the time Davies was persuaded to assume the leadership of the Association of American Painters and Sculptors in the early months of 1912, the New York Realists had already stepped out of the picture. Robert Henri, the overseer, and John Sloan, the toiler, were not numbered among the organization's inner circle, for they had attended only the first few meetings. George Luks had not even gotten to those. Everett Shinn was preoccupied completing a mural for the city hall in Trenton, New Jersey. And William Glackens was in Paris, having gone there as an agent to purchase a group of paintings for a Dr. Albert C. Barnes.

Glackens knew Barnes, a physician with a degree from the University of Pennsylvania, for they had been high school chums in Philadelphia back in the eighties, and later had played semi-professional baseball together. Beginning in 1893 the medical student had labored to develop an improved antiseptic which, by 1902, was perfected and marketed under the name of Argyrol. The medicine enjoyed tremendous success, with the result that Dr. Barnes, a product of the Philadelphia slums, became a millionaire at the age of thirty-five.

A frustrated painter-turned-collector, Barnes spent large sums of money accumulating the popular, academic art then being offered by Philadelphia and New York dealers. When Glackens was told of

the collection, he remarked to his former classmate: "I know what you have. A couple of Millets, redheads by Henner, a Diaz, and fuzzy Corots. They are just stinging you as they do everybody who has money to spend."[257] Barnes countered by proposing that the artist accept a letter of credit and journey to Europe to purchase $20,000 worth of contemporary art.

Glackens accepted the challenge, and during February, 1912 he combed the galleries of Paris. He was assisted in his search by Alfred Maurer, who happened to be in the French capitol at the time, and Gertrude Stein's brother, Leo. At the Stein house, Glackens was introduced to their collection of Renoirs and Cézannes, painters who were permanently to affect his taste in art.

When Glackens wrote home about his tiring pursuit of "hunting up pictures," he mentioned a small Renoir as the only canvas bought thus far. Yet by March 2, when he set sail for America, a total of some twenty works had been acquired, including several additional Renoirs, at least one each by Cézanne, Degas, and Manet, and Van Gogh's *Postman*. These selections were to form the nucleus of the now-famous Barnes Collection.

Beginning in 1912 Dr. Barnes made annual tours to Europe himself. By the following year he owned two dozen Renoirs, and eventually two hundred canvases by the French Impressionist were to constitute the heart of the Barnes Foundation Collection.

Although few people ever came to know the part played by artist William Glackens in the cultivation of Albert Barnes' taste, the good doctor never forgot. When he published a volume on *The Art of Renoir*, Barnes sent a copy to his old friend, "Butts" Glackens. On the flyleaf of the book, in the doctor's own hand, was inscribed this testimonial:

> To Butts, who started my interest in Renoir.
> ALBERT C. BARNES

For Arthur B. Davies, as for the entire Association of American Painters and Sculptors, the major stumbling block to their proposed exhibition was still that of finding a site. When they originally broached the question, Sloan had suggested Madison Square Garden, the location he and Albert Ullman had considered for their 1909 Independent show which never materialized. But once again, the arena

was deemed too costly. Then one of the members recalled that in the spring of 1908, what had been referred to as "the finest collection of American sculpture ever brought together" had been exhibited in the Fifth Regiment Armory in Baltimore. At the time *The Craftsman* had reported that the armory was beautifully decorated as a setting for the exhibit with grass plots, fountains, growing plants, and flowers. "New York had no place, so it was said, large enough and dignified enough to afford opportunity for showing the 461 sculptures . . .,"[259] the article concluded.

Was Baltimore's armory more grandiose than those to be found in New York? The Association secretary, Walt Kuhn, investigated by meeting with the commanding officer of each one. Finally the organization agreed to rent the nearly-new 69th Regiment Armory on Lexington Avenue for one of the early months of 1913.

Davies and Kuhn met often to discuss the nature of the forthcoming exhibition. Then, in early summer, Kuhn was dispatched to Europe to line up works for the show. He arrived in Cologne just in time to view the *Sonderbund* exhibit, then to Holland, Munich, and finally Paris. By now the magnitude of the assignment was apparent, and Kuhn cabled Davies for assistance. The Association's president was there in two weeks.

The two spent hectic days in Paris, visiting the studios and dealers of many of the European and American modernists. Walter Pach, a former Henri student, was especially helpful in furnishing advice, for he had been among the first pupils of Henri Matisse a few years earlier and had written about Cézanne in a 1908 issue of *Scribner's*. Pach knew just which artists to contact for the most experimental work, and when Davies and Kuhn hurriedly departed for London they left to him the task of assembling the canvases.

When the two Association officers returned to America in November, 1912, the nature of the show was crystallized. Paintings by Cézanne, Van Gogh, Edvard Munch, Odilon Redon, Marcel Duchamp; sculpture by Lehmbruck and Brancusi — this and much more had been spoken for in their whirlwind tour through Europe. But now, as Davies began drawing up plans for redesigning the armory's drill floor, the entire scheme seemed in jeopardy. Gutzon

Borglum, a sculptor and vice-president of the Association, came forth to insist that his kind of work be included in the exhibition. The suggestion was potentially disastrous for Davies' type of show because Borglum was slated to preside over the jury selection of sculpture.

On their first trip by car to several New York sculptors' studios, Borglum jokingly remarked that were Davies a sculptor, he too could own an automobile "I could," Davies quipped, "if I were that kind of a man."[260] That remark was enough for Borglum. His resignation appeared in a letter to the *New York Times* even before the Association had been informed.

As all of these preparations for the big show were taking place, Robert Henri was obtaining his first glimpse of modern art. While in Paris during the late summer and fall of 1912, Henri met his former pupil, Walter Pach, and together they went to the Autumn Salon. Henri was completely unprepared for what he saw. The Cubists' work shocked him. He had never witnessed anything like it, for during the previous decade his European tours had taken him to Holland and Spain, countries outside the mainstream of modern art.

Yet Henri, always appreciative of individuality in art, could see the personal interpretation in the Cubist canvases, especially when they were compared with academic work. While viewing the Salon, he stopped to examine a delicately executed study by the conservative painter, Boutet de Monvel. Turning to Pach, Henri confessed: "If it's a choice between the Cubists and that, I'm for the Cubists."[261]

During the weeks and days immediately before the February 17 opening of the Armory Show, the place was inconceivably hectic. Nearly 1,600 works of art had to be hung or, as in the case of sculpture, artistically placed upon home-made pedestals. Davies' plan called for dividing the vast, unbroken space of the armory's drill floor into eighteen cubicles created by burlap-covered partitions. Henri students assisted with carpentry work. And taking their cue from the Baltimore armory show, they encouraged Gertrude Vanderbilt Whitney to donate garlands of greenery to relieve the drabness of the interior. The festive mood was particularly appropriate, for this was Davies' party.

Two days before the momentous opening, as the

workmen strained to meet the approaching deadline, Robert Henri strolled into the armory. The place was a beehive of activity. Paintings were still strewn everywhere. Henri walked slowly, deliberately, oblivious of the hubbub of excitement around him. Accompanied by one of his pupils he proceeded to the area designated as the French section of the show. They gazed. They peered deeply. Not a word passed between them as both student and teacher sought to learn the lesson these works of art held for them. Both men were visibly shaken by the experience, for here, spread out before them, was a veritable microcosm of modern art.

As the chagrined mentor rounded the corner of one of the partitions, there, standing directly before him, were Arthur B. Davies and Walter Pach. The sides were drawn. For a brief moment they stood face to face, staring; for the first time in his life Robert Henri was speechless. Groping for words, he finally said: "Don't you think these pictures are hung a little low?" There was an embarrassing silence. Then

Henri was prompted to add: "If they were raised ten, eight, or even six inches, the visitors could see them better." The critic's question appeared to be directed at Davies, but with a turn of the head it was ignored. The query went unanswered as it grazed off his tall, stonelike façade. Henri gazed down at the dramatic color and distorted form of the Fauve paintings on the floor beside him. He then looked back at Walter Pach. "I hope that for every French picture that is sold, you sell an American one," Henri asserted, half-heartedly.

Pach faced up to his former teacher and resolutely remarked what they both already knew: "That's not the proportion of merit."

Henri stood for a moment with head bowed, then spoke out again as the two parted company: "If the Americans find that they've just been working for the French, they won't be prompted to do this again."[262]

And they weren't, for it wasn't necessary.

National Sculpture Society Exhibition, 5th Regiment Armory, Baltimore, April, 1908.

EPILOGUE

WHEN THE Armory Show opened with a preview on the evening of February 17, 1913, speeches were given and poetry was read. Even the regimental band was on hand to play rousing marches and music in three-quarter time. But it was the art, the European art, the modern French art, that stole the show.

Outside, hundreds of invited guests were arriving by carriage and car in sub-freezing weather; once inside, few warmed up to what they saw. The first to arrive viewed the exhibition as Davies had meant it to be seen, in chronological sequence. Beginning with the early nineteenth-century line portraits of Ingres, spectators would file past a canvas or two by Delacroix, then the realism of Courbet and Manet, and the light and bright works of the Impressionists. In this way the modern art was reached by gradual steps. Even though separate cubicles were designated for the Post-Impressionist masters Van Gogh, Gauguin, and Cézanne, it was the Fauves and the Cubists in general, and a canvas by twenty-five-year-old Marcel Duchamp in particular, which became the focal point of attention. The title of Duchamp's painting, *Nude Descending a Staircase*, was provocative enough. But middle-aged gentlemen, anticipating the sensuous female form such a title implied, looked in disbelief. Who could find the lady?

Word spread like wildfire, and soon the public was queuing up in front of this feature attraction. They waited in long lines just for a glimpse of the most famous woman since Whistler's Mother. Everyone had something to say. In the days immediately following, a newspaper printed a diagram to aid in locating the nude and the stairs, and an art magazine offered ten dollars to anyone who could

The Armory Show, 69th Regiment Armory, New York, February-March

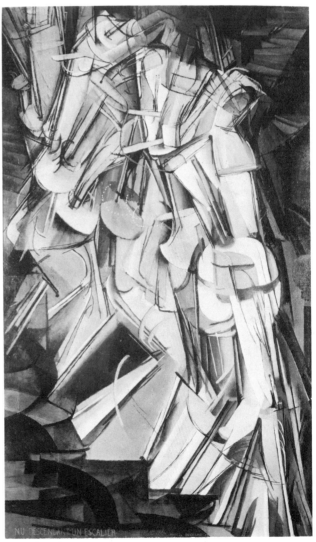

DUCHAMP: *Nude Descending a Staircase (No. II)*, 1912.

explain it. Cartoonists and newspapermen had a field day. And when one reporter referred to the *Nude* as "an explosion in a shingle factory,"[263] he was unwittingly updating the revolutionary character of The Eight show, for a *New York Globe* writer had labeled the Prendergast canvases in that 1908 exhibition as resembling "an explosion in a color factory."

Although the American and foreign sections of the Armory Show were roughly equal in numbers of works, the native productions were largely overlooked, seeming old-hat by comparison. William Glackens, who had been in charge of selecting the American art, said solemnly: "I am afraid that the American section of this exhibition will seem very tame beside the foreign section."[264] This proved to be the understatement of the show.

The academicians, of course, found themselves completely outclassed. Unable to fight back with the brush, they resorted to verbal and written attacks upon the European inventions. William Merritt Chase, for instance, took one look at Cézanne's work and publicly labeled him an "idiot." Similarly, Kenyon Cox wrote in *Harper's Weekly* that "Cézanne is absolutely without talent . . . cut off from tradition . . . hopeless."[265] And Royal Cortissoz, the arch-conservative critic, also pronounced judgment on Cézanne by stating that he "never quite learned his trade."[266]

On the other hand, Guy Pène duBois' article in *Arts and Decoration* proclaimed: "Cézanne is truly the great man of the great modern movement." And Robert Henri, who spoke of Cézanne and Matisse as "highly intelligent men,"[267] quickly revised his outmoded classroom comparison between Bouguereau and Manet by contrasting the conservative Frenchman with Paul Cézanne:

> Cézanne . . . was scorned or pitied or ignored by all. Bouguereau, the learned academician, on the other hand, was given every possible mark of esteem. Today, Cézanne lives for us; we recognize him as one of the master artists of all time; while Bouguereau is dead and we pass his pictures unheeding.[268]

Though Robert Henri had unintentionally sheltered his brood from the Post-Impressionists, the Fauves, and the Cubists, the liberal education he provided was beginning to pay off. Eighteen-year-old Stuart Davis, who had been studying at the Henri school for two and a half years, was represented in the Armory Show by five realistic water colors, but he came away with a new-found appreciation for Van Gogh, Gauguin, and Matisse. Morgan Russell, a former Henri student in both New York and Paris, exhibited pure color abstractions. Just a few months before he had been a co-founder of "Synchromism," the art style inspired by Cézanne and Cubism, which had been immediately labeled the first independent modern art movement to be launched by Americans. Within a couple of years Niles Spencer's realistic cityscapes would acquire Cézanne's geometric solidity, while Arnold Friedman's landscapes would be transformed into complete abstractions.

By 1917, *Who's Who in Art* listed well over one hundred Henri students. Many of them, already teachers across the length and breadth of the land, would propagate succeeding generations with the Henri philosophy: Julius Golz at the Columbus, Ohio, Art School; Clarence Chatterton at Vassar; Nathaniel Pousette-Dart at Minnesota College; and Clifton Wheeler at the John Herron Art Institute.

In the meantime, the students kept coming. When Henri instituted classes at the Ferrer Society and then the Art Students League, William Gropper, Robert Brackman, Margery Ryerson, Helen Appleton Read, Richard Lahey, and Peppino Mangravite were among those stimulated by his still-inspiring teaching. And when John Sloan also began instructing at the League in 1916, three decades of art students were to receive a similar stimulus, students by the name of Aaron Bohrod, Joseph Hirsch, Arnold Blanch, Reginald Marsh, Peggy Bacon, Fletcher Martin, and A. Stirling Calder's son, Alexander.

The Armory Show, of course, had been a smashing success, having served to bring modern art out of the confines of the 291 Gallery to a much larger segment of the population. Some 87,000 persons had viewed it in New York, plus another 117,000 when it went on tour to Chicago and Boston. But like the exhibitions of The Eight and the 1910 Independent, the Armory Show was just a one-time thing. A contemplated second exhibit never materialized.

There was still the need for continuing group exhibits where new talent could regularly have a voice and be heard. Toward this end Robert Henri and his associates and students never ceased to aid

their fellow artists. The concept of the non-juried group show was continued in the MacDowell Club exhibitions, a plan of rotating co-operative exhibits that Henri had conceived as a partial solution for providing everyone with exhibition opportunities. For nearly a decade the club's seventy-five-foot-long gallery was made available for two-and three-week periods, put at the disposal of self-appointed groups of artists who were free to organize in any way they chose.

And when a permanent Society of Independent Artists was formed in 1916, the Henri coterie was in the forefront once again, with Glackens becoming its first president, only to relinquish the post a year later to John Sloan, who held the office for more than three decades. With five former Henri students among the directors, and Henri, Luks, Lawson, and Prendergast on its Advisory Board, the organization could not help but be a model of democratic fairness. Proudly flaunting its motto of "No Jury, No Prizes," with works hung in alphabetical order, the society listed more than 1,200 members at the time of its very first exhibition in April, 1917, and for many years thereafter some of the best of the up-and-coming artists made their exhibition debuts at these huge, annual displays.

The Whitney Studio Club, established soon after The Eight show as a gallery in sculptor Gertrude Vanderbilt Whitney's spacious double studio, eventually flowered into the Whitney Museum of American Art, the first such institution to acknowledge the emergence of art in this country. And when the Museum of New Mexico Art Gallery was opened in 1917, Robert Henri was again one of the strong, devoted, guiding influences.

Time cannot dim their unselfish acts, their lives of devotion, their deeds which will forever stand as their memorial. And the years have given added substance to Robert Henri's profound observation that "Art is simply a question of doing things, anything, well. When the artist is alive in any person he becomes an inventive, searching, daring, self-expressive creature. He disturbs, upsets, enlightens."[269]

Certainly Robert Henri and The Immortal Eight had disturbed, upset, and enlightened.

ROBERT HENRI Photograph by Gertrude Kasebier

WILLIAM J. GLACKENS Photograph by Gertrude Kasebier

EVERETT SHINN Photograph by Gertrude Kasebier

JOHN SLOAN Photograph by Gertrude Kasebier

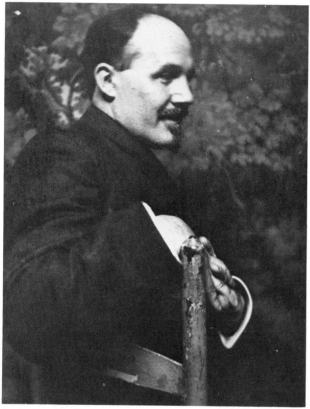

ERNEST LAWSON Photograph by Gertrude Kasebier

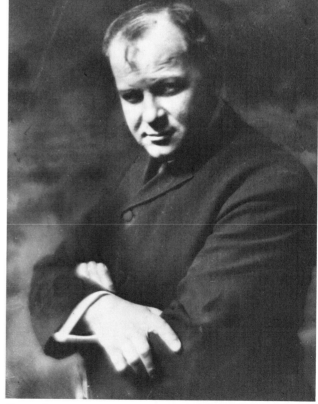

GEORGE LUKS Photograph by Gertrude Kasebier

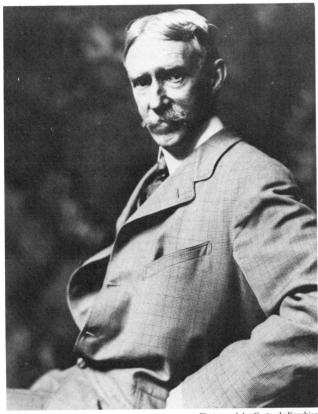

MAURICE PRENDERGAST Photograph by Gertrude Kasebier

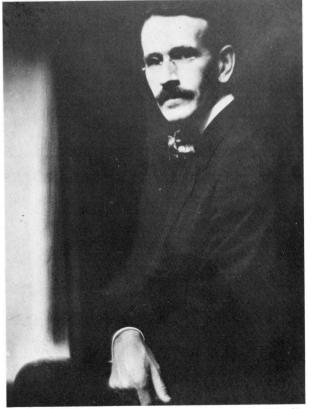

ARTHUR B. DAVIES Photograph by Gertrude Kasebier

BIBLIOGRAPHY

Unpublished Material

Charles Grafly Diary. Property of Dorothy Grafly.
Friedman, Arnold, "The Original Independent Show, 1908." Collection of the Museum of Modern Art, N.Y.
Gatewood, Robert H., "Who Was Robert Henri?" c. 1932.
Grafly, Dorothy, "Charles Grafly." Property of Dorothy Grafly.
John Sloan Notes, 1944-1951. Manuscript on deposit at the Delaware Art Museum from the John Sloan Trust.
John Sloan Diaries, 1906-1912. Notes from original manuscript. John Sloan Trust, Delaware Art Museum.
Karl, Adolph J., "The New York Realists, 1900-1903." Ph.D. dissertation, New York University, 1951.
Shinn, Everett, "Autobiography" and miscellaneous notes. Collection of Charles T. Henry.
—————, "The Eight by One of Them." Collection of Charles T. Henry.

Exhibition Catalogs

Brooks, Van Wyck, "Anecdotes of Maurice Prendergast, "*The Prendergasts: Retrospective Exhibition of the Work of Maurice and Charles Prendergast.* Addison Gallery of American Art, Andover, Mass. (1938), 33-45.
Catalog of an Exhibition of the Work of George Benjamin Luks. Newark Museum, Newark, N.J., Oct. 30, 1933-Jan. 6, 1934.
Catalogue of a Memorial Exhibition of the Work of Robert Henri. Metropolitan Museum of Art, N.Y., March 9-April 19, 1931.
Catalogue of a Memorial Exhibition of the Works of Arthur B. Davies. Metropolitan Museum of Art, N.Y., Feb. 17-March 30, 1930.
Catalogue of Paintings by Arthur B. Davies. Doll & Richards, Boston, Mass., Feb. 23-March 8, 1905.
Du Bois, Guy Pène, "William J. Glackens," *Memorial Exhibition of Works by William J. Glackens.* Carnegie Institute, Pittsburgh, Feb. 1-March 15, 1939.
Edward Hopper Retrospective Exhibition. Museum of Modern Art, N.Y., Nov. 1-Dec. 7, 1933.
Exhibition of A Private Collection of American Pictures: Arthur B. Davies, The Young Student. Macbeth Gallery, N.Y., Feb. 3-15, 1902.
Exhibition of Paintings by Arthur B. Davies. Macbeth Gallery, N.Y., April 24-May 8, 1897.
Exhibition of Paintings by George B. Luks. Macbeth Gallery, N.Y., April 14-27, 1910.
Exhibition of Water Colors and Monotypes in Color by Maurice B. Prendergast. Macbeth Gallery, N.Y., March 9-24, 1900.
George Bellows. Art Institute of Chicago, Chicago, Ill., 1946.
Goodrich, Lloyd, *John Sloan 1871-1951.* Whitney Museum of American Art, N.Y., Jan. 10-March 2, 1952.
John Sloan. Addison Gallery of American Art, Phillips Academy, Andover, Mass., 1938.
Maurice Prendergast Memorial Exhibition. Whitney Museum of American Art, N.Y., Feb. 21-March 22, 1934.
New York Realists 1900-1914. Whitney Museum of American Art, N.Y., Feb. 9-March 5, 1937.
Special Exhibition of Paintings by Mr. Robert Henri. Cincinnati Museum, Cincinnati, O., Oct., 1919.
Survey of American Painting. Carnegie Institute, Pittsburgh, Pa., Oct. 24-Dec. 15, 1940.
The Eight. Brooklyn Museum, Brooklyn, N.Y., Nov. 24, 1943-Jan. 16, 1944.
Whitney Museum of American Art, Catalogue of the Collection. Whitney Museum of American Art, N.Y., 1931.
William J. Glackens Memorial Exhibition. Carnegie Institute, Pittsburgh, Pa., Feb. 1-March 15, 1939.

Newspapers

"Academy Can't Corner All Art," *New York Evening Mail*, May 14, 1907.
"A New Art Group, 'The Eight,' " *New York Tribune*, May 15, 1907.
"Another 'Very Large' Exhibition," *New York Evening Sun*, March 17, 1910.
"Around the Galleries," *New York Sun*, April 6, 1902.
"Art Exhibitions," *New York Sun*, Feb. 5, 1908.
"Art Exhibitions of the Week," *New York Evening Sun*, Feb. 24, 1906.
"Art Notes," *New York Evening Sun*, April 11, 1901.
"A Significant Group of Paintings," *New York Evening Sun*, Jan. 23, 1904.
Baum, Walter E., "More Fame for Teacher of the Famous," *Philadelphia Evening Bulletin*, Oct. 12, 1942.
Burrows, Carlyle, "Robert Henri and His Service to Painting," *New York Herald Tribune*, July 21, 1929.
"Certain Painters at the Society," *New York Evening Sun*, April 1, 1905.
Chamberlin, Joseph Edgar, "With the Independent Artists," *New York Evening Mail*, April 4, 1910.
De Casseres, Benjamin, "The Fantastic George Luks," *New York Herald Tribune*, Sept. 10, 1933.
De Kay, Charles, "Six Impressionists. Startling Works by Red-Hot American Painters," *New York Times*, Jan. 20, 1904.
"Doors Slammed on Painters," *New York Sun*, April 12, 1907.
Du Bois, Guy Pène, "Great Modern Art Display Here April 1," *New York American*, March 17, 1910.
"8 Artists Secede from The Academy," *New York Sun*, May 15, 1907.
"Eight Independent Painters to Give an Exhibition of Their Own Next Winter," *New York Sun*, May 15, 1907.
"Eight Painters," *Philadelphia Press*, no date [Feb., 1908].
"Exhibition of the Eight," *Boston Transcript*, Feb. 5, 1908.
"Fine Arts—New Pictures by Arthur B. Davies and the Beales," *Brooklyn Eagle*, March 31, 1905.
"George B. Luks, Painter," *New York Evening Sun*, May 10, 1902.
Hoeber, Arthur, "A Most Lugubrious Show at the National Art Club," *New York Commercial Advertiser*, Jan. 21, 1904.
Huneker, James, "George Luks," *New York Sun*, March 21, 1907.
"Independent Artist," *New York Sun*, April 2, 1910.
"Independents Hold an Art Exhibition," *New York World*, April 3, 1910.
Lochheim, Aline B., "Last of 'The Eight' Looks Back," *New York Times*, Nov. 2, 1952.
"Luks Found Dead in 6th Ave. Hall After Dawn Study for Painting," *New York Herald Tribune*, Oct. 30, 1933.
"Luks Says U.S. Has Own Master Artists," *New York Evening Post*, May 9, 1925.
Mather, Frank Jewett, "Academic Arteriosclerosis," *New York Evening Sun*, March 19, 1910.
"Mr. Henri's Resignation," *New York Sun*, Jan. 6, 1909.
"Mr. Robert Henri and Some 'Translators'," *New York Evening Sun*, April 8, 1902.
"National Academy Elects 3 Out of 36," *New York Times*, April 12, 1907.
"New Art Salon Without A Jury," *New York Herald*, May 15, 1907.
"Six Impressionists," *New York Times*, Jan. 20, 1904.
"Some Pastels by Shinn," *New York Times*, March 12, 1904.
"Spirit of Luks, 'Dickens of the East Side,' Hovers Over Art Classes in Old Studio," *New York Evening Post*, Dec. 2, 1933.
"That Tragic Wall," *New York Sun*, March 16, 1907.
"The Deserted Academy," *New York Sun*, Dec. 31, 1907.
"The Independent Artists," *New York Evening Post*, April 2, 1910.
"Two Admired of Mr. Robert Henri," *New York Herald*, March 31, 1907.
"What is Art Anyhow?" *New York Sunday American*, Dec. 1, 1907.
"Wm. M. Chase Forced Out of N.Y. Art School; Triumph for the 'New Movement' Led by Robert Henri," *New York American*, Nov. 20, 1907.

216

Periodicals

Adams, Adeline, "The Secret of Life," Art and Progress, IV (April, 1913), 925-932.
Albright, Adam Emory, "Memories of Thomas Eakins," Harper's Bazaar, 81 (Aug., 1947), 138, 184.
"A New Poet-Painter of the Commonplace," Current Literature, XLII (April, 1907), 406-409.
Armstrong, Regina, "Representative Young Illustrators," The Art Interchange, XLIII (Nov., 1899).
_____, "The New Leaders in American Illustration, Part IV, the Typists: McCarter, Yohn, Glackens, Shinn and Luks," The Bookman, XI (May, 1900), 244-251.
"Artists of the Philadelphia Press," Philadelphia Museum Bulletin, 41 (Nov., 1945), 1-32.
Arts and Decoration [Armory Show Issue], III (March, 1913).
"Art School Notes," The Art Interchange, XLIII (Oct., 1899), 101.
"A Salon des Refusés," American Art News (March 26, 1910), 2.
Barrell, Charles Wisner, "The Real Drama of the Slums, as Told in John Sloan's Etchings," The Craftsman, XV (1909), 559-564.
Baur, John I.H., "Modern American Painting," Brooklyn Museum Quarterly, XXIII (Jan., 1936), 3-20.
Baury, Louis, "The Message of Bohemia," The Bookman, XXXIV (Nov., 1911), 256-266.
_____, "The Message of Proletaire," The Bookman, XXXIV (Dec., 1911), 399-413.
Benjamin, S.G.W., "American Art Since the Centennial," The New Princeton Review, 62 (July, 1887), 14-30.
Benson, E.M., "The American Scene," The American Magazine of Art, XXVII (Feb., 1934), 53-66.
Bonsal, Stephen, "The Fight For Santiago. The Account of An Eye-Witness," McClure's Magazine, XI (Oct., 1898).
Borglum, Gutzon, "Art that is Real and American," The World's Work (June, 1914), 200-217.
Boyesen, Bayard, "The National Note in American Art," Putnam's Monthly and The Reader, IV (May, 1908), 131-140.
Brace, Ernest, "John Sloan," Magazine of Art, XXXI (March, 1938), 131-135, 183.
Breuning, Margaret, "Henri on Life and Art," Art Digest, 26 (March 15, 1952), 23.
_____, "Macbeth Gallery: Six Decades of Art by Americans Only," Art Digest, 26 (April 15, 1952), 7.
Brinton, Christian, "The New Spirit in American Painting," The Bookman, XXVII (June, 1908), 351-361.
"Brooklyn Revives Memories of 'The Eight'," Art Digest, 18 (Dec. 1, 1943), 12-13.
Buchanan, Charles L., "American Painting Versus Modernism," The Bookman, XLVI (1917), 413-423.
Burroughs, Bryson, "Arthur B. Davies," The Arts, 15 (Feb., 1929), 79-93.
Caffin, Charles H., "Effect on American Artists of the Spirit of Realism," American Magazine, LXI (1906), 590-599.
_____, "Some American Figure Painters," The Critic, XLIV (March, 1904), 221-230.
Cheyney, E. Ralph, "The Philosophy of a Portrait Painter: An Interview with Robert Henri," The Touchstone, 5 (June, 1919), 212-219.
Clark, Elliot, "The Art of John Twachtman," The International Studio, LXXII (Jan., 1921), lxxvi-lxxxvi.
"Contributions to the International Exhibition, Philadelphia, 1876," Art Journal (1876), 153, 249.
Cournos, John, "Three Painters of the New York School," International Studio, 56 (1915), 239-246.
Cox, Kenyon, "Art—The Winter Academy," The Nation, 83 (Dec. 27, 1906), 564-565.
"Davies Memorial Opens at the Metropolitan," The Art News, XXVII (Feb. 22, 1930), 3, 5.
"Decorations Based on Truth," The Literary Digest, XLIV (Jan. 13, 1912), 71.
Dickerson, James Spencer, "Has America an American Art?" World Today, XIII (Dec., 1907), 1234-1241.
du Bois, Guy Péne, "George B. Luks and Flamboyance," The Arts, 3 (Feb., 1923), 107-118. 107-118.
_____, "Robert Henri: The Man," Arts and Decoration, 14 (Nov., 1920), 36, 76.
_____, "The Arthur B. Davies Loan Exhibition," Arts and Decoration, 8 (Jan., 1918), 112-113.
_____, "The Eight at the Brooklyn Museum," Magazine of Arts, 36 (Dec., 1943), 292-297.
_____, "William Glackens, Norman Man; the best eyes in American art," Arts and Decoration, 4 (Sept., 1914), 404-406.
Edgerton, Giles, "Is America Selling Her Birthright in Art for a Mess of Pottage?" The Craftsman, XI (March, 1907), 656-670.
_____, "The Younger American Painters: Are They Creating a National Art?" The Craftsman, XIII (Feb., 1908), 512-532.
Fitzsimmons, James, "Everett Shinn: Lone Survivor of 'The Ashcan School'," Art Digest, 27 (Nov., 15, 1952), 10-11.
Gallatin, A.E., "Everett Shinn's Decorative Paintings," The Script, I (Aug., 1906), 358-360.
_____, "The Art of William J. Glackens; a note," International Studio, 40 (May, 1910), lxviii-lxxi.
_____, "The etchings, lithographs and drawings of John Sloan," International Studio, LVIII (March, 1916), xxv-xxviii.
"George Luks, Lusty Proponent of American Individualism, is Dead," Art Digest, VIII (Nov. 15, 1933), 5-6.
Glackens, William J., "The American Section: The National Art," Arts and Decoration, III (March, 1913), 159-164.

"Henri, Artist, Emerges from Henri, the Man," Art Digest, 13 (Jan. 1, 1939), 5.
Henri, Robert, "New York Exhibition of Independent Artists," The Craftsman, 18 (May, 1910), 160-162.
_____, "Progress in our national art must spring from the development of individuality of ideas and freedom of expression: a suggestion for a new art school," The Craftsman, XV (Jan., 1909), 386-407.
"Henri vs. School of Art," American Art News, VII (Jan. 23, 1909), 2.
Hoeber, Arthur, "The Ten Americans," The International Studio, XXXV (July, 1908), xxiv-xxvi.
Huth, Hans, "Impressionism Comes to America," Gazette des Beaux Arts, XXIX (April, 1946), 225-252.
"Insurgency in Art," The Literary Digest, XL (April 23, 1910), 814-816.
Kuhn, Walt, "The Story of the Armory Show," The Art News, XXXVII (1939 Annual), 63-64, 168-174.
Larric, J.B., "John Sloan—Etcher," The Coming Nation (Jan. 6, 1912).
"Lusty Luks," Time, XLII (Jan. 26, 1931), 52.
Macbeth, William, Art Notes, 35 (March, 1908).
Mase, Carolyn C., "John H. Twachtman," The International Studio, LXXII (Jan., 1921), lxxi-lxxv.
McColl, W.D., "The International Exhibition of Modern Art," Forum, L (July, 1913), 24-36.
Mellquist, Jerome, "The Armory Show 30 Years Later," Magazine of Art, 36 (Dec., 1943), 298-301.
Moffitt, Charlott, "An Artist's House in New York," The House Beautiful, XIII (Dec., 1902), 18-22.
"Notes," The Chap-Book, 2 (Nov. 15, 1894), 40.
"Notes and Reviews," The Craftsman, 14 (June, 1908), 341.
Pach, Walter, "The Eight, Then and Now," Art News, 42 (Jan. 1, 1944), 24-25.
Pattison, James William, "Robert Henri—Painter," The House Beautiful, XX (Aug., 1906), 18-19.
Phillips, Duncan, "Ernest Lawson," The American Magazine of Art, VIII (May, 1917), 257-263.
_____, "Maurice Prendergast," The Arts, V (March, 1924), 125-131.
"Robert Henri, An Apostle of Artistic Individuality," Current Literature, LII (April, 1912), 464-468.
Roberts, Mary Fanton, "Progress in Our National Art Must Spring from the Development of Individuality of Ideas and Freedom of Expression: A Suggestion for a New School by Robert Henri," The Craftsman, XV (Jan., 1909), 387-401.
Ruthrauff, Florence Barlow, "Robert Henri—Maker of Painters," Fine Arts Journal (1912), 463-466.
Sawyer, C.H., "The Prendergasts," Parnassus, X (Oct., 1938), 9-11.
"Selection of Pictures from the Art Department of the Sixteenth Annual Exposition at Saint Louis," The Art Interchange, XLIII (Nov., 1899), 115.
Shepherd, Richard, "Henri and His Boys," Art News, XLV (May, 1946), 42-43.
Shinn, Everett, 'Life on the Press,' "Artists of the Philadelphia Press," Philadelphia Museum Bulletin, 41 (Nov., 1945), 9-12.
Sloan, John, 'Artists of the Press,' "Artists of the Philadelphia Press." Philadelphia Museum Bulletin, 41 (Nov., 1945), 7-8.
Smith, Katherine L., "Newspaper Art," The Art Interchange, XLIV (March, 1900), 52-53.
"Studio-Talk," The International Studio, XXX (Dec., 1906), 182.
Swift, Samuel, "Revolutionary Figures in American Art," Harper's Weekly, LI (April 13, 1907), 534-546.
"The American Poster," The Decorator and Furnisher, 27 (Feb., 1896), 135-137.
"The Armory Puzzle," American Art News, XI (March 8, 1913), 4.
"The Artist's Partnership with his Public," The Literary Digest, LXXX (Jan. 5, 1924), 27-28.
"The Big Idea: George Bellows Talks About Patriotism for Beauty," Touchstone, I (July, 1917), 269-275.
"The Dance: by Isadora Duncan," Touchstone, I (Oct., 1917), 3-15.
"The Henri Hurrah," American Art News, V (March 23, 1907), 4.
Townsend, James B., "A Bomb from the Blue," American Art News, XI (Feb. 22, 1913), 1.
_____, "The Eight Arrive," American Art News, VI (Feb. 8, 1908), 6.
Watson, Forbes, "Arthur Bowen Davies," Magazine of Art, 45 (Dec., 1952), 362-369.
_____, "John Sloan," Magazine of Art, 45 (Feb., 1952), 62-70.
_____, "Robert Henri," Arts, XVI (Sept., 1929), 2-7.
Whitworth, Grace, "The Summer Homes of Well-Known Painters," Town & Country, 60 (Aug., 12, 1905).
Wilhelm, Donald, "Everett Shinn, Versatilist," The Independent, 88 (Dec. 4, 1916), 398.
Yeats, John Butler, "Art, A Painter of Pictures," The Freeman, IV (Jan. 4, 1922), 401-402.
_____, "The Work of John Sloan," Harper's Weekly, LVIII (Nov. 22, 1913), 20-21.

Books

Biographical Sketches of American Artists. Lansing, Michigan, 1912.
Born, Wolfgang, American Landscape Painting. New Haven, 1948.
Boswell, Jr., Peyton, George Bellows. New York, 1942.
Breuning, Margaret, Maurice Prendergast. New York, 1931.
Brooks, Van Wyck, John Sloan: A Painter's Life. New York, 1955.
_____, The Confident Years 1885-1915. New York, 1952.
Brown, Milton W., American Painting from the Armory Show to the Depression. Princeton, New Jersey, 1955.

Bryant, Lorinda Munson, *American Pictures and their Painters*. New York, 1917.
_____, *What Pictures to See in America*. New York, 1915.
Caffin, Charles H., *The Story of American Painting*. New York, 1907.
Cahill, Holger, and Barr, Jr., Alfred H., eds., *Art in America in Modern Times*. New York, 1934.
Cary, Elisabeth Luther, *George Luks*. New York, 1931.
Cheney, Martha Candler, *Modern Art in America*. New York, 1939.
Clark, Eliot, *History of the National Academy of Design 1925-1953*. New York, 1954.
Clement, Clara E., and Hutton, L., *Artists of the Nineteenth Century and their Works*. 2 vols, Boston, 1883.
Cortissoz, Royal, *American Artists*. New York, 1932.
_____, *Arthur B. Davies*. New York, 1931.
Davidson, Marshall B., *Life in America*. 2 vols. Boston, 1951.
du Bois, Guy Péne, *Artists Say the Silliest Things*. New York, 1940.
_____, *John Sloan*. New York, 1931.
_____, *William J. Glackens*. New York, 1931.
Ely, Catherine Beach, *The Modern Tendency in American Painting*. New York, 1925.
Essays on American Art and Artists. Boston, 1895.
Gallatin, A.E., ed., *John Sloan*. New York, 1925.
Glackens, Ira, *William Glackens and the Ashcan Group*. New York, 1957.
Goodrich, Lloyd, *Thomas Eakins: His Life and Work*. New York, 1933.
Hartmann, Sadakichi, *A History of American Art*. Boston, 1913.
Henri, Robert, *The Art Spirit*. New York, 1923, 1939, 1951 editions.
Hunt, William Morris, *Talks on Art*. Boston, 1883.
Index of Twentieth Century Artists, The. 4 vols. New York, 1934.
Isham, Samuel, *The History of American Painting*. New York, 1905.
Kent, Rockwell, *It's Me, O Lord*. New York, 1955.
Kuhn, Walt, *The Story of the Armory Show*. New York, 1938.
Larkin, Oliver, W., *Art and Life in America*. New York, 1949.
Low, Will H., *A Chronicle of Friendships 1873-1900*. New York, 1908.
Masters, Edgar Lee, *Vachel Lindsay, A Poet in America*. New York, 1935.
Mellquist, Jerome, *The Emergence of an American Art*. New York, 1942.
Moore, George, *Modern Painting*. New York, 1893.
Myers, Jerome, *Artist in Manhattan*. New York, 1940.
Newhall, Beaumont, *The History of Photography from 1839 to the Present Day*. New York, 1949.
Pach, Walter, *Queer Thing, Painting*. New York, 1938.
Paris, W. Francklyn, *The Hall of American Artists, New York University*. 4 vols. New York, 1948.
Phillips, Duncan, *The Artist Sees Differently*. 2 vols. Washington, D.C., 1931.
Pousette-Dart, Nathaniel, *Robert Henri*. New York, 1922.
Price, Frederick Newlin, *Ernest Lawson, Canadian-American*. New York, 1930.
Read, Helen Appleton, *Robert Henri*. New York, 1931.
Ringel, Fred J., ed., *America as Americans See It*. New York, 1932.
Roof, Katharine Metcalf, *The Life and Art of William Merritt Chase*. New York, 1917.
Saint-Gaudens, Homer, *The American Artist and His Times*. New York, 1941.
Sloan, John, *Gist of Art*. New York, 1939.
Stuart Davis. New York, 1945.
The First Hundred Years: The National Academy of Design. New York, 1925.
Van Dyke, John C., *American Painting and Its Tradition*. New York, 1919.
Watson, Forbes, *William Glackens*. New York, 1923.
Yarrow, William, and Bouche, Louis, eds., *Robert Henri: His Life and Works*. New York, 1921.
Young, Art, *On My Way*. New York, 1928.

FOOTNOTES

Chapter 1

1. Lloyd Goodrich, *Thomas Eakins: His Life and Work* (New York, 1933), p. 52.
2. *Ibid.*, p. 54.
3. Adam Emory Albright, "Memories of Thomas Eakins," *Harper's Bazaar*, 81 (Aug., 1947), p. 139.
4. Letter to the author from Edward W. Redfield, Aug., 1956.
5. Goodrich, *op. cit.*, p. 88.

Chapter 2

6. Goodrich, *op. cit.*, p. 84.
7. Robert H. Gatewood, "Who Was Robert Henri?" p. 10.
8. Conversation with Violet Organ, Sept. 11, 1952.
9. Conversation with Walter Pach, Sept. 5, 1952.
10. John Sloan notes, p. 277.
11. Charles Grafly Diary, Sept. 9, 1888.
12. Robert Henri, *The Art Spirit* (New York, 1951), p. 22.
13. Dorothy Grafly, "Charles Grafly," p. 53.
14. *Ibid.*, p. 76.

Chapter 3

15. Art Young, *On My Way* (New York, 1928), p. 209.
16. Charles H. Caffin, *The Story of American Painting* (New York, 1907), p. 347.
17. Letter to the author from Edward W. Redfield, Sept. 8, 1956.
18. *Ibid.*
19. *Ibid.*

Chapter 4

20. Conversation with Mrs. John Sloan, Nov. 11, 1956.
21. Conversation with Mrs. F.R. Gruger, July 10, 1956.
22. Sloan notes.
23. *Ibid.*
24. Conversation with Mrs. John Sloan, Nov. 11, 1956.
25. Conversation with Mrs. John Sloan, Jan. 29, 1952.
26. Henri, *op. cit.*, p. 140.
27. Hans Huth, "Impressionism Comes to America," *Gazette des Beaux Arts*, XXIX (April, 1946), p. 234.
28. Henri, *op. cit.*, p. 160.
29. *Ibid.*, pp. 185-186, 214.
30. *Ibid.*, p. 64.
31. *Ibid.*, p. 130.

Chapter 5

32. Sloan notes.
33. *Ibid.*, p. 261.
34. *Ibid.*, p. 327.
35. Everett Shinn, "Recollections of the Eight," *The Eight* (Brooklyn, 1943), p. 19.
36. Conversation with Everett Shinn, Sept. 12, 1952.
37. *Ibid.*
38. *Ibid.*
39. Everett Shinn, 'Life on the Press,' "Artists of the Philadelphia Press," *Philadelphia Museum Bulletin*, 41 (Nov., 1945), p. 9.
40. Conversation with Everett Shinn, Sept. 12, 1952.
41. Everett Shinn, "The Eight. Four of Them," Unpublished Autobiography, p. 8.

Chapter 6

42. Everett Shinn, "George Luks," Unpublished Autobiography, p. 9.
43. *Ibid.*, p. 24.
44. Shinn, "The Eight. Four of Them," *op cit.*, p. 9.
45. Benjamin De Casseres, "The Fantastic George Luks," *New York Herald Tribune*, Sept. 10, 1933, p. 10.
46. *Ibid.*
47. "Luks Found Dead in 6th Ave. Hall after Dawn Study for Painting," *N.Y. Herald Tribune*, Oct. 30, 1933.
48. Shinn, "George Luks," *op. cit.*, p. 17.
49. John Sloan, 'Artists of the Press,' "Artists of the Philadelphia Press," *Philadelphia Museum Bulletin*, 41 (Nov., 1945), p. 8.
50. "Luks Says U.S. Has Own Master Artists," *New York Evening Post*, May 9, 1925.
51. Sloan, 'Artists of the Press,' *op. cit.*, p. 8.
52. Conversation with Will Luks, Sept. 12, 1952.
53. Shinn, "George Luks," *op. cit.*, p. 21.
54. *Ibid.*, p. 10.
55. Conversation with Everett Shinn, Sept. 12, 1952.
56. Sloan notes, p. 129.
57. Sloan, 'Artists of the Press,' *op. cit.*, p. 7.
58. Conversation with Everett Shinn, Sept. 12, 1952.
59. Shinn, "George Luks," *op. cit.*, n.p.
60. *Ibid.*, p. 4.
61. Conversation with Everett Shinn, Sept. 12, 1952.
62. Conversation with Mrs. John Sloan, Sept. 8, 1952.

Chapter 7

63. *The Philadelphia School of Design for Women, 1892-1893* catalog.
64. Letter to the author from Harriet Sartain, May 29, 1956.
65. Address by Redwood F. Warner, President of the Women's School of Design, Philadelphia, May 31, 1894.

66. Sloan letter to Henri, Sept. 2, 1895.
67. Sloan letter to Henri, Dec. 8, 1895.
68. Conversation with Guy Pène du Bois, Sept. 5, 1952.
69. Shinn, "George Luks," *op. cit.*, p. 43.
70. "Lusty Luks," *Time*, XVII (Jan. 26, 1931), p. 52.
71. Conversation with Mrs. Will Luks, July 30, 1956.
72. Shinn, "George Luks, '" *op. cit.*, p. 14.
73. E. Smith, "George Luks, Painter and Anti-Genius," as quoted in Adolph J. Karl, 'George Luks,' "The New York Realists, 1900-1913," p. 14.

Chapter 8

74. Shinn, "George Luks," *op. cit.*, p. 16.
75. Glackens, *op. cit.*, p. 24.
76. Sloan letter to Henri, Oct. 31, 1898.
77. Henri letters to Sloan, Sept. and Oct. 14, 1898.
78. Sloan notes, p. 139.

Chapter 9

79. Henri letter to Sloan, Oct. 14, 1898.
80. Henri letter to Sloan, Nov. 5, 1899.
81. Sloan letter to Henri, Feb. 14, 1900.
82. Regina Armstrong, "Representative Young Illustrators," *The Art Interchange*, XLIII (Nov., 1899), p. 109.
83. *Ibid.*
84. *Philadelphia Ledger*, Oct. 30, 1933.
85. Conversation with Everett Shinn, Sept. 12, 1952.

Chapter 10

86. Everett Shinn, "Maligning Mark Twain," Unpublished Autobiography, p. 1.
87. *Ibid.*, p. 2.
88. Conversation with Everett Shinn, Sept. 12, 1952.
89. *Ibid.*
90. *Ibid.*
91. Donald Wilhelm, "Everett Shinn, Versatilist," *The Independent*, 88 (Dec. 4, 1916), p. 398.

Chapter 11

92. "What Is Art Anyhow?" *New York Sunday American*, Dec. 1, 1907 and W. Franklyn Paris, *The Hall of American Artists*, vol. 4, p. 27.
93. Guy Pène du Bois, *Artists Say the Silliest Things* (New York, 1940), p. 73.
94. *Special Exhibition of Paintings by Mr. Robert Henri*, Cincinnati Museum (1919).
95. *Survey of American Painting*, Carnegie Institute (Pittsburgh, 1940), n. p.
96. George Bellows, "Introduction" to *The Art Spirit* by Robert Henri (New York, 1923), p. vi.
97. "Wm. M. Chase Forced Out of N.Y. Art School; Triumph for the 'New Movement' Led by Robert Henri," *New York American*, Nov. 20, 1907.
98. Conversation with Eugene Speicher, Jan. 26, 1957.
99. Conversation with Guy Pène du Bois, Sept. 5, 1952.
100. Conversation with Walter Pach, Sept. 5, 1952.
101. Conversation with Eugene Speicher, Jan. 26, 1957.
102. Milton W. Brown, *American Painting from the Armory Show to the Depression* (Princeton, N.J.), p. 130.
103. Conversation with Helen Appleton Read, July 9, 1956.
104. Conversation with Carl Sprinchorn, July 16, 1956.
105. Conversation with Manuel Komroff, Jan. 25, 1957.
106. Address to the School of Design for Women, Philadelphia, March 29, 1901.
107. Conversation with Mrs. George Bellows, Jan. 25, 1957.
108. Edgar Lee Masters, *Vachel Lindsay, A Poet in America* (New York, 1935), p. 121.

Chapter 12

109. *New York Evening Sun*, April 8, 1902.
110. *New York Evening Post*, April 10, 1902.
111. Henri, *op. cit.*, p. 262.
112. Conversation with Mrs. John Sloan, Sept. 8, 1952.
113. Henri, *op. cit.*, p. 262.
114. Letter from Sloan to Henri, Oct. 31, 1902.

115. Letter from Sloan to Henri, Nov., 1900.
116. Letter from Henri to Sloan, April 6, 1901.
117. "Art Notes," *New York Evening Sun*, April 11, 1901.
118. Charles De Kay, "Six Impressionists. Startling Works by Red-Hot American Painters," *New York Times*, Jan. 20, 1904.
119. *Ibid.*
120. Arthur Hoeber, "A Most Lugubrious Show at the National Art Club," *New York Commercial Advertiser*, Jan. 21, 1904.
121. "A Significant Group of Paintings," *New York Evening Sun*, Jan. 23, 1904.
122. Jerome Mellquist, *The Emergence of an American Art* (New York, 1942), p. 136.
123. Shinn, "George Luks," *op. cit.*, p. 21.
124. James William Pattison, "Robert Henri—Painter," *The House Beautiful*, XX (Aug., 1906), p. 19.
125. "Art Exhibitions of the Week," *New York Evening Sun*, Feb. 24, 1906.
126. Pattison, *op. cit.*, p. 19.

Chapter 13

127. Conversation with Everett Shinn, Sept. 12, 1952.
128. Everett Shinn, "The Eight by One of Them," Unpublished Autobiography, p. 11.
129. F. Newlin Price, *Ernest Lawson, Canadian-American* (New York, 1930), p. 3.
130. Everett Shinn, "Ernest Lawson," Unpublished Autobiography, p. 1.

Chapter 14

131. Sloan diary, March 8, 1906.
132. Eliot Clark, *History of the National Academy of Design 1825-1952* (New York, 1954), p. 98.
133. Will H. Low, *A Chronicle of Friendships 1873-1900* (New York, 1908), p. 234.
134. Clark, *op. cit.*, p. 99.
135. Frances M. Benson, "The Moran Family," *Essays on American Art and Artists* (Boston, 1895), p. 30.
136. Carolyn C. Mase, "John H. Twachtman," *The International Studio*, LXXII (June, 1921), p. lxxi.
137. James Spencer Dickerson, "Has America an American Art?" *World Today*, XIII (Dec., 1907), p. 1234.
138. "Certain Painters at the Society," *New York Evening Sun*, April 1, 1905.
139. Glackens, *op. cit.*, p. 59.
140. *Ibid.*
141. Pattison, *op. cit.*, p. 19.

Chapter 15

142. *Exhibition of Paintings by Arthur B. Davies*, Macbeth Gallery (New York, 1897).
143. *Town Topics*, April 4, 1902.
144. Henri letter to Sloan, Oct. 22, 1902.
145. Sloan diary, May 2, 1906.
146. Glackens, *op. cit.*, p. 65.
147. Sloan diary, July 26, 1906.
148. *Ibid.*, Sept. 12, 1906.
149. Jerome Myers, *Artist in Manhattan* (New York, 1940), p. 28.
150. Sloan letter to Henri, March 20, 1906.
151. Henri letter to Sloan, March 30, 1906.
152. *Boston Transcript*, Dec. 24, 1906.

Chapter 16

153. Sloan diary, Feb. 6, 1907.
154. Henri, *op. cit.*, p. 8.
155. Samuel Swift, "Revolutionary Figures in American Art," *Harper's Weekly*, LI (April 13, 1907), p. 534.
156. Rule V, *National Academy of Design Constitution and By-Laws, Amended and Adopted Jan. 15, 1907*.
157. Sloan diary, March 3, 1907.
158. "That Tragic Wall," *New York Sun*, March 16, 1907.
159. "The Henri Hurrah," *American Art News*, V(March 23, 1907)., p. 4.
160. "The Henri Hurrah," *American Art News*, March 23, 1907, p. 4.
161. *Ibid.*
162. "Two Admired of Robert Henri," *New York Herald*, March 31, 1907.
163. "The Henri Hurrah," *op. cit.*, p. 4.
164. "Two Admired of Robert Henri," *op. cit.*
165. *Putnam's Monthly and The Reader*. V (Dec.. 1908). p. 376.
166. Clark, *op. cit.*, p. 162.
167. "A New Poet-Painter of the Commonplace," *Current Literature*, VLII (April, 1907), p. 407.

168. Sloan notes.
169. "National Academy Elects 3 Out of 36," *New York Times*, April 12, 1907.

Chapter 17

170. Sloan diary, March 11, 1907.
171. Sloan diary, April 4, 1907.
172. Sloan diary, April 14, 1907.
173. "Eight Independent Painters to Give an Exhibition of Their Own Next Winter," *New York Sun*, May 15, 1907.
174. Sloan diary, May 19, 1907.
175. John I.H. Baur, *Revolution and Tradition in Modern American Art* (Cambridge, Mass., 1951), p. 15.
176. "Eight Independent Painters to Give an Exhibition of Their Own Next Winter," *op. cit.*
177. *Ibid.*
178. "New Art Salon Without A Jury," *New York Herald*, May 15, 1907.
179. "Academy Can't Corner All Art," *New York Evening Mail*, May 14, 1907.
180. Sloan diary, Dec. 16, 1907. Published in the *New York Evening Sun*, Dec. 31, 1907.
181. *New York Evening Sun*, Jan. 8, 1908.

Chapter 18

182. Sloan diary, Jan. 11, 1908.
183. *Ibid.*
184. Sloan diary, Jan. 12, 1908.
185. Glackens, *op. cit.*, p. 84.
186. Henri letter to Sloan, Jan. 29, 1908.
187. Sloan diary, Jan. 31, 1908.
188. *Ibid.*, Feb. 1, 1908.
189. Glackens, *op. cit.*, p. 86.
190. Goodrich, *op. cit.*, p. 34.
191. William Macbeth, *Art Notes*, 35 (New York, March, 1908), p. 545.
192. "Eight Painters," *Philadelphia Press*, no date [Feb., 1908]. Macbeth Gallery scrapbooks.
193. "Brooklyn Revives Memories of 'The Eight'," *Art Digest*, 18 (Dec. 1, 1943), p. 12.
194. Giles Edgerton, "The Younger American Painters, Are They Creating a National Art?" *The Craftsman*, XIII (Feb., 1908).
195. "Brooklyn Revives Memories of 'The Eight', " *op. cit.*, p. 12.
196. "Exhibition of the Eight, " *Boston Transcript*, Feb. 5, 1908.
197. "Art Exhibitions," *New York Sun*, Feb. 5, 1908.
198. "Eight Painters," *New York Sun*, Feb. 9, 1908. Macbeth Gallery scrapbooks.
199. James B. Townsend, "The Eight Arrive," *American Art News*, VI (Feb. 8, 1908), p. 6.
200. *New York Globe*, Feb. 6, 1908.
201. Townsend, *op. cit.*, p.6.

Chapter 19

202. Christian Brinton, "The New Spirit in American Painting," *The Bookman*, XXVII (June, 1908), p. 352.
203. Glackens, *op. cit.*, p. 105.
204. Sloan diary, Feb. 17, 1908.
205. Arnold Friedman, *The Original Independent Show, 1908*, n.p.
206. "Notes and Reviews," *The Craftsman*, XIV (June, 1908), p. 345.
207. Sloan diary, March 13, 1908.
208. *Ibid.*, April 18, 1908.
209. *Ibid.*, Feb. 17, 1908.
210. *Ibid.*, May 6, 1908.
211. *New York Herald*, May 17, 1908.
212. Glackens, *op. cit.*, p. 107.
213. Sloan diary, May 29, 1908.
214. *New York Evening Sun*, May 29, 1908.
215. Henri letter to Sloan, June 2, 1908.
216. Glackens, *op. cit.*, p. 110.

Chapter 20

217. Sloan diary, July 21, 1908.
218. Luks letter to Sloan, Oct. 29, 1908.
219. "Mr. Henri's Resignation," *New York Sun*, Jan. 6, 1909.
220. *Ibid.*
221. Sloan diary, Jan. 7, 1909.
222. *Stuart Davis* (New York, 1945), p. 2.
223. Conversation with Eugene Speicher, Jan. 26, 1957.
224. *Ibid.*
225. *Stuart Davis, op.cit.*, p. 2.
226. Mary Fanton Roberts, "Progress in Our National Art. . . ," *The Craftsman*, XV (Jan., 1909).
227. "Eight Independent Painters to Give an Exhibition of Their Own Next Winter," *New York Sun*, May 15, 1907.
228. Sloan diary, June 21, 1909.
229. *Ibid.*, Dec. 19, 1909.
230. *Ibid.*, Jan. 4, 1910.
231. *Ibid.*, Jan. 26, 1910.
232. *Ibid.*, March 15, 1910.
233. *New York Evening Sun*, March 16, 1910.
234. Guy Pène du Bois, "Great Modern Art Display Here April 1," *New York American*, March 17, 1910.
235. Frank Jewett Mather, "Academic Arteriosclerosis," *New York Evening Sun*, March 19, 1910.
236. Henri, *op. cit.*, p. 167.
237. Sloan diary, April 1, 1910.
238. "The Independent Artists," *New York Evening Post*, April 2, 1910.
239. Statement by Alden March, Sunday Editor of the *New York Times*, to John Sloan. Sloan diary, April 20, 1910.
240. "Around the Galleries," *New York Sun*, April 7, 1910.
241. *New York American*, April 4, 1910.
242. "Insurgency in Art," *The Literary Digest*, XL (Aug. 23, 1910), p. 814.

Chapter 21

243. C.H. Sawyer, "The Prendergasts," *Parnassus*, X (Oct., 1938), p. 10.
244. John Sloan, *Gist of Art* (New York, 1939), p. 6.
245. Sadakichi Hartmann, "Pleas to the Picturesqueness of New York" (1900), as quoted in Oliver W. Larkin, *Art and Life in America* (New York, 1949), p. 326.
246. Mellquist, *op. cit.*, p. 186.
247. *Ibid.*, p. 187.
248. *Ibid.*, p. 189.
249. "Insurgency in Art," *op. cit.*, p. 814.
250. Sloan diary, March 23, 1909.
251. Rockwell Kent, *It's Me, O Lord* (New York, 1955), p. 227.
252. Sloan diary, Feb. 7, 1911.
253. Kent, *op. cit.*, p. 228.
254. Myers, *op. cit.*, p. 34.
255. *The Eight* (Brooklyn, New York, 1943), p. 8.
256. Myers, *op. cit.*, p. 35.
257. Sloan, *Gist of Art* (New York, 1939), p. 25.
258. Letter to the author from Ira Glackens, Aug. 29, 1956.
259. "Notes and Reviews," *The Craftsman*, XIV (June, 1908), p. 341.
260. du Bois, *op. cit.*, p. 174.
261. Conversation with Walter Pach, Sept. 5, 1952.
262. *Ibid.*

Epilogue

263. Jerome Mellquist, "The Armory Show 30 Years Later," *Magazine of Art*, 36 (Dec., 1943), p. 298.
264. William J. Glackens, "The American Section: The National Art," *Arts and Decoration*, III (March, 1913), p. 162.
265. *Harper's Weekly*, March 15, 1913.
266. Mellquist, *op. cit.*, p. 298.
267. Henri, *op. cit.*, p. 194.
268. E. Ralph Cheyney, *op. cit.*, p. 219.
269. Henri, *op. cit.*, p. 5.

INDEX